THE APPRE ☁ _____ 1

General Editor: Harold Osborne

Architecture

ARCHITECTURE / *Sinclair Gauldie*

London · *Oxford University Press*

Oxford University Press, Ely House, London W.1

GLASGOW NEW YORK TORONTO MELBOURNE WELLINGTON
CAPE TOWN IBADAN NAIROBI DAR ES SALAAM LUSAKA ADDIS ABABA
DELHI BOMBAY CALCUTTA MADRAS KARACHI LAHORE DACCA
KUALA LUMPUR SINGAPORE HONG KONG TOKYO

CASED EDITION ISBN 0 19 211901 X
LIMP EDITION ISBN 0 19 211902 8

© Oxford University Press 1969

First Published 1969
Third Impression 1975

Made and printed by offset in Great Britain
by William Clowes & Sons, Limited,
London, Beccles and Colchester

Acknowledgements

Unlike the scholar—for whom it is a matter of professional habit to record his sources—the practising designer is best served by the ideas of others when he is least conscious of having absorbed them. If I have failed elsewhere in this book to acknowledge a particular borrowing, this must be my excuse.

Over and above the printed words I have read over the last thirty years, my indebtedness extends to all the people with whom I have exchanged ideas; and specifically to my partner Arthur Wright, to my neighbour Patrick Henderson, Professor of Philosophy in the University of Dundee, and to Dr. Terence Lee and Dr. John Uytman of the Departments of Psychology and Psychiatry respectively in that University, all of whom have given me valuable criticism and encouragement. I should like also to thank Mr. Val Morrocco of the Duncan of Jordanstone College of Art for his advice and comments, particularly in the field of interior design.

Finally, in a book which aims at opening its reader's eyes to the delights and splendours of architecture it is fitting that I should acknowledge my great debt to John Needham, now Professor of Architecture in the University of Sheffield, who first opened my own.

Dundee S.G.

May 1969

Acknowledgement is due to Constable and Company Ltd. for permission to quote material from Geoffrey Scott, *The Architecture of Humanism*, first published in 1914.

Contents

Illustrations

All unattributed drawings are the work of the author; so are the 35 figures and diagrams not listed here

The Nature of the Art

Somewhere above the level of brute survival, man begins to cultivate the search for pleasure in the things that make survival possible. One of these is shelter. Man builds first of all for protection; but as he extends his skill in building he begins to create a language of form which, as he develops it, becomes capable of touching the emotions, producing delight, surprise, wonder, or horror. At this level a building not only fulfils a practical purpose but commands an audience: in a word, it communicates. The ability to attend knowledgeably to such communications enhances life just as life is enhanced by the ability to relish those other pleasures, such as the enjoyment of good food, good drink, and good company, which are likewise built upon basic necessities of survival.

This is not a matter of esoteric connoisseurship or vintage-spotting, but a matter of tasting what is offered and forming one's own judgements. To relish in any meaningful sense is not just to swallow what is put before one, with thankfulness that it is no worse, or to like what someone else tells one to like. It implies an act of judgement, a comparison of the new experience with one's expectations,[1] placing it somewhere on one's personal scale of values; indeed, by assimilating it, extending that scale of values. This is what gourmets call 'cultivating the palate' and musicians 'improving one's ear', and it involves a certain effort.

In the first place one has to learn to *perceive*: not merely to glance and pass on, but to open one's senses fully to the new experience. Secondly one has to learn to understand. These are not two separate activities but rather two functions of a single activity. Psychologists call it cognition: the trappers of the American West used the simpler and more graphic expression 'reading sign' on something, a useful reminder that in less artificial surroundings than ours the visual environment cannot safely be taken as read and passed-over, like the dull minutes of some boring meeting, but must be studied with a certain concentration as a condition of survival.

[1] 'All culture and all communication depend on the interplay between expectation and observation, the waves of fulfilment, disappointment, right guesses and wrong moves that make up our daily life.' E. F. Gombrich, *Art and Illusion* (1960). (The place of publication of books referred to is London unless otherwise stated.)

The appreciation of architecture demands, then, the exercise of the mind as well as the senses. For exercise of the senses no book can be a substitute, especially since no building can ever be illustrated in anything approaching its totality. Architecture is 'read' through more senses than vision alone. Whether consciously realized or not, the feel of a balustrade under the hand, the freshness or staleness of air, the intimations of space given by reverberation or echo, are all components of a total experience, and a picture of the building can stand to the wholeness of that experience only as a printed miniature score stands to an orchestral performance. Similarly, an injection of ready-made critical values is no substitute for exercise of the mind. 'The one and only test of appreciation is delight',[1] and genuine delight is fed by understanding. The more one understands, the more clearly one sees, and the sharpened perception which comes from understanding enables the practised eye to find all sorts of delights which escape the uninitiated.

In the case of architecture a substantial groundwork of appreciation already exists, quite irrespective of expert knowledge, in one's unconscious but quite highly developed reactions to bulk, space, shape, and colour. When one becomes aware of a building at all, it is through one's assimilation (which may be quite unconscious) of the cumulative effect of these reactions that it registers itself as a building with a specific identity and not merely as some large unidentifiable object in the field of vision. But, although appreciation may be said to begin at this almost instinctive level, it does not end there. Every building is in some degree a historical document, a demonstration of structural technique, a performance test of building materials, a comment on the values of the society which produced it, and a reflection of the richness or poverty of its designer's imagination. The object of this book, therefore, is not to present the reader with a child's guide to styles or a manifesto in favour of any particular kind of architecture, but simply to help him towards a clearer understanding of architecture as a product of these interacting influences.

First of all it may be necessary, even now in the latter part of the twentieth century, to clear away a misconception about the nature of the art itself which has arisen out of its history and is still apt to colour the layman's judgement. Once the language of architectural form has been developed to the point where it is seen to have the

[1] Robert Lutyens and Harold Greenwood, *An Understanding of Architecture* (1948).

power of touching the emotions, we find it being used expressly for a particular kind of magic-making, as a means of celebrating the power of gods and rulers or (as in the great medieval cathedrals) as a means of symbolizing the higher aspirations of a society; or it may be used simply to celebrate a kind of victory over human mortality by building the personal attitudes of an individual into an artefact which will survive him. This celebration of something of conspicuous importance used to be regarded as the principal qualification distinguishing a work of architecture from mere 'building'; in particular the quasi-magical role played by ornament was held to be paramount and a hundred years ago architecture could be confidently defined as 'nothing more or less than the art of ornamented and ornamental construction'.[1] There have even been periods when serious critics were inclined to use the word 'architecture' in a still more restricted sense, applying it only to buildings whose motivation and language they understood and found sympathetic (the rest being dismissed as 'barbarous', if noticed at all) or to buildings whose function was to celebrate something of high and conspicuous importance.

Now anyone who maintains that it is futile to seek relish (as opposed to mere nutrition) in any food below the level of *haute cuisine*, or in any kind of drink less exalted than the great vintages, is cutting himself off from a very wide range of simpler pleasures, and the same applies to the enjoyment of buildings. The mere fact that we do, today, speak of 'vernacular architecture' (and by so doing acknowledge that the minor buildings of quite primitive communities may possess a quality which deserves serious aesthetic consideration) indicates that, whatever the distinction between architecture and mere building may be, informed modern opinion declines to draw it in the hard and fast terms which were acceptable a hundred years ago.

Nevertheless, the fact that the word exists in common usage does indicate that the distinction also exists. Some buildings *are* felt, however vaguely, to deserve a particular kind of attention which we do not accord to others and which makes it seem reasonable to write a book about the appreciation of architecture as a specifically aesthetic activity instead of a book about property-valuation or a manual for building inspectors. We are in fact able to appreciate architecture as a

[1] James Fergusson, *The History of Architecture* (1865).

form of art only in so far as we can detect this distinctive quality where it exists. In so far as it can be described at all, it might be described as the quality of being memorable. In the presence of a building which deserves the name of architecture we are conscious that someone cared, that someone made it his business to carry out the practical function of providing shelter in a way which the observer will not entirely have forgotten by the time he has rounded the next street-corner. As a result the building has 'got through' to him and in its own way has made a communication to which some response is expected, a statement which invites judgement: a statement, more-over, which is not merely commonplace but which is calculated to touch the feelings as well as the reason.

In the case of the other arts this communicative function is para-mount. We expect a painting or a piece of sculpture or a musical work to touch the sensibilities. We are prepared to accept this as sufficient reason for its existence and we generally assume that all the decisions its creator makes are governed by that end. It is a peculiarity of the work of architecture, however, that the aesthetic decisions made by its designer, to which it owes its emotive force, are inseparable from all the other decisions which he has to take in attacking a problem which is, in the first place, functional and practical. The genesis of the whole operation is a building task,[1] that is, the provision, on a given site and with given resources, of a suitable space for certain human activities. In carrying out the task the designer has to form an idea of the shapes and relationships of the spaces to be enclosed and an idea of the kind of envelope and supporting structure best suited to the job. Nothing can happen until he has formulated his functional and structural intentions[2] and communicated them to men with tools in their hands. In the course of arriving at these intentions he has a multiplicity of decisions to make and a great many of them are necessarily subjective, for it would be remarkable to find a building task so precisely definable that it determines with incontro-

[1] I have borrowed this terminology from Christian Norberg-Schulz's scholarly and thoughtful book *Intentions in Architecture* (1963). The word 'programme' is more commonly used in English but tends to convey the more limited sense of an explicit set of user-requirements and thus to obscure the fact that architecture is often expected to embody and transmit the social and cultural values of the people for whom it is created, and not only to meet their practical demands.

[2] Having quoted Norberg-Schulz's title, I should perhaps make it clear that I am not giving the word 'intention' the specialized psychological meaning which he assigns to it but merely its ordinary dictionary meaning of 'aim' or 'design'.

vertible logic the size, shape, colour, and placing of every single element in the building. In so far as he makes these subjective decisions because he feels that one choice will produce a 'better-looking' result than another and not merely by spinning a coin, they are aesthetic decisions. And when he consciously considers the effect of these aesthetic decisions upon each other and addresses himself to forging them into some kind of unified whole, he is in the process of formulating an aesthetic intention which, when followed through to its conclusion, will give this building a specific and, to a greater or lesser degree, a memorable identity.

As we shall see later, this intention may be conceived in a single sustained sweep of individual imagination or it may evolve, perhaps over years, through the interplay of ideas within a group:[1] the form of a building as we see it today may, in fact, be the product of a whole series of successive intentions, woven together either successfully or unsuccessfully. What is important to the observer is not *how* the intention was formulated but whether it has been realized in a coherent and memorable way. He is primarily concerned, that is, with the communication which that intention has produced in the language of building form. If he is to understand the nature of the art, however, he must necessarily recognize that in the greatest and most memorable work the aesthetic intention is not merely grafted upon the functional and structural intentions but is rooted in them and even inspired by them: and he must be ready to recognize also the sorry results of failure to achieve any organic unity between the three.

We are entitled, therefore, to expect of a work of architecture some evidence that the designer has, to use a common phrase, 'put something of himself into it'—not in the sense that he has added a few perfunctory cosmetic touches by way of fancy wrapping to a utilitarian parcel, but in the sense that he has allowed his imagination to be fired by the essential building task itself and has succeeded in passing over some of this fire to the observer through the apt and eloquent use of the language proper to his art. By the same token the

[1] When I speak of 'the designer' or 'the architect' I shall, in fact, often be referring to a corporate entity of this kind. Today it is exceptional for *all* the decisions which give a building its form to be taken by a single individual, but it remains essential that a coherent aesthetic intention emerges out of the group operation. It has been said that 'a camel is a horse designed by a committee'; the practised observer should have no difficulty in detecting the architectural equivalent and distinguishing between it and the very different product of an inspired team of collaborators.

observer who would appreciate the results of the exercise fully and judge them justly must open his own channels of communication to receive the complex statement which a building has to make, and for that he too requires some familiarity with the nature of the architectural language.

It must first of all be understood that the language of architectural form is not a fixed set of symbols which has been handed down to the architect by his predecessors to be reshuffled and dealt out again. It is rather to be considered as something endlessly developing in many different directions, and the trend of its development in any given society will be profoundly influenced by the kind of exploration of the possibilities of form which is encouraged by the intellectual climate of that society. The Periclean Greeks, for instance, had an intense and almost mystical interest in proportion and remarkably little interest (by our standards) in constructional exhibitionism: by contrast, the society of late medieval Europe encouraged designers to experiment in the most daring way with the structural possibilities of stonemasonry. Sometimes a society fixes strict bounds of stylistic 'correctness' within which its architects are expected to operate, and occasionally—as during the Renaissance and the 'revival' periods which followed—it may resurrect the vocabulary of an earlier society and set its designers the problem of using that vocabulary in a new way. In such periods, although the pace of technological development in building may slow down, aesthetic exploration is not necessarily halted but merely given a different direction.

The architectural language is capable of responding successfully to such diverse demands because its nature is a composite one, providing many channels of communication and many combinations of such channels. Our subconscious reactions to variation in the space around us, to the size, shape, and relationship of the solid masses which force themselves on our attention, to the colour and texture of materials, to the play of light and shadow, and even to the different acoustic characteristics of different rooms, all carry evocative associations of some sort through which the emotions can be engaged. And of all these channels the one through which architecture communicates most forcefully is provided by *the relationship of three-dimensional bodies in space as perceived by a moving observer.*

Such a relationship is inevitably created by the mere fact of enclosing space. Roofs have to be held up by some kind of solid support and the resulting system of shelter and structure will impinge from all sorts of different and changing viewpoints on the perceptions of

the people who circulate around it and inside it. The *form* of the entire building, in the sense in which I shall be using that word from time to time, is therefore not to be taken as meaning only the building's general shape as seen from any one fixed viewpoint. It should rather be understood as a convenient shorthand expression denoting the memory's record of a whole set of superimposed impressions.

We are better equipped to receive, sort out, and interpret these impressions than most people realize. The architect who spends his entire professional life sharpening up the two kinds of awareness which most concern him—awareness of space and awareness of structure—is only carrying on deliberately a kind of study which every normal person has pursued unconsciously but quite obsessively for the first two years of his life at least. The awareness of space, of course, comes quite directly from the point where eye and touch begin to gauge distances and heights. The awareness of structure—that is, the intuitive feeling for the ways in which the gravitational and overturning forces upon a building can be safely carried down to the foundations—emerges later, partly from observation of the world around us and partly from personal physical experience.

The forces which any structure has to resist—that is to say, those which tend to pull it down, overturn it, or blow pieces of it away—also operate on all living things, and the idea that there is a kind of immanent rightness in some organic forms is really a rather hazy recognition of the fact that they have grown in logical response to forces—such as gravity and wind-pressure—which our own bodily experience also acknowledges. Few people concern themselves with the structural mathematics of this response: we accept the form itself as a rough model which is felt intuitively to have a certain conclusiveness about it.[1] The range of these inferences which can be drawn from nature depends, of course, on the individual's environment as well as on the acuteness of his observation. A boy brought up among apple-orchards is given a yearly demonstration of the reversible deformation of elastic cantilever supports under an increase of imposed load (although he would never give the bending of laden branches such a pompous description) which is not available to the Greenland

[1] To quote D'Arcy Thompson's classic *On Growth and Form* (1917): 'Morphology is not only the study of material things and of the forms of material things but has its dynamical aspect under which we deal with the interpretation, in terms of force, of the operations of Energy.' Chapter 8 of this great book is particularly relevant to the appreciation of structural form in architecture.

Eskimo: the Eskimo, on the other hand, identifies seventeen different kinds of snow-formation by name.

A more immediate source of reference, and one which is shared by all of us, is our subconscious record of the personal contest, which begins in infancy, against the primal force of gravitational pull. The small triumph of standing up and staying up, culmination as it is of a long and perilous course of experiments, is a most significant assertion of the beginnings of mastery over the environment and leaves implanted in the memory a whole stock-pile of associations which can become symbolical and be invoked by some elements at least of the basic vocabulary of architecture.

This assertion is not by any means as fanciful as it may seem at first sight. After all, the written and spoken language has already embedded such associations in the most commonplace metaphors of everyday speech. The heart sinks, the face falls, the spirits rise. One falls down on the job, rises to the occasion, recovers one's poise, stands up to trouble, jumps for joy, gets high. Such turns of phrase all embody the idea that power, success, and joy are associated with victory over the force of gravity; submission, failure, and sorrow with yielding to it. They are references to a primordial language of gesture which every actor knows how to exploit, expressing defeat by the sag of the body, liveliness by a springing step, determination by a firmly planted stance, and so on through the whole elaborate and refined catalogue of mimetic pose and movement.

Everyone, then, has a kind of rough-and-ready structural instinct, unsupported by calculation and really amounting to a predisposition to read into the building the associations of his own bodily experience; and this predisposition, further extended, inclines us to read the 'signs' of the architectural vocabulary—especially the relationships of masses in space—by reference to experience of our own physical states and bodily movements. We are in effect trying to fix that building in our consciousness by attaching it to the most readily available system of references we possess—the stored associations of physical reflexes—as a painter or poet might seek to fix his impression by transcribing it into the terms of his own art.

Some building forms, of course, are quite directly suggestive of physical gestures. The cantilever has something of the arresting quality of an outflung arm and, most obviously, the spire makes the gesture by which one identifies oneself in a crowd or summons a cab. It says simply and directly: 'I am here. Pay attention.' An entire

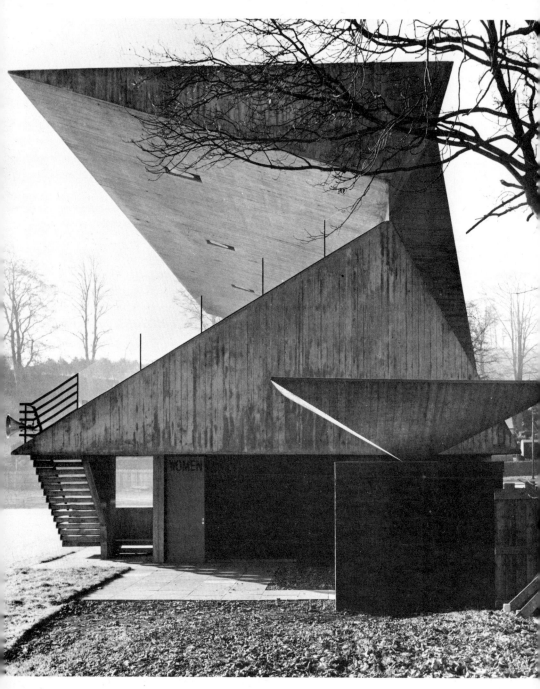

building, again, may exhibit that total stillness, as of a guardsman at attention, which is itself a kind of gesture, while another—as in the case of some Baroque examples—seems to gesticulate in a way which can be positively disturbing. These are only the crudest and most obvious illustrations. Often the gesture is only the shadow of a hint and it is quite impossible to identify consciously which chord of memory has been touched, exactly why the entrance to one building has extended an unequivocal invitation to come in while another has seemed to suggest that one should think twice before intruding. These are gestures, nevertheless, just as the faint movement of a facial muscle is a gesture capable of interpretation.

It is not to be understood by this that the essence of the architectural language can be embodied in some simple phrase like 'frozen gesture' (although this would still be nearer the truth than Schelling's 'frozen music'); still less that there is some mystical correspondence between architectural forms and proportions and those of the human body, but simply that architecture makes a very direct and immediate appeal through lines of communication which are well established in all of us by daily habit and lifelong experience—the awareness of space, the awareness of the flow of force (especially of gravitational force) and the associations of bodily movement derived from it.

To these should be added a third kind of awareness which also develops in very early life, and that is the awareness of rhythm. The origin of this faculty is obscure, but it is clear enough that the ability to distinguish patterns of repeated movement plays some important part in the business of making sense out of the bombardment of sensory impressions to which we are subjected from the cradle to the grave. It is clear also, and a matter of everyday experience, that different kinds of rhythm-pattern evoke different emotional responses: compare, for instance, the special liveliness of a complicated pattern with the hypnotic, even oppressive, quality of a sustained simple beat.

Rhythm provides a visual line of communication as well as an auditory one: the measured flick of the telegraph poles across the carriage window is as characteristic of a train journey as the beat of the wheels. In architecture this visual rhythm may be apprehended directly in the actual movement of the observer through space—as, for instance, in walking through a long colonnade—or by a visual reference, as when the eye traverses the façade of a building and records the pattern of alternation between window and wall.

Grandstand at Galashiels, Selkirkshire, by Peter Womersley. *Photo: Waverley Studios*

So the architect is communicating in a language full of direct allusions to everyday physical experience, concerned primarily with the grouping of bodies in space in variable relationships in which visual rhythm plays some part as an indicator of movement. This basic vocabulary is capable of being enriched and made still more expressive by the emotive associations of light, colour, and texture: polished white marble and rough dark sandstone stimulate quite different responses. Over and above this we bring to the observation of a building (as indeed the architect brought to the designing of it) a whole set of preconceptions added to the memory-store in the course of growing up. For example, the associations of wood with warmth and stone with weight are records of very early experiments in touching, lifting, and throwing. Moreover, observation and convention have superimposed a further layer of referents—the aesthetic judgement may be biased, for instance, by the natural tendency to prize rare and costly materials and it may be influenced by the fact that certain forms (such as the spire of the parish church) have acquired a particular symbolic importance within one's own society.

Out of such conventions, and out of the nature of their own building tasks and the materials and tools available, different cultures create their own styles which are, so to speak, the dialects of the architectural language. Again, a designer may use the language in a way peculiar to himself and reflecting his individual cast of mind and his personal attitude to his art: that is, he develops his own idiom. One's understanding of architecture is deepened by the study of these dialects and idioms and the influences which formed them, but the basis of all appreciation is a cultivated awareness of the *universal* elements of the language. One might compare it with the enjoyment of ballet or mime, which is not confined to those who (like the professional critic) can draw comparisons between one interpretation and another, or to those who are experts on the stylistic conventions of this school or that, but is open to anyone who is capable of being moved by the basic language of movement and gesture—a language already half familiar through everyday experience.

Dangerous though it is to explain one aesthetic language in terms of another, the parallel with these arts of entertainment is a suggestive one. The full enjoyment of architecture is not so much that of 'contemplating a work' as attending a performance in which one is simultaneously a spectator and a participant, and in which the buildings are not only a setting for human movement (including one's

own) but silent and rather heavy-limbed actors. The theme of the building unfolds itself through a sequence of movement in which sensation succeeds sensation over a period of time according to a predetermined and probably complex pattern, and for this silent ballet the architect is at once deviser, choreographer, producer, and scenic designer. His business—his aesthetic business, that is—is not just to present a potpourri of aesthetic incidents, however evocative each one may be in itself, but to bring them together in a coherent and eloquent whole.

Like the theatre, too, architecture has its nine-day wonders and its enduring masterpieces. The value placed on a building by the critics of its own time will inevitably depend, more than they may be prepared to admit, on the accuracy with which it hits off the mood of its period and if it has no more to commend it than this, the passage of a generation will see it written down to the level of a historical curiosity if not written off altogether. The building which, long after the fashionable idioms of its time have degenerated into clichés, still continues to contribute some memorable quality to human life is the building which draws its communicative force from the unchanging emotional associations of the archetypal elements in the architectural language, those which are most deeply rooted in the common sensory experience of humanity. So it is to these associations that we must first turn for an answer to the question: What makes a building enter the consciousness and lodge its image in the memory in a particular way?

Canons of architectural propriety tend to be based on the possible, that is, on the exploitation of such combinations of form, colour, and texture as simple technologies put at the designer's disposal. A culture develops its own architectural dialect (and strikes its own critical attitudes) through a slowly-formed consensus of opinion that some of these combinations are more agreeable than others.

Today technological possibilities seem limitless, and new ideas emerge and spread with unprecedented speed. Consequently the observer who aims (as any serious observer should) at being also something of a critic[1] will find few undisputed criteria or theories of beauty to guide him. Instead he must cultivate his ability to rationalize unconscious responses, which may be peculiar to himself or shared with people in general. Fortunately these responses at least provide some consensus of opinion about certain attributes which are found positively disagreeable, disconcerting, or even downright ugly; and this will provide a point of departure for the next stage in the exploration.

To begin with most buildings have some utilitarian function, and they obviously fail in it if they fall down. One can reasonably say that malfunction and instability go against the very nature of architecture and thus, when detected, cannot be excluded from aesthetic criticism. When one says that a building is meanly planned, that its internal circulation is frustrating, that its rooms are cramped, badly lit, or awkwardly shaped, one is acknowledging irritations which have made the experiencing of that building *in its totality* less than pleasant, however smiling a face it may present to the street. Likewise when one describes it as top-heavy, rickety, lop-sided, and so on, one is voicing an aesthetic reaction to the designer's failure to produce a recognizable structural order.

Given that malfunction and structural incoherence, when apparent, are by common consent aesthetic defects, it follows that a building

[1] By 'critic', here and elsewhere, I do not, of course, mean a professional fault-finder but rather the kind of observer who can voice opinions which command respect because the assumptions on which they are based are clearly more than unthinking prejudices. And I assume it to be a characteristic of the good critic that he is perpetually testing his assumptions against new experience.

acquires some aesthetic merit when it demonstrates structural neatness and convenience for use. It should not be concluded that these are aesthetic virtues whether they are apparent or not—one cannot, after all, enjoy invisible architecture—still less that convenience and stability by themselves necessarily make a building an object of aesthetic admiration. Nevertheless, these half-truths help us to approach the real truth.

Architecture lies close to the practical affairs of life, and the judgement by which we conduct these affairs (and which we transfer in some degree to the appreciation of architecture) is a matter of assessing the balance of advantage, that is, of calculating risks. One calculates risk by recognizing its existence and measuring it against experience: *Will this branch bear my weight? Will this tool slip in my hand?* —or against learning: *Is this the red berry the old man said was poisonous?* To be at risk is the natural condition of man as it is of other animals, but man does not simply react like an animal to the immediate scent of danger. He has built upon his learning-patterns the habit of foreseeing latent risks and taking steps to counter them; and through this capacity for organizing experience into learning and foresight he has become able to master his physical environment instead of merely adapting himself to it.

Twentieth-century man is, therefore, the inheritor of an elaborate risk-calculating apparatus which, if he keeps it in trim, will protect him equally against losing his life on a motorway or his money on the Stock Exchange. He seldom brings it to bear on the appreciation of the arts, which mostly threaten nothing but his susceptibilities. But it can be shown, I believe, to play some part in conditioning his responses to the omnipresent and massive art of architecture, which does, simply by its omnipresence and massiveness, give him occasional intimations of real physical risk. The collapse of a theatre is, to say the least, more distressing to the audience than the collapse of a play.

We cannot, therefore, discount the influence on architectural appreciation of this system of security checks by which we are so elaborately equipped to be afraid. We would hardly expect the aesthetic impact of any building to throw the main switches which activate the 'fight or flight' mechanism, but behind the disquiet evoked by certain combinations of forms (and behind our consciousness, when in the presence of certain buildings, of that fear-made-tolerable which is called 'awe') there can be detected a certain

sensitivity to the muted undertones of menace. Hence it is reasonable to suppose some degree of correlation in architecture between what is described as 'ugly' and what is felt to be in some way inimical to well-being.

In the first place it should be noted that the use of a word like 'ugly' indicates that the danger is some way removed. Percepts which offer clear indications of an imminent danger against which the security-system has been thoroughly programmed—like red-hot pokers and bottles labelled 'POISON'—are not so described: the ugly is rather that which suggests a *potentially* inimical quality, and suggests it strongly enough to be treated as suspect until proved innocent. Consequently any individual is likely to tag as 'ugly' a percept which stirs memories of past unpleasantness. Some of these memory-impressions are the private property of the observer, but others are common to the bulk of humanity and these do provide certain generally accepted gauges of disapproval which are applied consciously or unconsciously to the judgement of architecture. The suspects so identified might be put into three broad and rather loose categories: the confusing, the monstrous, and the ungovernable.

The confusing—that is to say the amorphous or ambiguous—causes a disturbance of the first order because it declines to come forward and be clearly identified. The spectres and shape-shifters of mythology, the 'faceless horrors' of ghost stories, represent an extreme and terrifying degree of formlessness which is seldom found in architecture for the obvious reason that only remarkable and perverse ingenuity could produce a building imbued with its full nightmarish flavour. Associated with it, however, is the irresolute or ambiguous shape which worries the security-system quite enough to cause discomfort, or at least irritation.

Consider, for instance, that classical and elementary blunder the 'unresolved duality' (Fig. 1) presented by two identical and unrelated shapes so placed within the field of vision that they compete equally for attention. The perceptual system is so ill equipped to deal with this situation that it utters signals of protest—like the 'I can't serve you both at once, you know' of the harassed barmaid—and can only be pacified by providing a third element dominant enough to master them or, as a designer would say, to 'pull them together' (Fig. 2). There is a similar equivocal quality where two opposites are present—light and dark, solid and void, horizontal and vertical—and neither predominates. When the perceptual system is thrown into confusion

by ambiguities its owner may become highly vulnerable (as thousands of road accidents witness), and his security apparatus does not hesitate to inform him of the fact.

Lesser degrees of ambiguity signal less insistent warnings: they provoke, rather, a kind of active coming-and-going between the security-system and the more consciously intellectual processes. Nevertheless, the system remains quite highly intolerant of percepts which, although not productive of immediate confusion, convey the impression of a concealed trap. It is alerted, for instance, when it detects a visual confidence trick, such as an arbitrary break in an established rhythm. We have already noted the soothing and monotonous quality of a sustained simple beat (Fig. 3). Once peacefulness has been established, an inexplicable and perverse disruption of it (Fig. 4) is a suspicious event to which the visual judgement is not easily reconciled. At best it asks the conscious mind to record some resentment at the disappointment of a reasonable expectation.

The most reasonable expectations of all are, of course, those which have been formed by reason. Even an animal can sense a trap: detecting a cheat is a more intellectualized operation, but it provokes a similar reaction. 'Detecting', it must be noted, is the operative word. In architecture, as in ordinary affairs, it is the detection—or at least the suspicion—of an intention to cheat which offends, rather than the intrinsic nature of the form itself. To quote Santayana, 'The uncomfortable haunting sense of waste and trickery prevents all enjoyment and therefore banishes beauty.'[1] The strongest indictment of 'untruthful' or 'insincere' architecture is that the inclination to cheat is rarely compatible with successful integration of the functional, structural, and aesthetic intentions. It shows through in a kind of ambiguity of attitude[2] and the sensitive eye can detect it without quite knowing why, just as a skilled judge can see through the respectable witness to the plausible liar.

One must, however, qualify the notion that the detected deception represents an archetypal kind of ugliness in the sense that the formless or the overtly confusing is archetypal. One does not usually describe

Fig. 1

Fig. 2

Fig. 3

Fig. 4

[1] *The Sense of Beauty* (1896).

[2] Where the creation of illusion is specifically and obviously a major element in the building task—as so often in High Baroque—no such ambiguity exists. Indeed it is the evident *conviction* that the 'willing suspension of disbelief' is a worthy end in itself which we detect in such architecture, and its power to delight is proportional to the force with which that conviction comes across.

a *benevolent* deception as a swindle—one is more likely to find it amusing than to resent it—and consequently one's reactions will be quite strongly influenced by one's sympathy with the intention. A considerable amount of ideological dishonesty may be involved in putting a new office building behind the domestic eighteenth-century façade of a London or Dublin square; but the deception is undoubtedly well-intentioned, and the odds are heavy that it will offend fewer people than the insertion of a building designed to 'give truthful expression to the ethos of the twentieth century'.[1]

It is almost certain in fact that someone will describe the latter as a 'monstrosity', and this brings us to the second kind of ugliness. Whereas the unpleasantness of the formless lies in the absence of a detectable pattern of relationships, the unpleasantness of the monstrous lies in the presence of forms which do not conform to an expected and acceptable norm. The individual security-system is alerted by it according to the kind of norms it has been programmed to accept and the degree of deviation which is to be treated as a danger-signal. Human adults are expected to be roughly of a certain height and such noticeable deviants as the giant and the dwarf are monsters, to be considered sinister (as so often in mythology) until proved harmless. Humans and other animals are expected to be roughly of a standard shape and they partake of the monstrous in so far as they depart from it—distressfully, as by deformation; horribly, as by having two heads; or preternaturally, as by being like the satyr a composite of two norms.

In so far as a culture has acquired stereotyped ideas of building forms and given them symbolic value, it will tend to label any deviant forms 'monstrous'. In a primitive, closed culture this may well be valid criticism, since the accustomed building type, like the accustomed tools and weapons, will have evolved by a long process of rejecting the demonstrably unfit and can fairly be considered an embodiment of the best performance-specification available within the given situation. In a more advanced, open culture, where the whole relationship of design and production has changed under the pressure of technological advance, the stereotype may represent no

[1] I am referring here to the case where the original frontage is retained as a mask in order to preserve completely the unity of design which is the virtue of such squares. This is not the same thing, of course, as putting up a building which does destroy the unity—as, for instance, by being four storeys higher than the rest—but is given a pseudo-Georgian façade as a half-hearted concession to decency.

more than a preference for the familiar—no longer necessarily related to optimum functional performance—and as such it can form a real impediment to judgement and enjoyment of the new or foreign by suppressing or distorting the communication they would make.

To see architecture clearly, therefore, one must acquire the habit of looking at it *past*—not *through*—the stereotyped images of a lifetime, and also the rather more difficult art of detecting whatever substratum of truth lies beneath the stereotype itself. For the idea of the norm is connected, even if only loosely, with the idea of what is 'fitting' and this concept of fit is fundamental to the judgement of buildings, whether one uses fitness in a literal sense (the building fits its site and its parts fit each other) or metaphorically, as when one says that it 'fits its purpose' or that Versailles is a 'fitting symbol' of the French monarchical ideal.

The notion of fitness will be examined more closely in a later chapter. For the moment it will be enough to note that the reaction which tags a building as 'ugly' in the sense of 'monstrous' is a reaction of the security-system to a percept which, from the evidence of previously accepted norms, it has been programmed to reject, and that one effect of knowledgeably observing architecture—and so taking fresh evidence—is to compel revision of this programme with a consequent enlargement of the possibilities of enjoyment.

In some respects, however, the programme is not susceptible to amendment. However wide the range of norms, the perceptual system will still be suspicious of a hybrid (Fig. 5), for the hybrid flies the danger-signal of ambiguity. It will also condemn as ugly, in the sense of 'monstrous', a perverse deviation from expected proportions (Fig. 6) or the amputation of an expected part. The expectation which has been disappointed may have been built on scholarship or connoisseurship (as when one detects an anachronism in an historical pastiche, or an 'incorrect' use of a classical detail); but it may on the other hand have been built on experience which is shared by all of us. No study of Palladio is necessary to find the mutilated Palladian[1] mansion (Fig. 7) distasteful: the amputation advertises itself by reference to the ordinary human sense of balance.

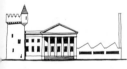

Fig. 5

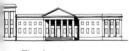

Fig. 6

Fig. 7

[1] The name given to the severely classical style of architecture, characterized by formality, symmetry, and obedience to 'laws' of proportion, which was fashionable in the first half of the eighteenth century. It originated in the work of Andrea Palladio (1508–80), whose theories were based on the study of Roman remains and the writings of the Roman architect Marcus Vitruvius Pollio.

This brings us immediately to the last category of menace: the ungovernable. An eruption of energy is really frightening when it is outside one's control—the energy of a wild dog and of a furious parent are obvious childhood examples—and much more so when it is clearly outside anyone's control, like a tornado or a thunderstorm. Now the basic motive of architecture is the provision of shelter, and implicit in the idea of shelter is the assurance that things are under control. We assume that the people inside the architectural envelope will be able to go about their activities in a way which is not entirely chaotic, that they are protected from the various unfriendly energies (of burglars, for instance, or hurricanes) which are at large in the world outside, and that they are efficiently served, through pipes and wires, by the various energies which man has harnessed to his own purposes. We expect an architect, when he designs a building, to reduce this multiplicity of energies to some kind of benign order and we may well be disturbed when instead of bearing witness to such an order the building presents an appearance which suggests dis-ordered or ungoverned force. Consequently, we may conclude that the building is, in this particular sense, 'ugly'. But we may equally well arrive at such a conclusion quite independently of any such intuitive diagnosis of the architect's function, for it is not the experience of the designer which we first 'read into' the building, but our own. The human body is a thinking and value-forming energy system and from infancy the human mind applies itself consciously or uncon-sciously to the problem posed by the ownership of this machine and by the action of external forces on it. Even a baby is conscious of the operation of some of these forces and can resent them quite vocally: it is equally resentful of the frustration of its own energies and it becomes fretful when it feels the machine running down. The process of growing up is a process of learning to control one's own energies and to balance them against gravity, overturning forces (such as gales of wind and rough boys), and the other energies of the environment. Such lessons are not easily forgotten, and from such primitive experi-ments one becomes suspicious of the appearance of imbalance. Equally one learns when to give the benefit of the doubt: the rein-forced concrete cantilever is exciting rather than terrifying because one is assured by the experience of one's own body, irrespective of any structural mathematics, that such a thing is, within limits, possible (see p. 10).

Quite apart from the kind of energy distribution which brings the

forces upon a building safely down to earth is the impression or inference of energy which it can convey simply by the shape of its parts. As has already been noted, we attach some expressive value to the manifestations of muscular power over gravity and apply to architecture some of the patterns of reference thereby acquired. Thus when we talk of spires soaring, arches leaping, and so on, we are reading into the building manifestations of a kinetic energy which, as we know very well, it does not possess: we are granting it a degree of imaginary animation and in doing so we require of it some quality vaguely corresponding to human self-control. In so far as we think of it as making gestures, we like to feel that these gestures are controlled and are not wholly incompatible with our *intellectual* awareness that a building is something static and immovable. The degree of imaginary mobility or energy-display which the individual finds tolerable will, of course, depend on his own mental set, which in turn is partly a product of his own social and physical environment: an Englishman who thinks that all foreigners gesticulate too much will tend to feel much the same about a Baroque church. Even so, the normal man's tolerance of 'restlessness'—to use the architect's common word for it—is not unlimited: most people would be disturbed to their depths by a spire which gave the visual illusion of really taking off skywards or an arcade which really gave the impression of a building hopping up and down. In fact it takes a strong stomach to enjoy the flounced façade of Gaudí's[1] Casa Mila, swirling like the petticoats of a demoniac flamenco dancer, and only a slight fever of the imagination to picture the Provident Trust Building—as arbitrarily angular as the other is arbitrarily curvaceous —shuffling and twitching across Philadelphia like some overwrought and arthritic ogre.

The idea of energy running wild seems to be not unconnected with the less disturbing but still unpleasing idea of energy running to waste, and there is certainly an intellectual connection. Technology has not been developed simply by erecting protective barriers against flood and wind but by harnessing their energies to man's purposes, as by the dam and the windmill. Moreover, man has a fair idea— especially in harsh climates—of the importance of husbanding his own energy resources for purposes of survival, releasing them in wanton exuberance only on occasions which call for a celebration.

[1] See Biographical Note.

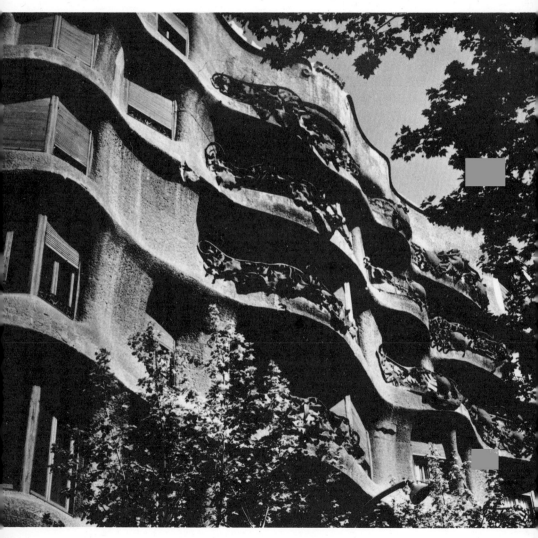

Casa Mila, Barcelona, by Antoni Gaudí. *Photo: J A Coia*

Provident Trust Building, Philadelphia, Pa., by Frank Furness

From this practical cast of mind there derive unconscious attitudes to energy-disposal which also enter at some level, as will be seen later, into the judgement of buildings: it was not idly that Santayana bracketed waste and trickery together as disturbers of the peace.

Finally, it need hardly be mentioned that these three categories of implied menace—the confusing, the monstrous, and the ungovernable—are not by any means mutually exclusive. The Provident Trust Building, for instance, is indebted to all three for its peculiar 'horror-comic' quality.[1] In as much as it has a pronounced basic symmetry it escapes (as almost any building must) the full charge of formlessness, but there is certainly an ambiguity between the massive solidity suggested by the material and the febrile restlessness of the shapes given to it; and this cavalier treatment of energy is reflected in the proportions of the arcade, whose curiously abbreviated columns, hinting that the building is telescoping under its own weight, almost make the signal: 'Enter at your peril.' And to this has to be added the perverse suggestion that the upper half is a flat-topped excrescence sprouting from the shoulders of a pyramidally roofed two-storey building, an impression which not only confuses by simple ambiguity but adds something of the monstrous quality of the satyr.

It is a revealing, if not wholly enjoyable, experience to study the most grotesque building one can find and to probe the buried layers of experience for the associations which underlie one's reactions to it: but tracing the roots of ugliness is not quite the same thing as searching out the sources of enjoyment. Pleasure is rather more than the absence of pain and the architect does not make much of a contribution to the richness of life when he aims no higher than keeping people under sedation. Somewhere between apathy and ecstasy daily life is tolerable, and within the limits of tolerability lies a rather narrower area in which it is positively pleasurable. If one accepts the view that the whole architectural background of life is important and that the architect's business is not solely to inject an occasional shot of ecstasy into acres of inevitable tedium, then the foothills of pleasure deserve exploration no less than the peaks of revelatory experience.

[1] In his *Changing Ideals in Modern Architecture* (1965) Peter Collins has pointed out that Furness and other architects of his period were, in fact, deliberately exploiting the elements of ugliness as a matter of shock-tactics.

Let us first look for the boundaries of the pleasurable. At the lower level is the relaxed, comfortable feeling connected with the memory-traces of pleasant experiences: the pleasure of the familiar, of family jokes and old friendships. Above it comes that livelier kind which might be called 'delight', into which enters some element of enjoyable surprise. And when this surprise extends itself into wonder, an exalted state of mind can be induced (romantic love is the commonest example) in which the admired object and everything connected with it seem transfigured by the reflected light of the wonder it inspires. This exaltation, sufficiently intensified, transmutes delight into awe, an extreme of adoration not far removed from fear.

Architecture, then, can please by playing on our affection for the familiar; it can delight by touching our capacity for wonder; and it can awe by stretching that capacity almost to the boundary of fear.

The first is a gift not to be despised—in a rapidly changing environment there is a necessary reassurance in being reminded of one's spiritual roots—but even the pleasure of the familiar, since it is only a hairbreadth removed from the boredom of the inevitable, needs a subtle seasoning of wonder to make it recognizable as a rediscovery.

The second is to be prized especially. We do not ask—nor even want—the architect to strike amazement into us at every street-corner, but life is tremendously enriched if he can keep on reminding us, however gently, not to take the world for granted but to keep 'reading sign' on it as a condition of full living if not of survival.

The third is obvious. If only because its products are necessarily and literally superhuman in size, and often very much so, architecture is of all the arts the most capable of intensifying wonder to the point of fear and sustaining it on that uneasy threshold.

It seems, then, that wonder—for want of a better word—is a lever for prising open the gates of perception; so the capacity for wonder is essential to the enjoyment of architecture and the enjoyment can be expected to increase as the capacity is developed by observation and speculation. This argument leads on to tricky ground, because wonder is not a function of aesthetic appreciation only. Great size, great ingenuity, and great cost are perennial wonder-provokers, but

this does not necessarily make a colossal, ingenious, and costly building a source of *delight* to anyone but a newspaper reporter.

What sort of architectural experience, then, does provide the compound of wonder and sensuous pleasure (as opposed to the grosser emotion of plain astonishment) which we are calling delight? In the enjoyment of architecture, as in all the sensuous pleasures, two strains of delightful experience can be detected: the experience of an assured pleasure intensified beyond expectation, and the reassuring experience of discovering pleasure—on the rebound, as it were--where one would least expect it. Both of them are, in their different ways, the result of a compound interaction between one's first impression, the expectations it aroused, and the subsequent adjustment of impression and expectation in the light of closer examination.

Since one's security-system is programmed to accept at first screening a building which presents the elementary credentials of congruity, stability, and order, such a building offers at first glance the possibility of a pleasing rather than a disturbing experience. If now the designer, by his command of form and colour and their associations, has somehow managed to distil out of these rather commonplace virtues some quintessence of pleasantness, one experiences the delight of a promise more than fulfilled: the building is not only a thing of a transparently good kind but is *wonderfully* good by the standards of that kind. Such a building must have pre-eminently the virtue of consistency, and consistency in a very positive sense; for the same urge—to seek out and intensify some virtue which is felt to be inherent in its purpose and form—must be reflected in each part as it is in the whole. When a hard edge is natural and proper the hardness is honed to a fine precision; where a curve is called for the curve is 'sweetened', as a boat-builder would say, to the kind of curve which pleases the hand; and so on.

Since the Greeks of the classical period were intensely interested both in physical beauty and in abstract geometrical relationships (indeed one might almost say that they were connoisseurs of the shape of shapes) it is not surprising that their architecture provides the most commonly quoted examples of this kind of refinement. Consider, for instance, the capitals of the Doric columns of the Parthenon (Fig. 8). And when I say 'consider', I mean look at this shape as if for the first time, as if you had never seen a column-capital before, still less a nineteenth-century copy of this one on a commonplace public building. In the first place, the general functional idea could hardly be more

obvious. The business of the column, which is to hold up the lintels above it, could be done by a fat enough pillar without any capital at all (Fig. 9), but a pad between the lintel and the column-head makes it look more comfortable, and it needs no calculation of bearing-pressure to show why: you can sit more comfortably on a shooting-stick than on the knob of a walking-cane. A simple square block (Fig. 10) is enough to remove the sensation that the column is boring into the lintel ends; but it seems, if anything, to accentuate a certain abruptness about the junction: the horizontal movement of the eye along the lintel-line trips over the block and is pulled almost peremptorily down the vertical line of the column. At this point one becomes aware of the block as an intruder. The lintel is rectangular and horizontal (which is obviously the natural thing for a lintel to be), the column is cylindrical and vertical (which is equally proper), and there is no quarrel between them as functionally distinct entities: if anything, one would say, '*Vive la différence.*' But here now is this block which confuses the whole visual issue. It is rectangular like the lintel but does not belong to the lintel: it does seem to belong to the column but is the wrong shape.

Once a shape-conscious designer is aware of this problem, he becomes interested in correcting both the feeling of abruptness and the feeling of intrusion, and there is a certain satisfaction in finding that the double correction can be made in one move by putting a more or less conical cushion between column and block (Fig. 11). This is a solution, moreover, which feels right in a structural sense: one can visualize the column as a pipe conducting the downward flow of force, and the capital as a funnel directing the force into it. A perfectionist will work upon this idea, not only in the direction of finding a profile which suggests maximum functional efficiency but even beyond this to a degree of refinement which with the greatest subtlety extracts the essence of its sensuous quality *as shape*. The junction of the cone with the fluted column could easily have been clumsy —either muddled or over-emphasized—whereas in fact it is defined just clearly enough by a series of sharp, neat incisions. The surface of the cone could have been flat, but in fact it is fashioned to a taut curve[1] which suggests a tactile as well as a visual pleasure. The whole evolutionary history of a refining and polishing process is summarized in the shape itself, and the first impression of a generally satisfactory

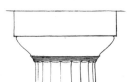

Fig. 8

Fig. 9

Fig. 10

Fig. 11

[1] The curve is in fact so subtle that the observer is only just aware—and hardly even consciously aware—of the absence of flatness.

form (the recognition, that is, that horizontal and vertical, rectangular and circular, have been neatly reconciled) is intensified on closer examination by the discovery that the form is not only satisfactory but exquisite in a quite sensuous way.

Forms which have been evolved in this way have the classical quality of the thoroughbred: all gaucherie has been bred out of them by a controlled process of rejecting the infelicitous. The authority of such buildings, which may be considerable, is aristocratic in the true sense: physical and intellectual qualities which command general approval are here exhibited in a concentration which commands respect.

Not everyone, however, enjoys being respectful all the time, or orderly all the time, or even safe all the time, and there is another strain of architectural delight connected with the human inclination to play with the mechanism of survival, flirting with the disorderly, dangerous, and dubious and so titillating the emotions by a little twitch at the security net, rather as one wakes up a spider by shaking its web. Probably our risk-calculating apparatus needs some harmless exercise of this kind to keep it in good order. Hence the magic of the circus for a child. The sensuous pleasures of colour, music, and move-ment are spiked with real danger at a slight remove: a man controls real lions, a trapezist swings over a real and vertiginous void. The circus presents a feast of mixed expectations, fear (*the lions are going to turn on him*) being succeeded by reassurance (*they haven't—and anyway Daddy wouldn't have brought me if they were really wild*) and both being comprised within a 'show' which in its totality is sensuously pleasing.

Architecture rarely offers such a heady brew of sensation, but it can draw delight from the same sources, as one can see by referring to the archetypal unpleasantnesses. The formless alerts the security-system; but there is delight in discovering that it is not formless after all but a complexity of familiar or at least comprehensible signs to which a second glance provides a key. The suggestion of imbalance provides delight when the second glance suggests a hidden counterpoise. A frantic explosion of energy becomes a dramatic excitement when the second glance shows it to be subtly controlled. And a deception becomes amusing when it shows itself to be playfully intended.

Like the pleasures of the circus, these delights of the second order have an elemental and natural, even childish, appeal. They are vulgar in the true and non-pejorative sense, for they are equally open to the crowd and to the connoisseur. Indeed they furnish non-professional

criticism with many of its commonest epithets of praise: 'quaint', 'picturesque', 'romantic', 'exciting'. But an apparatus of criticism which seeks to dismiss them as frivolous or unworthy is self-condemned. Architecture is a reflection of the whole of human nature— not only the cool, reasonable, disciplined part but also the irrational, danger-courting, and mystery-loving part. And just as these two strains are interwoven in the human personality, so the two strains of delight are inextricably intertwined in the creation and appreciation of all architecture. The Parthenon, for example, has just been instanced as a paradigm of the classical ideal. But in its working life it was not simply a cool and aloof exercise in refinement of form; it contained within its precise, geometrical framework a controlled explosion of polychromatic and sculptural energy, and enshrined in its core a holy place of the deepest mystery.

We can detect, therefore, a polarity of delight in architecture derived from a polarity in ourselves and familiar to anyone who remembers a happy childhood. There is delight in certainty, in the security offered by definite things, in knowing explicitly where one stands, in being guided and fenced around by just authority. And there is delight in the exploration of mysteries, in freedom to doubt, in following one's own whimsies, in breaking rules and taking risks. One man's personal point of balance between these poles is not the same as another's (and indeed may vary from one moment in time to the next), and the temper of the society in which one lives inclines also towards one pole or the other. This is why it is entirely futile to pretend that there is any ultimate recipe or prescription for the kind of architecture one *ought* to enjoy, and we need waste no time in looking for one. A much more fruitful and fascinating activity is to look for the sources of enjoyment in the tension between the poles which gives architecture its dynamic, and to study how the architect tempers this tension to his purpose.

Scale, Order, and Rhythm

To look closely at something and form a judgement on it is to 'take its measure' in a literal as well as a metaphorical sense, for measuring, like judging, is a matter of applying the known to the unknown and among one's first reactions to a building is a rough-and-ready attempt to assess size. By this I mean, of course, its *apparent* size, for one is not immediately concerned with feet and inches but rather with *scale*, since this is an indispensable key to three important questions which crop up, whether we are consciously aware of them or not, whenever a new percept presents itself: *What is it? How close is it? How big is it?*

We usually take this question-and-answer mechanism for granted and rely on it to place an object fairly accurately against the scale of more or less standard size-references provided by the memory, a dimensional ladder whose steps are provided by dozens of common objects from match-boxes through milk bottles and chairs and stair-balustrades to lampposts and lighthouses. Consequently, when we sense that something does not conform to its expected placing—that is, when we recognize it as 'out of scale'—we are likely to find it disconcerting or even alarming unless there is some likely explanation by which expectation can be adjusted and reason satisfied: if six-foot milk bottles appeared one morning on every doorstep, we should *have* to believe it was an advertising gimmick in order to stay sane.

The most obvious measures of expectancy are those which we conveniently carry around with us in the neatly articulated structure of the human body. The body, in fact, provided the first primitive units of mensuration (the hand, the span, the cubit, the fathom) and many of the commonest clues to scale have some rough anthropometric connection: a step is expected to be nearer ankle-height than knee-height, a balustrade somewhere between hip- and shoulder-height, the top of a door somewhere above head-height, and so on. Although the science of exact measurement has progressed a long way from its crude beginnings and can now put figures to the diameter of a nebula or a molecule, the intuitive grasp of sizes and distances in the immediate environment remains obstinately anchored to anthropometric rather than abstract measurement. One is asking, in the first instance, how big this thing is *relative to oneself,* and the emotional response to size is a result of this process of question and answer, in which the

element of expectancy becomes proportionately more important when the percept is part of a series.

One's experience of a building, as we have already seen, is made up of a prolonged sequence of impressions, each superimposed on the last, and the perceptual system becomes unpleasantly confused when the expectation of size aroused at any one step is contradicted by the next. So there has to be at least some degree of consistency in scale if the progression is to make sense. On the other hand, consistency can be carried to the point of deadliness at which the experience, being wholly unmodulated by any tincture of surprise, contains no perceptible element of delight. Consequently, while the *establishment* of scale is the designer's necessary means of giving the building simple identity, the *modulation* of scale, as a potent means of producing controlled surprise and sustaining it into wonder, is the means by which he may give it a personality.

Obviously scale-expectancy can be modified in two directions, by finding the percept unexpectedly small or by finding it unexpectedly large. As we have already seen in our consideration of the monstrous, the deviation may be too large or sudden to be pleasurably acceptable; but within limits we are prepared to be disarmed by the unexpectedly small ('a dear little thing', 'a charming little cottage') and pleasantly impressed by the unexpectedly large ('high, wide, and handsome'). In other words, the ideas of smaller-than-me and bigger-than-me carry emotional charges which enter (although at several removes) into our reactions to building and can be played upon deliberately as a matter of aesthetic intention. Usually the downward limit of deviation is set by practical function (even the 'quaintest' of cottages has to allow head-room for a small man at least) whereas the upward deviation is limited only by technical practicability, and for this reason it is the modulation of scale between the human and the superhuman which particularly concerns the architect.

Great size is undoubtedly impressive. As children we learn very early that we cannot impose our will on inanimate objects above a certain size, and that we are liable to be subject to the will of animate objects larger than ourselves, such as parents or the school bully. We also acquire a habit of equating size with worth when comparing similar objects: in the simplest terms, a big lollipop is more valuable than a little lollipop. Consequently there is an unspoken presumption that the small-scale building is not intended to impress, that its virtue is to charm rather than to awe, and equally that a large-scale building

is intended to wear an air of authority and entitled to claim respect. From this it follows that the latter will please us best when we are in some degree identifying ourselves with that assumed authority, and not simply cowering at the feet of an alien giant.

The identification may have a connection with the symbolic associations of the building's function. For instance if there are protests that a new multi-storey office block overtops the cathedral a few yards away and 'takes away from its appearance', they will be coloured to some extent by attitudes to the relative *spiritual* values of cathedrals and office-blocks. But it can, and does, take place also at a more deeply buried level of consciousness, enabling us to form comparative value-judgements on different buildings of the same size and kind. We may find one office-block more pleasing than another (or one cathedral more pleasing than another) because something in its design reconciles us to its great size.

In the shadow of a very large building the sensitive observer is rather like a small boy in the presence of his headmaster. The thing looms over him, it claims authority by its very size, and he enjoys not only a sensation of relief but a heart-warming experience when it indicates, if only by a friendly nod, that he is something more than a beetle at its feet. To make such a concession to the human is a function of scale, and a function which becomes especially important when the building is of a novel or unfamiliar kind which offers none of the short cuts to cognition afforded by accustomed clues and symbols such as the church spire and the pillars of the court-house: it provides a means of mediating between the puny human being and the big building by establishing a series of size-gradations. The mediation may achieve nothing more than to produce a kind of reassuring condescension of big towards little (and this is at least some contribution to the reconciliation of man with his environment); but it can go beyond this and produce a kind of empathy with the building which seems in some indefinable way to expand the observer towards the building's own stature. To revert to the earlier analogy, it is rather like having tea with the headmaster and finding, with some surprise, that one is being treated as an adult and indeed *behaving* like an adult and not like an awkward schoolboy.

It is not invariably the purpose of a building to put the observer at his ease in this way. It was no part of the function of the Baroque palace, for instance, to encourage the common man in the belief that he might one day be taking tea with the Archduke, for absolute

authority admits no need to woo its subjects and the purpose of its symbols is to reconcile them to their subjection. Clearly the way in which a building's scale is established and modulated can be something towards polarizing the impression it produces. In proportion as it is absolute, authority seeks expression of its power through declaredly superhuman scale, making no more concessions to the human than are necessary to remind him of his lowly position and not encouraging him to presume upon it. In the architecture of autocracy, therefore, every adjustment of scale is designed to reinforce the finality and consistency of the statement of power; the more closely the building is approached, the more impressive it seems. In other words, the first impression of great size is never contradicted but always modified upwards, and the whole experience is strictly controlled to that end. The opposite effect is produced when scale is skilfully modulated downwards. One finds in some of the smaller Georgian country houses, for instance, that a tall, pillared portico gives a first impression of considerable grandeur which gradually gives place to domesticity as the observer draws close enough to relate the pillars to the windows, door, and steps. By the downward modification of scale the statement of power is qualified: authority unbends, the headmaster is in an armchair pouring out tea. Instead of being overawed, we are being charmed.

The establishment of the basic scale of a building must therefore be regarded as a statement of what is to be expected at the outset of a planned series of impressions following one another in time, rather as the mood of a play is set by its first act. The sequence, as it unfolds, will generate a series of reassessments of this first expectation and the building will satisfy in proportion as each of these mental adjustments (in whichever direction and however surprising) is felt to be a meaningful step in a coherent and convincing experience.

Scale is established initially by one's first distant impression. The necessary data are usually provided by objects external to the building, such as people, trees, and other buildings, and it is noticeable that in 'ceremonial' architecture the placing of such objects—which is another way of saying the timing of the steps in the sequence—is often very deliberately contrived. The Taj Mahal at Agra, for instance, is approached through a strictly controlled sequence of scale-gradations, the trees reinforcing the scale of the minarets (which by their nature are already expected to be tall), the minarets scaling the minor domes and the central arch, and these in turn the main dome

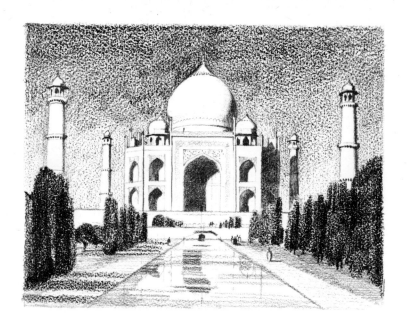

The Taj Mahal, Agra

and the whole silhouette.[1] By comparison the medieval cathedral often stands wrapped around by the houses of its town, revealing itself not at the end of a deliberately planned vista but through an irregular sequence of accidental and brief impressions. It has no lack of revealed authority, but the tempo of revelation is very different. First there is the distant general impression of a great fabric looming above its domestic neighbours. This is followed by closer accidental glimpses, above rooftops and through the vertical slits of narrow streets, in which its parts can be briefly measured against each other. And finally, when the observer is confronted with it at close range, he is exposed to a very rapid and skilful modulation of scale from human through statue, through rose-window, to buttresses, pinnacles, and superimposed arcading and so to the upward rush of towers and skyline—echoed internally by the soar of pier and vault— a sequential experience so condensed that it is often, and with reason, called 'breathtaking'.

At close range, then, it is the proportional relationship of the parts of the building to one another, externally and then internally, which

[1] The example is elaborated upon in Heath Licklider's *Architectural Scale* (1965), which treats this very important subject in a far more extensive and scholarly fashion than is possible within the compass of a single chapter.

must carry forward and modulate the theme set by the longer-range impression. The observer's experience will be profoundly affected by the compounding of these relationships as one impression succeeds another and by their consistency or inconsistency with the direction the experience is felt to be taking. Given this importance of proportion as providing a ladder of related sizes to assist cognition and aid the interpretation of the aesthetic intention, it is not surprising that architects of the high civilizations have looked for the ultimate key to beauty in numerical ration and in mathematically constructed systems of proportion. Although history is strewn with the debris of their exploded theories, it should not be assumed that they were entirely mistaken in looking to mathematical expressions (which, after all, are conceptualizations of order) to help them towards their objective of creating order.

Granted, the ordinary man is not greatly given to conscious geometrical analysis of the things he sees; nor does he very commonly use the expressions 'well proportioned' or 'badly proportioned' when describing them. He is not, in general, accustomed to use proportion in the abstract as a canon of criticism except—and the exception is significant—in the case of the human body itself. When pronouncing judgement on this most interesting of natural objects he does manage to bring into conscious expression his subconscious awareness of the geometry of the natural order. In describing a fellow-human as 'hippy', 'busty', 'short in the leg', or 'twiggy', he (or, perhaps more commonly, she) is voicing a concern with proportion, and when the description conveys approval—as for instance 'well-built' or in the splendid Edwardian phrase 'a fine figure of a woman'—there is an inference that the subject displays a topological correspondence with an ideal, or at least acceptable, set of human proportions.

Once a culture attaches symbolic significance (either for magical or intellectual reasons) to numerical proportion this kind of comparison with an ideal of 'correctness' may play a most important part in architectural criticism. But even where no such considerations apply, the notion of *correspondence* is still (for sound psychological reasons) central to the act of judgement; and since it is also central to the idea of proportion, it deserves some closer consideration.

Assuming it were possible to design a building in which no correspondence of scale, shape, or position could be detected between one part and another, it needs no arguing that the resultant confusion

would be psychologically upsetting and unpleasing. Acceptable visual order is produced by reducing the visual disparities, which is simply another way of saying increasing the visual correspondences. This may come about in the most natural and proper way when a building is articulated by the nature of its structure, as in a modern steel building or a Gothic cathedral (and most explicitly where, as in the case of the cathedral, the construction is pointedly revealed), simply because of the repetition demanded by structural technique. Likewise it may result from the use of covering materials of standardized dimensions: regular courses of brick or tiles, or the widths of prefabricated sheet-materials, can all establish visible modules which help the process of scaling and of cognition generally. On the other hand, such inherent and natural correspondences may be absent (as, for instance, where no structural module exists or where the modular pattern of materials is suppressed by distance), and in such cases the architect may choose to give the observer some positive help by establishing lines along which the eye can travel and by dividing the visible faces of the building into units whose relative dimensions and areas can readily be compared.

It seems to be easier to make such comparisons between straight-sided (especially rectangular) figures than between others, and consequently a building designed on a matrix of rectangles presents a large number of detectable correspondences. Clearly correspondence is carried to the limit if the rectangles are identical squares, since all sides of a square are equal. This is a very final and definite correspondence, detectable within quite close limits even by an untrained eye, and it makes the square a very definite kind of shape. It is also, by virtue of this correspondence, a particularly stable shape, running neither upwards nor sideways and looking exactly the same whichever side it lies on. The solid generated from it—that is, the cube—is similarly definite, stable, and static and if one sought no more than the assurance of order and stability, the ideal would be a cubical building whose parts were all related to one another as squares or multiples of squares (Fig. 12).

We have already noticed, however, that although a measure of order is a precondition of delight, it is not by any means the whole story; for if there is to be delight there must be some spice of wonder. On the subject of human comeliness, Bacon observed: 'There is no excellent Beauty that hath not some strangeness in the proportion';[1]

Fig. 12

[1] *Essay XLIII* (1612).

and the same adage might be applied to architecture. There must be not just *maximum* correspondence but some subtlety of correspondence which catches the eye and asks to be deciphered; ideally, a relationship which presents the possibility both of arousing curiosity and satisfying it.

A close study of pleasing natural forms (such as the whorls of shells) often exposes an underlying mathematical order of this subtle kind, the result of biological processes which we are only beginning to understand. Mathematical formulas, when put into graphic form, may themselves generate figures and shapes which are found aesthetically pleasing, such as the pentagram and the parabola, and others of much greater complexity. Such discoveries are capable of stimulating a designer's imagination and setting him off on the quest for a perfect system of relationships which would satisfy both the need for order and the appetite for complex visual experience. Quite apart, therefore, from any specific belief in the magical power of number, architects have always been susceptible—for purely aesthetic reasons—to the fascination of mathematical ratios. This interest is reinforced by the fact that proportional systems have practical as well as aesthetic uses. They may, for instance, help to systematize the whole building operation, and indeed they were often very necessary in the past for the setting out of large and complicated buildings. Before calibrated tape-lines, foot-rules, and theodolites were invented, dimensions and angles had to be set out by some such device as knotting a cord (Fig. 13) and in these circumstances there was great practical convenience in being able to set up all the major sizes of a building as fixed proportions of one part of it. More relevant to present-day practice is the fact that a discipline of this kind, provided it is sufficiently flexible, can ease the burden of multiple decision involved in a purely intuitive and empirical search for visible order, and so bring the designer's emergent ideas more swiftly into focus.

For it must be made clear that the alternative to a consciously defined proportional system (whether dictated by structure, by component sizes, or by pure geometry) is not total unconcern but a *subconscious* groping towards recognizable correspondences. It may be—to take a simple example—that considerations of structure, function, and cost will absolutely fix the height and width of an opening in a wall; but if they do not, the decision will have to be made subjectively. The designer will choose a proportion which, to him, looks right both in itself and by reference to the part of the wall which

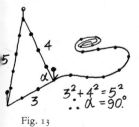

$$3^2 + 4^2 = 5^2$$
$$\therefore \alpha = 90^\circ.$$

Fig. 13

is left blank. He is, in fact, carrying out a mental comparison of dimensions and areas, which will be a good deal easier if the wall (and indeed the whole building) has already been designed on a grid of proportions which relate naturally to each other. Consequently a special fascination attaches from the designer's point of view to relationships—such as $1:\sqrt{2}$, $1:\sqrt{3}$ and $1:\frac{1}{2}(1 + \sqrt{5})$—which 'yield the greatest number of similar shapes similarly related'.[1] This economy of comparison-effect is more evident as a source of pleasure to the observer when the eye is presented with a pattern than when it is confronted with an isolated abstract shape, for there is no doubt that a complicated pattern which can be 'read' with ease is more generally pleasing than either a dull chequerboard or total confusion. Here, at least, there would seem to be some validity in associating delight with a combination of exercise and economy of effort—easiness on the eye, in fact—just as it is so associated in the pleasure of a good drive at golf or a good cast in fishing.

Moreover it seems likely that proportional correspondences enter even more into appreciation when the sensuous experience is—as in the case of architecture—a serial one, since we are all relatively well equipped to detect a rhythmic series of incidents within the totality of an experience and it is arguable that we seek in such a rhythm, as we do in scale, some key to what the experience is likely to offer. Rhythm is, after all, a measure of the time dimension as scale is a measure of the space dimension and, as in the case of space, we are provided with elementary measuring equipment in the form of physiological references. We live and move by an alternation of muscular contraction and relaxation (of which the most obvious example is the heartbeat) and we have a certain intuitive appreciation of the part played by rhythm in conserving and canalizing muscular effort—as anyone can observe by watching a good oarsman or, for that matter, a good navvy. We are also well aware of the time-measuring rhythms of the natural world, such as the cycle of the seasons and the alternation of day and night and the rise and fall of tides.

We have therefore quite a stock of associations which can be played upon by any experience of the senses involving a pattern of alternation over a period of time, and this play is one of the fundamental ways in which architecture can make an emotional impact. It is most evident, of course, when the period of time is an appreciable one, as in passing along a colonnade or walking down the long nave

[1] P. H. Scholfield, *The Theory of Proportion in Architecture* (Cambridge, 1958).

of a Gothic cathedral; but a regular alternation can be picked up by the eye even in the few moments which it takes to scan a long façade or skyline and can be received into the consciousness as a rhythmic series of a recognizable kind. The rhythm, if any, thus detected, and the emotional associations of that rhythm, are evidence on which—because of the very fundamental nature of the response—intuitive aesthetic judgement will be founded to a much greater extent than the observer is likely to recognize consciously.

Since the essence of visual rhythm is *spacing*, just as the essence of heard rhythm is *timing*, and since the full enjoyment of architecture is an experience involving an intuitive kind of space-measuring over an appreciable length of time, one ought to consider proportion and rhythm as factors of appreciation which are intimately and inseparably connected, and the nature of the connection has to be understood if one is to make any cogent and clear-headed use of these factors as instruments of judgement. The simplest kind of rhythmic alternation —like the sound of marching feet—is no more than an alternation of sound and silence or, to put it in less exclusively aural terms, *incident* and *interval*. It is the incident which catches the sensory system's attention, and it is the interval between the incidents which helps us to interpret or place the experience in the light of memory and possibly attach some emotional reference to it: inevitably we think of a marching rhythm as purposeful and distinguish a different kind of purpose behind the rhythms of a quick march and a funeral march.

The smack of a boot on the street is an instantaneous kind of incident, and one could represent it in visual terms by a dot. But in the rather more elaborate situation where the incident has an appreciable duration in time or space one 'reads the message' not only by comparing the intervals but by measuring the incidents against the intervals and against each other. To read a Morse signal, for instance, one has to know the proportional relationships of dot and dash in the code and the proportional intervals which denote the start of a new letter and a new word, and if the operator is careless or confused about these relationships the message will be incoherent. Similarly, the apt use of rhythm is of some considerable importance in the communication made by a building and increases in importance the more the architect's aesthetic intention inclines towards explicitness, clarity, and authority. If the predominant character of the building inclines towards this 'classical' pole, it will be a positive virtue to have incident and interval related by an explicit and noticeable set of visual

correspondences and we are likely also to find this explicit formality accentuated in buildings whose function is ceremonial. Conversely, if the building's character turns naturally towards the irregular and indeterminate, it may be just as positive a virtue if the correspondences are subtle rather than self-evident and ask to be deciphered with a certain amount of subconscious effort rather than merely read and noted.[1]

Some kind of dimensional correspondence, then, is necessary to the establishment of the kind of rhythm-pattern which gives the building access to important subconscious sources of appreciation. It is now necessary to look at the sensuous effect of rhythm in itself as a determinant of a building's personality. Its effect is most marked when there is a sharp demarcation of incident and interval, as for instance when an open space is divided by a row of pillars or a wall by a series of windows. Such rhythms are easy to interpret and their associations are quite obvious. Other things being equal, most people would agree that there is more liveliness in the quick-march beat of the openings in Fig. 14 than in the slow-march measure of Fig. 15, and that the rhythm of Fig. 16 is somehow livelier than either. These are very simple examples, the rhythm being read across the face of a single storey; but where several storeys are superimposed, so that there is a vertical as well as a horizontal rhythm, a much more complex visual experience may offer itself.

Fig. 14

Fig. 15

Fig. 16

Compare, for instance, the façade of the Quirinal Palace in Rome (page 41) with the canal frontage of the Doge's Palace in Venice (page 42). In the Quirinal an absolutely regular measure ($1:2:1:2:1:2$) is stepped out horizontally along each storey but is relieved by a vertical rhythm which, although still regular and closely related to the first (compare the height of the small windows with their width and the height of the tall windows with the horizontal and vertical wall-spaces between them), is nevertheless just lively enough to take a little of the impassiveness off the face of authority.[2] In the Doge's Palace the rhythm and scale of successive storeys (and of successive

[1] Especially if it is part of the building task to create a sense of mystery or uncanniness (as in a religious building) or, as in the architecture of pleasure, to suggest 'a place where anything could happen'.

[2] Steen Eiler Rasmussen—to whose book *Experiencing Architecture* (1959) I am indebted for this example and indeed for much of the inspiration of this chapter—proposes the Quirinal Palace, with its majestic and serene rhythms, as a key to the experience of Rome as an architectural spectacle: 'It is like the opening chords of a great symphony which, in an *andante maestoso*, prepare the ear for complex adventures.'

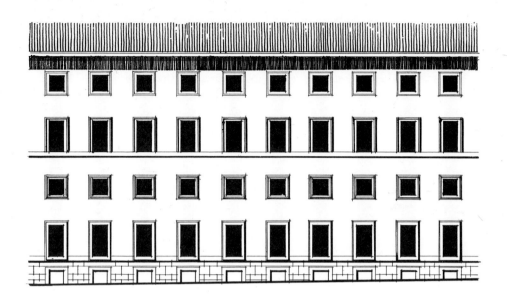

The Quirinal Palace, Rome, by Domenico Fontana: window-rhythm of south façade

rows of alternating pattern *within* each storey-height) are related in a much more complicated and subtle way. The superimposed arcades present a very marked series of correspondences (two beats of the upper to one of the lower) bound together with well-defined horizontal lines, and there is an equally well-marked correspondence between their combined heights and the height of the lightly patterned wall above. These simple and positive correspondences contribute greatly towards an over-all impression of consistency and coherence which is strong enough—but only just—to conquer the curious discrepancy in the upper window levels in the right-hand half.[1] In the dullest kind of civic building the theme of authority which is sketched by this strong rectilinear matrix of proportions would be followed relentlessly to a sternly rectangular conclusion: but here the chill is taken off not only by the syncopation of the little circular windows but by the elastic counter-rhythms of the double-curved arches and the subtle undulation (detectable perhaps at the second or third glance) provided by the interlinked roundels of the upper arcading. Here we have a different kind of rhythmic alternation, and one capable of great subtlety of expression.

[1] The reader who is interested in this curiosity will find it explained in Ruskin's *Stones of Venice* (VOL. II, ch. 9), where it is described as 'one of the most remarkable instances I know of the daring sacrifice of symmetry to convenience'.

So far we have been studying alternations of the most obvious kind—solid against void, dimension against dimension along a straight horizontal or vertical line of movement: alternations which lend themselves readily to measurement simply because incident and interval are as clearly discrete as black against white or sound against silence, and which one might compare with staccato passages in music. If these were the only rhythms which architecture could offer, the art would be a good deal less expressive than it is because its emotional references would be so strictly limited. Staccato rhythms are certainly purposeful—they are the characteristic rhythms of the military march and the work-song, and in unmechanized societies they play a positive part in assisting hard physical labour. One might say, without being too metaphysical, that they are the rhythms associated with 'unnatural' or 'organized' man, the creature who controls and concentrates his energies and those of others and stamps his authority upon the face of his physical environment. Purposeful though it necessarily is, however, architecture is not denied access to the emotional correlates of that other kind of rhythm which musicians call legato and which represents in physical terms a *continuous* (instead of a sudden) alternation in energy-flow—or, in the simplest visual terms, a rhythmic treatment of continuous curves. In giving visual form to rhythms of this kind architecture taps sources

The Doge's Palace, Venice: frontage to the lagoon. *Italian State Tourist Office*

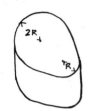

Fig. 17

Fig. 18

Fig. 19

Fig. 20

of reference to natural movement of the most pleasant kind, for these are the rhythms of elasticity and of that sort of vitality (suggestive of energy at play and therefore energy to spare) which is sketched in such verbal expressions as 'a springing step', 'full of bounce', 'swinging'. Moreover they give more occupation to the eye than it can usually find in obvious rhythms of the staccato kind: instead of stretching an imaginary tape-measure from one clear line of demarcation to another, it has to read the subtleties of a gradation of light and shade over a continuous surface and sense the gradual direction-changes of flowing curves. The alternations are present but not overt and the imagination is stimulated by the resultant guessing game or—if the game is made too difficult—exasperated to the point of finding the building 'fussy' or 'shapeless'.

It follows that if one is to find delight in the subtler varieties of legato rhythm one has to practise looking *for* them as well as looking *at* them. It would probably not occur to most people that a building like the one in Fig. 17 presents any rhythm at all; but if you were to walk round it two or three times (as its continuous form so clearly invites you to do), keeping exactly at arm's length from the face of the wall, you would find the curve of the surface alternately tightening and relaxing. There is in fact a rhythm of changing tension. Changing tension can be combined with changing direction as in Fig. 18, which is a more obviously rhythmical form simply because change of direction is more readily perceptible: the tension may emphasize the directional turn, as it does here, or soften it (as in Fig. 19) into a gentle and even undulation.

Forms which simply undulate, however, can easily defeat enjoyment if the undulation is carried to the point where it begins to resemble an over-prolonged ride on a roller coaster. If the undulating rhythm is regular, it becomes boring; if irregular—as on the frontage of the Casa Mila (p. 22)—it may become too perplexing to be comfortable unless it has some punctuation to give it form, point, and reality. One very commonly finds, therefore, that some kind of sharp and positive break is introduced as a corrective. It may be no more than a pause before the undulation is resumed (Fig. 20) or it may be made into an opportunity to change step and break into a new figure, as in the counter-curved pediments and gables of the Baroque. It can be seen therefore that the eloquent use of legato rhythms demands very acute judgement and considerable sensitivity on the designer's part. If he really aims at calling up these joyful associations of energy

43

at play, a heavy flaccidity or a twanging oscillation will not serve the purpose; he needs a cultivated and disciplined sense rather like the actor's sense of timing, and it will help if he also has a certain natural exuberance for the discipline to work upon.

Where the rhythmic patterns are purely decorative—like those magnificent Baroque interiors where the undulating and swirling forms of the plasterwork are simply decorative masks for the structure—the designer's discipline has to be entirely self-imposed; and if it fails, the result will be a kind of blowsy vulgarity which one may find either comical or nauseating according to one's temperament. On the other hand, a lack of the necessary exuberance—or, worse, the substitution for real exuberance of a kind of synthetic enthusiasm —can make the whole legato exercise ring false and hollow. Both these failings are only too common among the buildings which commemorated the public pomp and private affluence of the Victorians and Edwardians, and the result was a very understandable revulsion against 'soft' forms and rhythms in general: they had come to symbolize all too clearly that debasement of the architectural language which so commonly follows a divorce between aesthetic expression and structural logic.

It may seem curious therefore that there has been such a marked revival of the swinging elastic curve since the middle of the present century and it must be made clear that this was not simply a turn of fashion in the direction of illogic and frivolity, but the outcome of discoveries in the field of structural engineering. In the most advanced forms of modern construction, involving thin shells and skins whose strength derives from their continuously flowing shape, legato rhythms are not only natural but inevitable: far from being contrary to logic, they are born out of structural logic itself, and the architect finds them especially exciting for that very reason. In such structures he finds mathematical support for the artist's intuition of the dynamics of natural form and physical movement, and it was largely through their intermediacy that the curve was readmitted to respectable architectural society.

This rehabilitation of 'soft' form restored a line of communication which the dominance of the T-square had almost closed—the modulation of character by the interplay of staccato and legato rhythms— and a most valuable line of communication it is. The classical virtues of clarity and consistency can easily tend to dullness when they are manifested through a too explicit and too predictable pattern of

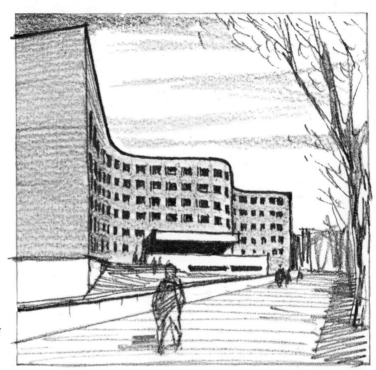

Baker House,
Massachusetts Institute of
Technology, by Alvar
Aalto

correspondences; conversely the magic of the flowing rhythm—whose alternations have to be guessed rather than measured—can turn into a nightmare of confusion if the guesswork is made too difficult. Much of the architect's evocative skill lies in achieving a balance between these two extremes, and it is here that the ability to play off staccato against legato can make such a valuable contribution.

We have already noticed this interplay at work in the façade of the Doge's Palace, where a flowing alternation of curves gives subtle relief to a preponderantly rectilinear grid of proportions. In Aalto's[1] Baker House the situation is reversed: it is the mass of the building itself which suggests a slow, legato movement and the staccato rhythm of the windows which gives point and coherence to the whole, while the severity of this window-rhythm is itself modified by the soft curve of the wall in which they are set. In a highly studied and richly expressive building one may find such plays of rhythm-

[1] See Biographical Note.

within-rhythm carried down to the smallest detail. The mouldings of the Gothic pier and the fluting of the Greek column are miniature rhythm-plays which can best be appreciated by the finger-tips, and the example in Fig. 20 has the same essential rhythmic quality whether the diameter of the section is 20 inches or 200 feet. The character of a building can, in fact, be set very subtly indeed by the way in which its macro-rhythms—those which establish its general form from a distance, such as the winding skyline of Baker House—are related to the subsidiary rhythms which appear in close-up, and these again to the micro-rhythms of the finger-tips. Hence the intense interest of Renaissance architects—and notably of Le Corbusier[1] in our own time—in searching out systems of proportion by which a sequence of correspondences can be followed through the whole building from the smallest elements to the largest. Indeed it is this quality of homogeneity which distinguishes the really masterly work in any period, and the lack of it which gives so many buildings the air of having been thrown together out of a collection of ill-assorted parts whose discrepancies and inconsistencies the architect has been unable to synthesize.

It should be clear by now that we have to think of rhythm, scale, and proportion as a kind of indissoluble trinity, as three aspects of a single aesthetic activity in which the building fixes itself in the consciousness. By 'reading' its scale, we first come to terms with the building and embark on a search for correspondences—not only correspondences of dimension as read through proportion but correspondences between what is expected and what is perceived. And by 'reading' the rhythm set up by proportional correspondences we become more fully conscious of the building's personality: we become involved in it, as the designer no doubt hoped we would, and thereby more receptive to the communication it is trying to make and more appreciative of what it has to say. This involvement is a pleasure-giving offshoot of the deeply ingrained human habit of getting to understand things by measuring and counting—taking the measure of an experience, asking what it 'adds up to'. A similar instinct leads us also to speak about 'weighing it up', and it is the working of that instinct in the appreciation of architecture that we must consider next.

[1] See Biographical Note.

Needless to say, the weight of a building does not enter our consciousness in any direct or literal sort of way. A building is not something you can pick up in the hand and appraise like a water-melon in the market, and in fact its *real* weight is irrelevant to appreciation. What we are concerned with is the effect on us of an *appearance* of weight—the sort of assessment we make when we call it 'massive' or 'flimsy' and which is part of the process of asking ourselves how big it is—and a building which strikes the eye as heavy calls up a set of emotional associations rather different from those evoked by one which is evidently delicate, fine-boned, and transparent. The appreciative process does not by any means stop here because, as we have already noticed, the stability of this great thing is a matter of some interest and so we are liable to go further and develop an interest in how it 'carries its weight' rather as we do with people. One big man may be heavy-footed and another surprisingly light on his feet, and any observant person notices the difference. In its simplest form this interest is simply a matter of detecting *imbalance* and may go no further than noting whether the building is symmetrical or not; but it may very well extend itself into an appreciation of the structure as a kind of load-carrying organism. We can say, therefore, that a building has a line of communication to us through our awareness of mass, our sense of balance, and our sense of support, and that the appreciation of architecture calls for the exercise of all three.

The awareness of mass involves a kind of subconscious detective operation, and the architects of the past often had a subtle understanding of how to set it going. This understanding was in fact a most necessary part of their professional expertise because great mass, although strongly suggestive of great importance (which they were very generally called upon to celebrate), can also call up other associations of grimness, foreboding, and general 'heaviness of heart', which are far from engaging and not necessarily appropriate. The architecture of Renaissance Italy is especially rich in devices for modulating the effect of massive structures by way of the clues presented to perception; but the process of unravelling such clues is just as relevant to appreciation of the most modern of structures since it depends on recognition of the innate qualities of materials and shapes.

The materials and forms which most clearly convey the idea of heaviness or lightness are, of course, the ones we are used to handling, because through force of habit we have formed some expectation of their relative densities. We would not expect a plywood tea-chest to weigh as much as a granite block of the same size; and even if some joker has filled the tea-chest with concrete, it will still *look* lighter than the stone block. Such associations play some part in establishing a first impression of a granite building as 'substantial' or of a plywood building as 'flimsy'. The expectation of density is modified, moreover, by our empirical knowledge that there is a correlation between size and weight. Knowing that logs are thick and heavy and that planks are relatively thin and light, we see a clapboarded wall as something lighter than the wall of a log cabin although both are made of the same wood; knowing that bricks are usually small and fairly light compared with boulders, we tend to see a brick wall as something less massive than a stone wall although in fact the relative densities of the actual materials are much the same. We are used to the idea that some materials—such as glass—come in sheets of large size but small thickness and so we can read the idea of lightness and insubstantiality into a wall faced with such sheets irrespective of the kind of material concealed behind them.

Beyond this point the detective work begins to be more subtle. Thickness in the back of one's mind is something that one obtains by *building up*, so that a wall visibly constructed of thick material such as stone gains in apparent weight the more its 'builtness' is emphasized. Its individual stones may be made to call attention to themselves as large and heavy things, as for example by giving them convex or roughly textured surfaces. Moreover, since the joints between them are in themselves evidence of the 'builtness' of the wall, its massiveness (other things being equal) will be emphasized or diminished according to whether the joints are accentuated as wide, deep grooves or are suppressed by making them narrow and flush with the stone surface. This technique of accentuating the mass of a wall by emphasizing the massiveness of its stones and underlining the importance of the joints is called *rustication*. The Italian Renaissance architects found it a simple and effective method of imparting grandeur to the *palazzi* of Florentine merchant princes, and the name might indicate that they felt a certain bashfulness about introducing a kind of country-bumpkin obviousness into the scenery of a polished urban society. However that may be, it was developed in countless sophis-

ticated and subtle ways and passed into the architectural vocabulary of all the countries which the Renaissance touched, until it eventually suffered a fate worse than death as the tired Edwardian architect's recipe for instant pomp and circumstance.

Such clues to mass are fairly obvious, but others which are rather subtler present themselves easily to anyone who can cast his mind back to childhood experience on the playroom floor. Even at toy-brick level one soon learns that the strength of a built wall depends on the 'bond'— that is, the overlapping of the blocks of one course over those below—and that a wall without bond (Fig. 21) will not go very high without toppling over. It is easy to deduce from this that masonry which shows this unbonded joint-pattern, however stony and large its blocks, must be no more than a facing—probably quite thin and fixed to the real structure behind by some concealed device— and that the visible size of the stones is therefore not to be read as evidence of thickness. Very little experimenting in another direction will show the difficulty of building rough irregular stones into anything but a very thick wall: having no flat faces to lie on, they are inherently unstable and have to lean on each other for support like a crowd of very drunk men. So one expects a random rubble wall to be thick and weighty. By the same train of thought (if one is a good detective) one does not expect it to be carried to any very great height or to be receiving a heavy concentrated load, and one will receive any such appearance with surprise amounting to disbelief: either it must be even thicker than its face suggests or else it is an ingenious fake.

The jointing-pattern, then, can present a variety of persuasive evidence to affect one's judgement of weight; and by the same token its concealment—as, for instance, by stucco—can obliterate the surface evidence of weight altogether and make the wall 'read light', as architects say, instead of 'reading heavy' as it would if rusticated. In such a case one is in fact being urged to read the wall as a two-dimensional surface instead of a three-dimensional mass and thus to forget about weight altogether, and the hint can be made a good deal stronger by the use of colour. Reverting to the earlier contrast between the tea-chest and the granite block, the apparent weight of the block will diminish startlingly if its faces are polished smooth and painted in strong contrasting colours: they are now read as planes which butt together where they touch instead of turning the corner.

Just as emphasizing the turn of the corner underlines solidity—and for this reason rustication of the corner-stones was a favourite

Fig. 21

49

Renaissance device—so a reduction of emphasis diminishes solidity. This particular way of suggesting lightness, however, is liable to be a dangerous trick when applied to serious architecture (as opposed to, say, exhibition design). It diminishes not only the apparent weight but also the apparent strength simply because we know from common, everyday experience that it is precisely the strength of the corners which keeps a hollow box from distorting. A similar feeling of lightness, however, can be given in another way. Suppose the smooth stone block is covered all over with patterned wallpaper instead of being painted. Its faces have now not only lost their stony and weighty character but have been given another character specifically associated with thinness and lightness. The corner-continuity has not been abolished as in the previous example, but the observer's interest has been strongly engaged with the surface skin instead of with the solid: visually, the block might as well be made of cardboard. It is this method of weight-reduction which can be seen on the upper storey of the Doge's Palace with its continuous diaper pattern of red and white marble, and indeed on many of the older Venetian palaces along the Grand Canal. Similar suggestions can be seen in the tiled surfaces of Persian and Arab architecture and their descendants in Spain, Portugal, and Latin America, and in the mosaic surfaces of Byzantium and modern Mexico. We know very well, however, that buildings are not in fact made of patterned cardboard, and no doubt it is this interplay of two different associations—the insubstantiality associated with thin skins as skins against the substantiality associated with buildings as buildings—that so often gives a fairy-tale quality, a kind of special enchantment, to buildings in which such solidity-diminishing treatments are used.

I have dealt at such length with the suggestive properties of this one element of building—the wall—partly because wall-weight plays so large a part in the business of 'reading sign' on architecture and partly because walls provide such an accessible and useful exercise-ground for that practice of the eye which is so necessary to the appreciation of an art. Nothing is easier than acquiring the habit of looking at them, learning to read them, noticing when one wall is evidently meant to look particularly heavy and another particularly light. By such practice one comes to distinguish the finer shades of weight-suggestion (for there are many gradations between 'substantial' and 'flimsy') and to assess the kind of contribution they make—for better or worse—to the character of a building as a whole

or a street as a whole. If this exercise leads the observer to speculate on what he sees, so much the better; for, as I said at the outset, there is an intellectual as well as a purely aesthetic dimension to the appreciation of architecture. A street will present the same face whether or not one knows why it is likely to be a stone face in Scotland and a brick face in Denmark, how the face of Venice was affected by its ancient trade with the East, why the Brazilians have such an affection for *azuleijo* tiles or how gold mosaic was invented. Nevertheless the pursuit of such curiosities not only adds a certain interest to life but helps one to see architecture in all its dimensions, as a continuous record of history, geology, geography, and a few other things besides.

From the consideration of apparent weight as a factor in appreciation it is necessary now to turn to apparent *stability*, for the two concepts are really so closely interrelated that they cannot be dissociated from each other. Even when a building is a single self-contained volume, like a box, it enters the consciousness as something whose centre of gravity is high or low, something which may hug the ground in a particularly stable and restful way or stand up and challenge the elements. When it is made up of a collection of discrete geometrical elements, whether they are domes, spires, or rectangular prisms or any other kind, a rather more complicated comparison and balancing of their apparent weights enters into the assessment. As far as dimensions go, the two buildings in Fig. 22 are identical and it is the superimposition of the sense of weight upon the assessment of dimensional scale which gives them their different characters. The art of communicating an aesthetic intention by this particular route used to be called 'composition', one of those quite innocent words which have fallen from grace in our time through keeping bad company. It ought to mean no more than putting the various parts together to make a meaningful whole rather than an architectural jumble, but it became so associated with the idea of manufacturing beauty out of symbolic shapes assembled according to hackneyed rules (and often with a sublime disregard for the usefulness of the building) that it was edged out of the progressive architect's vocabulary some thirty years ago. Its place was taken by the relatively unsmeared word 'massing', which has at least one real merit: it does indicate that architecture is not a two-dimensional and weightless thing but an art which concerns itself with the relationships—from *all* viewpoints—of three-dimensional and weighty elements. Nevertheless I shall have to use

Fig. 22

the word 'composition' occasionally if only for brevity's sake, and when I do so it should be understood that it is this matter of mass-relationship, and not a formal and static kind of conventional picture-making, that I have in mind.

A look of obvious stability attaches to a building whose centre of gravity is 'carried low' and with this look come all sorts of connotations of permanence, security, authority, and respectability: these incidentally accounted largely for the popularity of weightily rusticated lower storeys in the age of top-hats and frock-coats. Symmetry is another such indicator, especially when the apparent weight is distributed near the 'point of balance' (Fig. 23). Spread of base, suggesting resistance to overturning forces, is another—a common-sense structural principle which one learns from childhood rough-and-tumbles if nowhere else. Since the pyramid displays all these characteristics in a marked degree, it is not surprising that civilizations in places as far apart as Egypt, Central America, and South-east Asia have given it a special place as a symbol of eternal authority, and any composition of elements which gives the pyramidal impression of weight spreading downwards and symmetrically outwards in this controlled way will have a similar character of marked stability and authority.

This does not automatically make it noble architecture, of course. Exaggerated stability can be merely banal, and in a sense the very portentousness of symmetrical and pyramidal massings puts upon the architect a special obligation to go beyond the obvious. The great pyramidal compositions of the Renaissance masters do a great deal more than register the single idea of stability. The complex visual experience which they present is more easily recognized than described, but something of its quality seems to lie in the fact that one is made to read them both upwards and downwards. The eye is led to climb them, by the ladder of scale and proportion, from base to apex while at the same time one is conscious of mass bearing *down* on mass from apex to base: and this downward bearing is not a simple succession of steps like the tiers of a wedding-cake, for each distinct mass is made to transmit its load to the next not only with stability but with a kind of eloquence. Analysing the 'impression of mass immovably at rest' given by Sta Maria della Salute, Geoffrey Scott noted the contribution made by the sixteen great curling volutes in removing any sense of abruptness from the downward

Fig. 23

step between the dome and the body of the church, and went on:

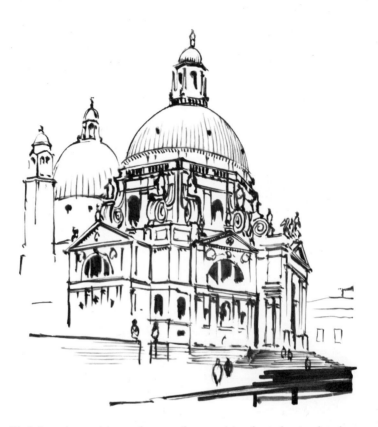

Sta Maria della Salute,
Venice, by Baldassare
Longhena

Their ingenious pairing makes a perfect transition from the circular plan to
the octagonal. Their heaped and rolling form is like that of a heavy substance
that has slidden to its final and true adjustment. The great statues and pedestals
which they support appear to arrest the outward movement of the volutes
and to pin them down upon the church. In silhouette, the statues serve (like
the obelisks of the lantern) to give a pyramidal contour to the composition, a
line which more than any other gives mass its unity and strength . . . there is
hardly an element in the church which does not proclaim the beauty of mass
and the power of mass to give essential simplicity and dignity even to the
richest and most fantastic dreams of the baroque.[1]

Such an organizing of elements into unity around a central domi-
nant feature—especially when to this completeness and stability is
added the effect of great mass and height—is characteristic of an
architecture of power-celebration, for it is capable of inspiring the

[1] *The Architecture of Humanism* (1924).

awe which attaches to the combination of great scale, great weight, and singleness of purpose. It compels the eye to read the communication it makes, and the communication is an assertion of power. On a less exalted level markedly symmetrical composition, whatever its defects, is at least easy to read, for it provides an evident fixed point about which one expects its elements to balance, making a discrepancy of visible weight on one side or the other very quickly detectable even by an untrained eye. This is why a near-symmetrical massing can be so disagreeable: a definite expectation that the game is to be played according to one set of rules has been flouted, and the perceptual system takes grave offence.

It is not offended in this way, however, by a massing which makes no pretension to symmetry at all, and this is fortunate because, considered from the point of view of usefulness, few buildings really lend themselves to a symmetrical disposition of space. This is not to say that in such a case we abandon the intuitive effort to compare the masses involved, for (as the examples in Fig. 22 clearly show) the diverse characters of different buildings—one might almost say, the attitudes they strike—are established at the outset by just this comparison. But it is no longer a matter of a straightforward security check on a point of balance: we are interested in *how* the masses compare and what the comparison suggests from all sorts of different points of view, rather than in looking for a stable balance around a fixed point. Finding a particular massing pleasant or unpleasant is a judgement still related to the sense of balance—an experienced observer will still say that such-and-such a part reads too heavy in relation to its neighbour or that another doesn't carry enough weight for its position—but it is a judgement more leniently made, simply because the grounds for it, in the absence of that fixed point of balance, are so much less easy to define. In most cases we are content with the interest itself, and hardly choose to bring it to the point of judgement; perhaps we even welcome the fact that we are not specifically asked—as the symmetrical composition implicitly asks us—to stamp 'checked for stability' on the building's metaphorical identity-card. Hence we can find pleasure in a million kinds of accidental and informal groupings and in markedly asymmetrical treatments of single volumes, as long as the eye assures us in the first place that they are not would-be symmetries gone wrong and in the second place that they do not overtly suggest disequilibrium: or, as an architect would say, that the masses are not fighting each other.

The natural associations of symmetry have been exploited over the centuries from Guatemala to Peking wherever an 'architecture of importance' has been in demand, and never more than by the Renaissance and Baroque architects and their later followers. To the doctrinaire classicist informal massings of the kind we have just been considering could be admitted as pleasing, romantic, or picturesque, but not as an appropriate architectural treatment for the seats of power—a purpose for which, it was commonly agreed, they lacked authority. This assumed incompatibility of asymmetry with authority (which during the last century or so led to the forcing of symmetry upon so many buildings, at the expense of sensible and functional planning) is in fact an over-simplification which finds no place in modern architectural criticism. It is rare for the buildings of today to display the kind of monumentality associated with centrally piled-up mass and when a contemporary critic says that such-and-such a building 'has great authority' he has usually discovered in it formal qualities which convey the feeling of a commanding presence in a subtler and less oppressive way. There is, after all, a kind of human authority which needs no uniforms or symbols to make itself evident, but which makes a man stand out in a crowd simply because his movements and posture betray a powerful, controlled, and self-assured personality. It is a similar sense of force under control which characterizes the authoritative building: what in the man is clearness of purpose reflected in a resolute bearing becomes in the building a clarity in the ordering of space reflected in the firm structural disposition of weight.

A building, then, can make an aesthetic impression through the medium of its structure by making us take notice of the way it carries itself. One might almost say that the designer has given it a particular attitude to the forces which play on it and it is this attitude, rather than any demonstration of engineering expertise as such, which enters our consciousness as giving the building its personality. Its structural system may reduce these forces to the simplest terms of horizontal and vertical and take care of them with evident and rock-like solidity (as with the Parthenon) or it may dramatize them (as with a Gothic cathedral) and excite us by a balance of thrust and counter-thrust which seems almost precarious. In such assessments we are joining the idea of *strength* to the idea of stability, and very properly too since it is *deformation*, and not simple overturning all in one piece, which the structure has to resist.

As we noticed earlier, we have an intuitive notion of the look of strength just as we can recognize intuitively the look of balance, and this awareness can be sharpened by understanding something about the play of forces upon a building's structure and by being able to detect how they have been brought into equilibrium. Straightforward gravitational load is the most obvious and universal of these forces: every building is in a constant state of being crushed between its own weight (including, of course, the 'live load' of the people and things it contains) and the resistance of the earth's crust on which it sits. Its task of standing up to this vertically acting load is complicated to a greater or less degree (according to its height and situation) by the sideways acting force of wind and, in earthquake areas, by the possibility of movement in the earth's crust itself. The earth-tremor is too prodigious a force to be resisted, and the building which would survive it has to be designed to ride it out rather than fight it: but the others can, and must, be brought into equilibrium and carried down to the ground. The structure may also have to withstand powerful sideways forces generated within itself, as when the downward action of gravity is deflected by an arch or an inclined strut (Fig. 24), and these too have to be balanced if the building is not to rack itself apart.

The structure will accommodate these various loads either by spreading them out (as a solid wall does) or by gathering them together towards a number of points or by a combination of the two. The Doge's Palace, for instance, distributes its roof-load along a wall and then brings the wall-load down through a series of columns. In either case it has to resolve them, at foundation level if not before, into a vertical direction and this it may do by sheer mass—absorbing them into the downward push exercised by its own weight—or by playing them off one against the other through a system of relatively slender ribs, membranes, and ligaments. In the first case mass compensates for lack of inherent strength: the load on the material in terms of force applied per square inch is small. In the second case the converse applies, and the inherent strength of the material must compensate for lack of mass.

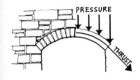

Fig. 24

The way a building carries itself, then, is not unrelated to the loads it bears, the materials of which it is built, and the skills available for fitting those materials strongly together. Today the choice is almost infinite, but pre-industrial civilizations had to work within the practical limits of stone, brick, and timber. Structures of stone or brick have to rely on compression for their strength and stability because

they cannot be put together with joints which resist pulling apart. Forces can obviously be balanced very economically by arranging for some to push and others to pull (as in the struts and ties of an ordinary roof-truss); but this is not an option open to the architect who has to span space with a masonry vault, and the slimness of Gothic architecture had to be obtained entirely by wresting the maximum compressive advantage out of strong stone carefully worked and aligned with a wonderful intuition of the balance of force. Timber has the considerable advantage of strength both in compression and in tension and also of lending itself to the making of joints which resist both push and pull. But it is essentially impermanent and only the Japanese have resisted the appeal of permanence of fabric (as opposed to permanence of *style*)[1] strongly enough to make it the major structural medium for buildings of lasting importance. By and large the history of architecture before the present century is the history of making buildings stand up by the push of one building element against another. The structural theme upon which the architect could play his individual variations is essentially the theme of compression.

An architecture of compression is naturally (as far as its purely *physical* nature is concerned) an architecture of rigidity: it is the locking of its joints by gravity which gives such building its strength. When the compression involved is the simple bearing of a strong lintel on two strong vertical supports the rigidity is underlined by the calm and static quality associated with the simple association of horizontal and vertical. To describe this as the quality of 'undisturbed gravity' is both literally and metaphorically just, and some cultures have not only accepted this essential quality of the simplest kind of compression-structure but have idealized it. The heavy columnar architecture of ancient Egypt, for instance, has a character as hieratically rigid as their figurative art, and the calm stable quality of classical Greek work is a subtler distillation of the same essence.

A wider range of expression through structure was available in cultures which used the arch, and there is evidence here that we do not really read structure in a purely mechanical way but inevitably bring to it associations which have very little to do with the facts of engineering. A brick or masonry arch depends just as much as a lintel on the rigid locking of its joints by compression—in fact it is just an assembly of wedges—but merely by uttering in visual terms the

[1] Kenzo Tange and Noboru Kawakazoe, *Ise: Prototype of Japanese Architecture* (Eng. trans., Cambridge, Mass., 1965).

simple statement 'I spring', it brings a new set of associations into play. It makes this statement by virtue of all the associations of its shape as soon as it is seen to be playing some major part in the structural system (not, obviously, when it reads merely as a small hole drilled into a masonry mass), and the associations which it introduces (and which are aptly summed up in the Arab saying 'the arch never sleeps') are those of movement and elasticity. The vault and the dome —which are translations of the arch into three dimensions—have the same quality with all the added power of spatial depth: however rigid and static they may be *structurally*, they are read as dynamic rather than as static form, and so are capable of catching the imagination simply by the subconscious suggestion of arrested movement.

This power to play simultaneously on the associations of rigidity and elasticity, stillness and movement, adds associative richness to the architectural language: it establishes a kind of bridge between the abstract formal values of architecture and the sources of human sensory experience. It may not be particularly sensible to feel that the arcade of Brunelleschi's[1] foundling hospital (p. 60) skips along while the arcading in James Lewis's design for Christ's Hospital (p. 60) plods along, or to see in the finely ribbed structure of King's College Chapel (p. 61) associations with living and growing form; but it is significant that such metaphors are helpful in clarifying our impressions of how a building carries its weight, and that some critics have even assigned a special value to the kind of architecture which does lend itself to description in these 'organic' terms.

The significance lies in the fact that to most people living things are more attractive than dead matter, and the more vividly alive they are the more attention they attract. Consequently we are always open to the suggestion of life, even when it appears in something as inanimate as a building. It is characteristic of living things (of those, at least, which present themselves to the naked eye) that they function most efficiently by getting the maximum amount of work done with the minimum amount of weight, and those which we recognize as graceful illustrate this excellent engineering principle to a high degree. In particular they save weight by dividing the surface into thin panels between strong ribs (as in a leaf) and by using folds and corrugations to give stiffness to thin shells; they tend to assume forms which allow force to flow in the way it wants to go, along easy paths and

[1] See Biographical Note.

not around sharp angles; and they resist breakage by resilience (as a branch does) or by continuity (as a shell does) rather than by thickness.

When a building's structure suggests these properties it inevitably catches the eye, and we are apt to find ourselves willy-nilly judging it against the frame of reference provided by the organic world. Brunelleschi's arcade suggests strength combined with lightness and its rhythm suggests elasticity: the eye has hardly 'brought the force down' on to the head of the strong slim column before it is swept up again in the swing of the next arch. The metaphor of lively youthful movement sums up the essence of its quality perfectly.

It is part of human nature to fix impressions in the mind by metaphors such as this, and a helpful and innocuous habit it is as long as one remembers that it is a mere convenience and does not push it too far. There is a fundamental difference between structure in building—and especially in the masonry buildings of the past—and structure in the organic world. Living things derive their strength from resilience or from the ability to resist tensile force or from continuity of structural surface: commonly from all three. Now the elasticity which we can tolerate in a building is very limited. As far as traditional masonry is concerned, it is not tensile but compressive strength that it relies upon; and until quite recently practically all buildings have been *discontinuous* structures—that is, they have been made by fixing together a collection of fairly large pieces. Moreover they are exempt, for obvious reasons, from the natural laws which govern the forms of organisms according to their food and habitat. Clearly, then, the organic analogy has only limited application: a trick played by the memory upon the perceptions (useful though it is when it helps to make abstract form in some way more real) is not a very safe basis for judgement.

Obviously the analogy is least dangerous when brought to bear on structures which, unlike the discontinuous compression-structures of the past, *do* derive their strength from tensile resistance, resilience, or continuity, and this applies to those constructions of the present day which exploit the possibilities of thin shells and skins and welded metal lattices. Thanks to steel—either by itself or as a tension-resisting network in reinforced concrete—strength can be obtained by playing off push and pull against each other with a consequent saving in dead weight. Thanks to the high strength of laminated timber and the plasticity of poured concrete the designer can at last achieve

page 60
Design for Christ's Hospital, London, by James Lewis.
RIBA Library (above)

Ospedale degli Innocenti, Florence, by Filippo Brunelleschi. *Radio Times Hulton Picture Library* (below)

page 61
King's College Chapel, Cambridge.
Photo: A F Kersting

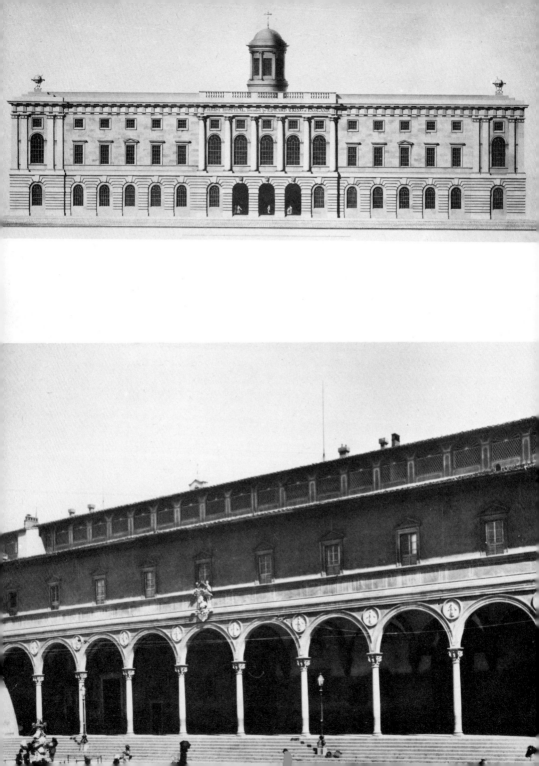

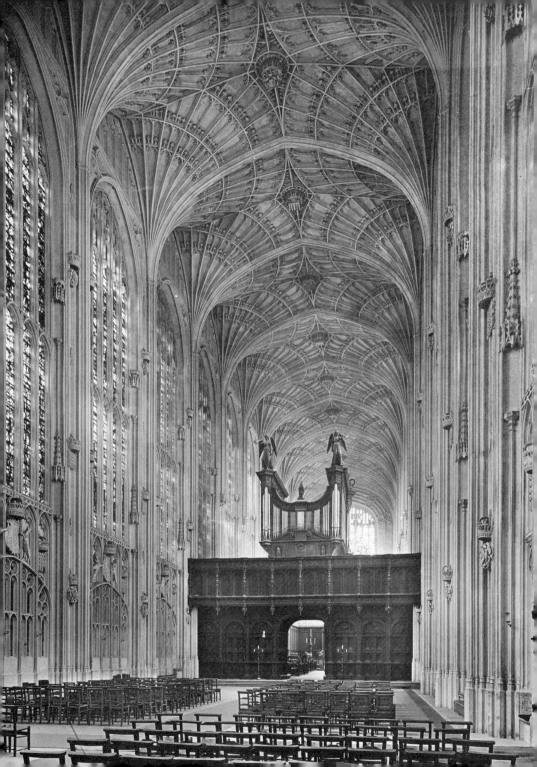

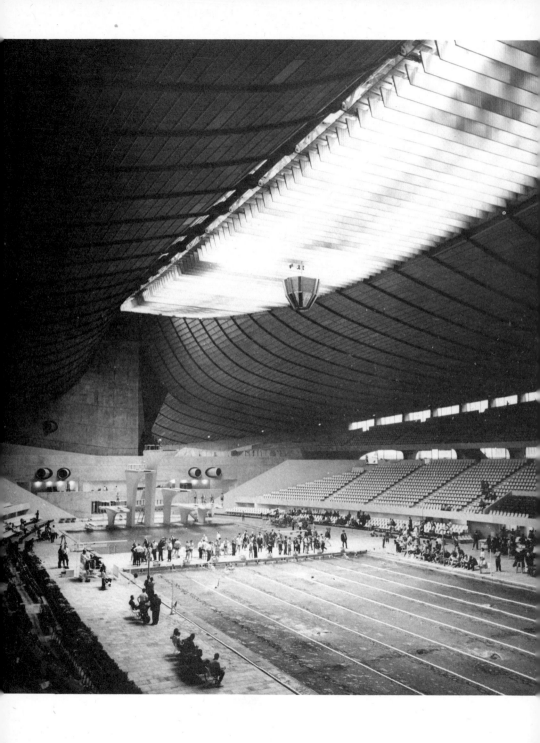

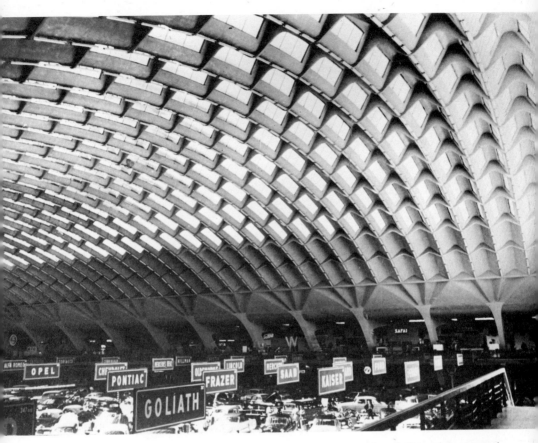

above: Exhibition Hall, Turin, by Pier Luigi Nervi. *Cement and Concrete Association*

something like organic continuity, constructing shells and corrugated and twisted skins which resist deformation by the inherent strength of their *shape* instead of by thickness. In Pier Luigi Nervi's[1] Turin Exhibition Hall, for instance, the ribbed vault of 325 feet span is built up of *ferrocimento*[2] units only 1 inch thick, and the weight of the construction amounts only to about 25 lb. per square foot: in Kenzo Tange's[3] Olympic Swimming Pool at Tokyo the roof is a great tent of steel plating draped on cables in the manner of a suspension bridge.

[1] See Biographical Note.

[2] Nervi's name for the type of construction invented by him, consisting essentially of very thin reinforced concrete produced by pressing a high-quality cement mortar between meshes of steel. The shell thus produced behaves more like a bent steel plate than an ordinary concrete slab.

[3] See Biographical Note.

left: Olympic Swimming Pool, Tokyo, by Kenzo Tange. *Japanese Information Centre*

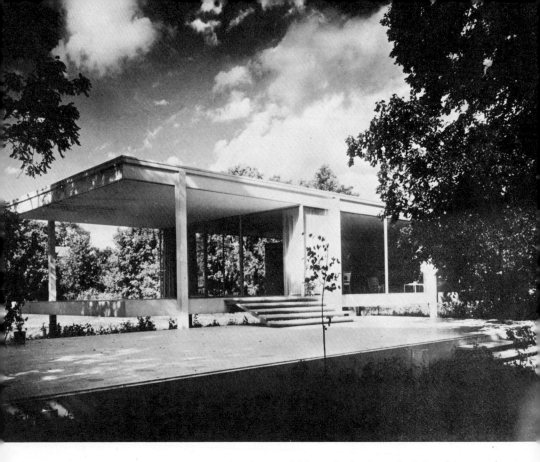

Constructions like these, which embody the principle of 'strength through form',[1] do demonstrate the kind of structural economy which occurs in nature and the smooth flow of energy which they suggest is a real flow of real force: to that extent the organic analogy is here more truly descriptive and helpful.

We have to recognize, however, that there are occasions when, so far from being helpful, this particular short-cut to cognition is no use at all. It does not help our enjoyment of the Parthenon to reflect on its high weight-to-load ratio and if we are looking for a smooth flow of force, the precise and abrupt right-angle connections of the steelwork in the Farnsworth house will strike us as distressing rather than elegant. Criticism in such terms is clearly inadequate to say the least (although Ruskin in his day did his best to build a com-

[1] Nervi's own phrase, with which he introduced the characteristics and possibilities of *ferrocimento* in his original paper on the subject (*L'Ingegnere*, No. 1 (1951)).

plete theory of architectural beauty on just those foundations) and it is inadequate because the organic analogy is being dragged into a situation where it is inappropriate. We have seen that it comes naturally into play when the eye is caught by a suggestion of life. But where there is no such suggestion—where the building, by evident and deliberate choice, has been given a form which makes no such appeal—the perceptual system will be perfectly satisfied to judge what it sees against an entirely different and abstract frame of reference. As we have seen, the form of a building is not dictated by the logic of cellular growth but by the job it has to do and the materials at hand and possibly by a symbolic function for which the associations of broad-based mass or the visual stability of the pyramid or the precise rectangle are completely appropriate. If the fulfilment of its own inner logic deprives the building of those allusions to natural form which we find so easy to interpret, we shall probably have to work a little harder at making its acquaintance but this does not necessarily entitle us to dismiss it as 'inexpressive'.

It seems, then, that sensitivity to the appearance of weight and a reaction to the way a building carries its weight play some important part in the experiencing of architecture; all sorts of suggestions can be conveyed through our innate sense of balance, our habits of move-ment, and the emotional correlates of lightness, heaviness, weakness, and strength, and the more open we make ourselves to these sugges-tions the more intense the experience will be. This is essentially an appreciation of the solid, of three-dimensional bodies standing in space. But a building does not only *stand in* space, it *encloses* space: and the awareness of this contained space and what it does to us is also an essential part of the experience.

It may well come as a surprise to find that contemporary architects and critics show at least as much interest in the empty spaces inside and around a building as in the 'real' masses of structure, and that they can even describe architecture—this practical art which involves shifting tons of solid material—as the art of moulding space. This proposition is not quite as perverse as it seems at first sight, but it will be helpful to enlarge upon it for the benefit of the reader who—very reasonably—finds it hard to swallow the idea that space is stuff which can be modelled like clay.

First it should be explained that this is quite a new way of discussing architecture. Until about the middle of the nineteenth century criticism and appreciation were still guided very largely by the philosophy of classical authors, to whom *spatium* seems to have meant, more or less, a *two-dimensional* expanse—the surface of the earth, for instance, or the face of a wall. The three-dimensional volumes enclosed between the building elements were simply *vacua*, the empty bits, and one has the impression that the critics were much less interested in them than in the treatment of the solid and its surfaces.

This does not mean, however, that the deliberate organizing of space for aesthetic purposes is any kind of new activity as far as the designer is concerned, or that nobody appreciated spatial qualities until the critics began to analyse them. The architects of the past, like those great Renaissance men of whom Berenson has said: 'They took space for a language as a musician takes sound',[1] knew very well how to touch the emotions by playing on those very qualities—although (being highly practical artists) they were much more interested in applying their knowledge empirically than in philosophizing about it. The fact that the modern critic and the modern architect do talk a great deal about space does nevertheless show that there has been some significant change of emphasis in the conscious appreciation of architecture over the last century or so and, since we are all inheritors of this change, it is necessary to know something about it.

Like so many other changes it was accelerated, if not brought

[1] Quoted in Clough and Amabel Williams-Ellis, *The Pleasures of Architecture* (1924).

about, by the effects of the industrial revolution. New kinds of buildings for large concourses of people were demanded. The planning and construction of these posed new problems which could not readily be solved by old formulas, while a succession of technological advances—notably in the fields of structural engineering and glass production—made it possible to reduce enormously the proportion of solid and opaque structure required to enclose a given space. Concurrently, and especially after the end of the nineteenth century, the background of architectural thought was infiltrated by new ideas about the nature of space in the abstract sense (ideas picked up from the scientists and the philosophers as well as from the experiments of the frontiersmen in the other arts), and also by a new kind of social consciousness which placed an increasingly higher value on usefulness and an increasingly lower value on monumentality. From this point onwards the architect's role as a designer of *spaces to accommodate people in movement* (whether at work or leisure) becomes more important than his classical role of raiser of monuments to temporal power or religious myth.

This last change of emphasis has been, perhaps, the most fundamental of all in forming our twentieth-century attitudes to architecture, and fundamental in the most literal sense in that it takes us back to the primordial foundation of the building activity out of which the art has grown and to which it must periodically return to renew its strength: the idea of a building as an envelope in which people move about. Whatever 'space' may mean to the physicist and the astronomer, and whatever inspiration the architect may draw from the ideas they pass down into the common currency of thought, the nub of the matter as far as the creator and the observer of buildings are concerned can be summed up in a single phrase coined some fifty years ago: 'Space, in fact, is liberty of movement. That is its value to us and as such it enters our physical consciousness.'[1]

This is not a mere truism but a reminder that the *total* aesthetic impact of a building includes the response to suggestions of spaciousness, confinement, intimacy, and so on, and that these suggestions—which are really hints of constraint or freedom—have had their origin in the designer's individual approach to the functional task of providing the right amount of room for certain physical activities. It follows that a society which focuses attention—as ours does—on the

[1] Scott, *The Architecture of Humanism.*

practical importance of this task becomes acutely conscious of the *awareness of space* as a factor in the appreciation of architecture. In fact, it is necessary that it should: the more we all develop this faculty, the better our chances of providing ourselves with buildings which not only work well but feel right.

It is a faculty which only has to be cultivated, not acquired, because we all have it already. It is the habit of asking subconsciously, from moment to moment, 'How much space have I got around me?' that saves us from banging our heads and falling downstairs: in fact it is in such constant use for these everyday purposes that we are apt to take it for granted unless it goes wrong (as in the case of claustrophobia) or provides us with an unexpected bonus of pleasure, as for instance on the top of a mountain or inside some great building. Whether this faculty is truly instinctive and part of the equipment we are born with, or whether it is acquired among the learning patterns of infancy, we are certainly conscious from childhood of the unpleasantness of being hemmed in, and the fact that we describe some kinds of spaces as 'suffocating'—even when there is no real question of asphyxiation—shows that they carry suggestions of the nightmare sensation associated with physical frustration of breathing. This is a condition one seeks to correct by 'making room' for oneself, and it is a short step from conceiving space as something necessary and desirable to seeing a certain excess of this prized commodity as a perquisite of the top people. Thus throughout human history a symbolic prestige-value has attached to this rawest of the architect's raw materials.

Already we can see that the architect's manipulation of space is providing something more than liberty of physical movement in terms of so many square feet per person. He is also, inevitably, operating upon our emotive reactions through the associations of different kinds of spaces *as they appear to us*. This last qualification is important because we not only react to the physical area or volume of an enclosure but also respond to the kind of intimation it gives of exterior space or of other volumes adjoining it. The idea of Inside—*my* place, a refuge, set apart for *me*—and Outside—the immeasurable and hazardous—has coexisted, ever since man first took shelter, with the idea of Inside as prison and Outside as free range. The way in which Inside and Outside are interconnected determines how one idea is played off against the other, and consequently has a great deal to do with the impression made by any given enclosure. A cell whose

window, however small, high up, and closely barred, allows a glimpse of sky is more tolerable than a bottle-dungeon; a window at eye level can make the same cell a still more tolerable little room; while the same room glazed from floor to ceiling is another thing again. To alter the relationship of Inside and Outside, even in so small a detail as the positioning of a window, is to give the whole experience of an interior a different turn. So in 'liberty of movement' we must include not only real bodily movement but also the extension of that movement which we make *in imagination*. It is real and measurable space plus the space to which the eye and the imagination are given access that we must think of when we speak of 'architectural space' as a factor in the aesthetic experience.

The possibility of catching the observer's imagination through his awareness of space is present from the moment the designer commits himself to those very early design decisions which measure out particular areas for particular uses and determine the relationships between one area and another and between Inside and Outside. The observer's activity is likewise one of measuring (although less consciously and much less accurately) and of detecting relationships. If these relationships touch his imagination and sense of wonder in a way which gives some momentary poignancy to the unconscious practical query 'How much room have I got?' he is launched into an aesthetic experience.

As a practical being man concerns himself first with *area*, that is, with the space around him in the plane in which he normally moves. As an imaginative being he is only slightly less interested in taking the measure of the superfluous space above and below his plane of action, the space into which he could (if only in imagination) leap up or fall down; and this impression of vertical scale, superimposed on the impression of free space in the horizontal, gives him the assessment of volume which he embodies in descriptions like 'spacious', 'cosy', or 'airy'. This last adjective, incidentally, is a reminder that the enjoyment of architecture is an experience of more senses than one. Our noses and ears are insensitive receptors compared with those of the hunting animals, but they can nevertheless provide some intimations of space to supplement our visual assessments. The 'uncontrolled breeze from the garden'[1] can accentuate a feeling of spaciousness by its suggestion of continuity between Outside and Inside, and the

[1] Richard Neutra, *Survival Through Design* (New York, 1954).

hollow sound of a great and possibly mysterious cavern (which does, in fact, bear a mathematical relation to its measurements) is familiar and evocative enough to have become a stock sound-effect in radio and the cinema.

The aesthetic impact of any enclosed volume will therefore depend on how the architect has disposed area and height, and on the kind of measuring-clues he has provided by way of scale. This last factor will in turn depend on the quality of the light he has provided, for this will affect the observer's ability to measure scale at all and so will tend to pitch the key of the emotional experience in the direction of mystery—the traditional dim, religious light is a case in point—or clarity. Even within a single room, then, the appreciation of architecture involves a reaction to volume as apprehended by the eye (helped perhaps by the other senses) and modified by the lighting of the interior and by the kind of expectations which arise from a sense of the *symbolic* value of space. Over and above this we have already seen that the reaction is affected by any intimations which are given about the volumes adjoining the room or about that infinitely greater part of the continuum which we loosely call exterior space.

A room or enclosure which offers free access to these intimations (among which the most obvious are breezes, light, flying creatures, and the noises of Outside) might be described as highly *space-permeable*. The most permeable kind of structure is obviously one through which physical travel is possible in all directions, like an open pergola or 'breezeway'. Close the gaps with a pierced lattice, like the fretted *jali* of the East, and the interior is still permeable to light and sound as well as to air-currents; close them with glass and it still remains permeable to light and sound; black-out the glass and it still remains sound-permeable. Only when the shell is made opaque to sound as well as to light, air, and passage does the enclosed volume become a thing on its own, divorced from the spaces adjoining it and all their associations.

Only a tomb, therefore, can be assumed to provide space in the form of a single, wholly impermeable volume. All architecture for living people has to lie somewhere between this and the other extreme of a total absence of shelter. Its impact on the observer's awareness of space will have been determined in the first place by the position between these extremes assigned to it by its function and the way it is built; and this position will have been dictated—or at least

very strongly influenced—by such practical considerations as the need for climatic protection, the need for security and the constructional methods available to do the job.

The most impermeable kind of building might be described as a *space-trap*: the kind of building represented at its simplest by the Eskimo's igloo, in which the living-area is to all intents and purposes a bubble of space trapped and encapsuled in a solid shell. The opposite might be described as a *space-frame*,[1] a minimal protective umbrella like the *benab* of the Guyana Caribs, held up by a skeleton so slight that Inside and Outside seem to flow together through its interstices. In the one *insideness* is the whole essence of the matter, and it is so much a man-made cave that one visualizes it as hollowed out of a solid rather than made by assembling separate units. The other represents the bare minimum of encapsulation (whatever problems the Carib may have, sub-zero temperatures are not among them) and is self-evidently something put together, like a fence, and not made by hollowing out.

Guyanan *benab*

One cannot make any very high claim for the emotional impact of either of these two simple forms of shelter, though it might be noted in passing that a child finds one kind of pleasure in a dug-out and a different kind in a tree-house, and that they are both real pleasures. Nevertheless each illustrates in a very simplified way one method of enclosing space which, when developed for the more complex purposes of the higher civilizations, *is* capable of carrying a pronounced emotional charge. The interior of Saint-Front, Perigueux, is much more than a glorified igloo, but it is still essentially a space-trap—a great cavern with all the cavern's potential for suggesting apartness, mystery, almost entombment. The Farnsworth house (p. 64) is very much more than a glassed-in *benab*, but it is still a space-frame with all the corresponding associations of penetrability, clarity, and light.

When a building contains many cells it can touch the human awareness of space in a great many ways, especially when its internal subdivisions lie on a line of movement (Fig. 25) so that a *sequence* of changes of volume is experienced. Again we are reminded of the importance in architecture of the movement of the observer, and this is nowhere more telling than in the penetration of a series of different

Fig. 25

[1] The term is not to be read here in the specialized sense (denoting a particular kind of three-dimensional latticed roof construction) in which it is often used by structural engineers.

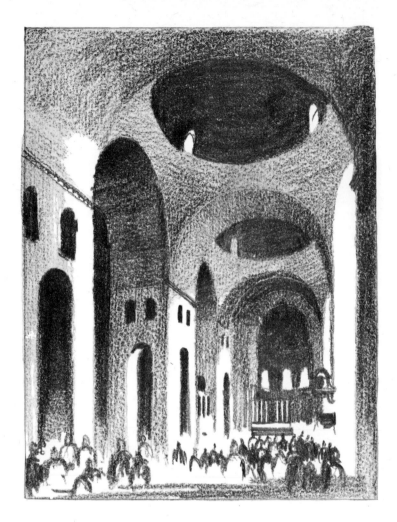

Saint-Front, Perigueux

volumes. The accident-preventing perceptual mechanism is a wake-ful travelling-companion whose running commentary on the relation-ship of body to space becomes especially vocal on such an expedition, so that wonder and delight can be evoked out of the security-checking instinct as a kind of aesthetic bonus. To take a very simple example, an attic room provides more of this kind of exercise than a flat-ceilinged room since the head-to-ceiling relationship keeps con-stantly changing as the observer shifts his position. The same sort of titillation of the senses (often labelled 'interest' or 'charm' in ordinary house-purchaser's language) attaches to the split-level room, where

it is heightened by a *below-me* as well as an *above-me* dimension, and becomes still more marked when one passes through a series of rooms which all return different answers to the perpetual subconscious question: 'How am I to behave in this context?'

The shapes of rooms can, in fact, give quite strong hints about how one is expected to behave. *A, B, C,* and *D* in Fig. 26 are all plans of rooms of the same area but there is no doubt that they will all feel different, and the difference is connected with liberty of movement. Each makes its own suggestion about the directions in which one can move most freely, *C* being so non-directional that it gives a strong hint that one should stop and look around for further instructions. This commanding, or at least persuasive, power of space can be quite emphatic. Observe (Fig. 27) how the hint towards movement given by a long rectangle can be made more pointed by the addition of an alcove or apse at one end, strengthened still further by the rhythm of a colonnade leading towards the apse, made into a more complex kind of suggestion by the presence of subsidiary cells whose depths invite a sideways glance, and elaborated still further by the addition of an intermediate halting place.

Fig. 26

In passing through subdivided space, then, one is accessible to all sorts of subliminal messages which originate in the designer's space-shaping operation and will contribute to the total experience according to his skill in playing upon expectation and imagination, and according to the observer's own suggestibility. The nature of the experience, its place between the two poles of delight, will also depend on how the architect has chosen that this persuasive power shall be exercised, and this may be anywhere along the line from pungent directness to extreme delicacy.

Consider, for instance, the stair. The liberty of movement which a stair provides is strictly controlled, for its designer has not only set exact boundaries to its length and width but has literally prescribed every step in the progression. At the same time, however, an infinite number of expressive changes can be rung on its simple functional message, which is: 'Come on up (or down)—and stay inside the balustrade unless you want to break your neck.' In fact only the simplest stair puts it as bluntly as that. According to its steepness and the length of its flight—its private rhythms, in fact—a staircase can offer encouragement to movement in various different ways and the experience of traversing it can be tedious, strenuous, delightful, or terrifying according to the physical sensations it inflicts *and the kind*

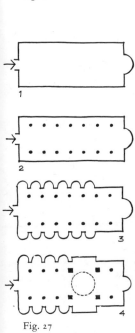

Fig. 27

73

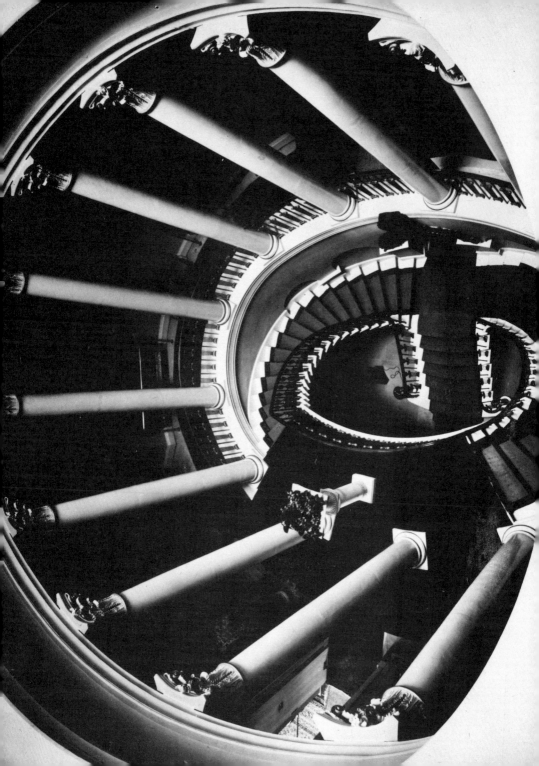

of movement through space which it suggests. It can be simply a borehole through solidly enclosed layers of rooms, like the wheel-stairs of medieval castles, or it can itself be a tall room, opening at different levels on to different prospects of horizontal space, internal and external. The space-permeability of the stair-well, and of the stair itself, can vary between the gouged-out space-trap quality of the medieval example and the transparent quality of the modern glass-enclosed stair through whose balustrades and walls, perhaps even between its steps, the eye can travel in all directions. The route of its flights can dictate decorous straight-line ascent with right-angle turns or, like the winding stair illustrated on the facing page, it can turn the head with the more highly charged and tempting offer of flowing movement—an experience recharged as it unfolds under the stimulus of a revolving field of view.

No doubt we are more consciously aware of moving in space when we use a stair than when we simply walk along on the level, because our perceptions are somewhat sharpened by moving in the vertical as well as the horizontal plane. But it is really only a special and highly illustrative case of the general principle that there is more to the architect's space-ordering activity—which is an activity of *making arrangements for movement* by allowing freedom of flow in certain directions and restricting it in others—than simply traffic-planning. According to its rhythms and the nature of its boundaries a space-sequence can be made to issue firm directives as in the processional, axial plan; it can beckon from round a corner as in the 'free' or 'open' plan; it can cajole or tempt with the offer of swift and easy movement, as we have seen in the case of the helical stair; or it can propose stillness and contemplation as in the Persian garden or the medieval cloister.

These commands or hints are given primarily by the arrangements of the spaces in plan—that is, on the horizontal. The response to them will be modified by reactions to changes of volume and level—that is, by the design of the spaces in section—and by the effects of the factor which we have called space-permeability. In fact it is chiefly the manipulation of this last factor which makes it possible to conjure out of simple spatial relationships an infinite variety of aesthetic experience.

Consider, for instance, the different ways in which a square building can be divided into nine equal spaces. The dividing elements may be minimal as at *A*, where apart from the four columns

Staircase, Culzean, Ayrshire, by Robert Adam. *Photo: Campbell Harper*

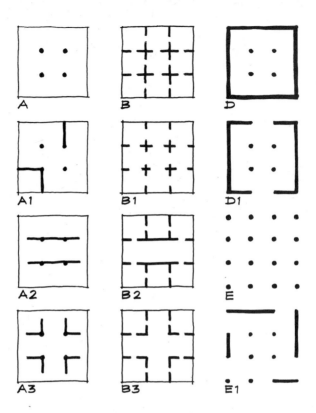

Alternative subdivisions
of a square plan

permeability between the nine compartments is absolute: they may
be visually defined by decorative patterns on the floor or ceiling, but
there is no physical barrier between them. *B* represents the opposite
case, where the compartments are isolated by solid walls with only
the minimum of necessary openings. By contrast with *A*, which is a
single large volume subdivided by an internal space-frame, the plan
in *B* consists of a group of space-trap cells joined together.

B can be modified in the direction of openness by enlarging the
doorways (*B1*, *B2*, *B3*), while *A* can be modified toward enclosure
by putting screens between the compartments (*A1*, *A2*, *A3*); and
the feel of the space resulting from these operations will clearly be
affected by the height of the openings in the one case and in the other
by the heights of the screens (and especially by variations in their
heights as between one part of the building and another) and by their
opacity. They may be entirely solid, in which case the enclosure will
be permeable to sound—provided they stop short of the ceiling—but

opaque to vision. The occupants are apart and yet not apart, a circumstance which provokes a certain curiosity and can be used to heighten an atmosphere of mystery and awe, as when Mass is sung in the invisible sanctuary behind the inconostasis[1] of a Byzantine church. Alternatively the screens may be wholly transparent to the eye, like the plate-glass partitions of some modern buildings; they may be semi-transparent like the fretted Oriental *jali*, allowing some visibility from the darker side to the well-lit side but none in the opposite direction; or they may be translucent like the paper screens in Japanese houses, passing filtered light but not vision. Moreover the openings or the screens may be so disposed as to suggest a traversing axial movement (A_2, B_2) or a movement into or out from a central focus (A_3, B_3) or a free and informal circulation between compartments (A_1). To these permutations of possibility must be added the various alternatives of *external* enclosure, from the wholly enclosed space-trap (D) to the open space-frame (E) with all their own variations of opacity and axiality.[2] D_1, for example, is wholly directional and formal. E_1 is non-axial and non-directional, and is likely to present a series of unexpected views both inside and outside.

It will be clear from these examples that a whole host of different spatial possibilities can be generated even by a simple group of spaces of the most ordinary kind, and the possibilities are infinitely multiplied when instead of being identical the compartments vary in shape, size, and height. Such an embarrassment of riches might well defeat the architect in his attempt to conceive a firm aesthetic intention and communicate it coherently, but in fact the options are usually reduced to something less than infinity by practical considerations. Such considerations will, for instance, dictate that there will be more traffic between some cells than between others, that certain of them will be closely connected with certain others but isolated from the rest, that some require maximum light-penetration and others little, that some must be sealed off against sound or smell, and so on. In addition to these functional factors, structural possibilities exercise their own discipline, and this has had a most important bearing on the develop-

[1] Literally 'image-stand': the screen which, in Greek Orthodox churches, separates the sanctuary from the congregation in the nave.

[2] A space is described as having 'a high degree of axiality' when it is disposed symmetrically about a dominant longitudinal axis, and 'a low degree of axiality' where no such evident dominance exists.

ment of space-consciousness in architecture over the course of history.

We shall examine this development in detail in a later chapter. Meantime it is sufficient to bear in mind that a spatial arrangement like example *A* only became possible, as far as very large buildings were concerned, when iron and steel became available to replace massive masonry supports, and that the visual interpenetration of Outside and Inside offered by *E* had to await the invention of plate-glass[1] and central heating for its fullest realization. Consequently the architects of the West were chronically restricted in their exploitation of continuous visual space—at least as far as permanent and monumental buildings were concerned—by the limitations of masonry construction. These limitations were of no great consequence in ordinary run-of-the-mill building, where there was no physical need for great continuous spaces and where a stout and impenetrable barrier between the comforts of Inside and the hazards of Outside was often a necessary and reassuring asset. The case was different, however, when the architect was obliged to create covered spaces for great assemblies of people—the cathedral or the palace, for instance—and at the same time to give ceremonious expression to the idea of unlimited space as a symbol of power and glory. Here the restrictions of masonry technique bore hard upon him. Sometimes they were purely practical restrictions such as the difficulty of supporting great weights of vaulting at great heights and sometimes (as in the centuries following the Renaissance) they were imposed by aesthetic convention—by what it seemed decent for masonry to attempt, rather than by what it *could* do when pushed to a finely judged limit of safety.

We have already seen, however, that *architectural* space is not to be described solely in terms of quantifiable distances between physical obstructions. It is the imaginative experience generated by the relationships of space which counts, and the ability to produce such an experience has enabled the great architects, whatever their period, to transcend—often in the most striking way—limitations of structural possibility or stylistic convention which lesser men might have found merely frustrating. As might be expected, we find this faculty most fully extended in cultures which have attached especially high value to the *idea* of space and the nature of this value is apt to leave its own distinctive impression on the architectural dialect of that culture.

[1] To be more exact, the development of the manufacturing process which allowed plate-glass to be commercially mass-produced in large sizes.

In the Christian cathedral, for instance, it was to the celestial Outside, where God sat in glory among his saints, and not to the temporal Outside of nature and human activity that the worshipper's vision was to extend itself as if from a space-lock between man's world and eternity. The golden bubble of the Byzantine dome, the 'storied windows' and soaring vaults of the Gothic, the theatrical lighting and swirling forms of the Baroque, are architectural epitomes of an ideal and boundless state to which the soul is supposed to aspire. A similar impatience with physical boundaries characterizes the Baroque palace, but here the emphasis is different. Not only was the Baroque mind interested in the world in all its manifestations, but the Baroque ruler had assumed something of the dimensions of the God from whom his power theoretically derived and he demanded visible manifestations of his godlike authority over space. So his public role was played in apartments of physical grandeur, in which any device of visual illusion or persuasion—the long perspective vista, the vanishing-trick of the mirror-covered wall, the transformation of the ceiling into a pictured allegory—might be used to make them seem more spacious still. And this internal order of room and vista did not stop short at the external walls but extended itself outwards into the ordered scene of avenue, parterre, fountain, and statuary commanded by the windows. *Le Roi Soleil* was the centre and focus of a miniature universe in which his pleasure was law.

The characteristic twentieth-century attitude to architectural space is as different from this as twentieth-century cosmology is different from the cosmology of Newton. We have said goodbye to the concept of a static universe ordered into majestic and definable neatness and to the concept of time as a uniformly flowing stream, and the same period of history has seen the erosion of the idea that great architecture is a matter of the ordering of spaces in relation to climaxes such as the altar, the throne, the theatre proscenium. It becomes less an art of *composition* concerned primarily with the picture which the building makes from certain preferred viewpoints, and more an art of *juxtaposition* in which a most important part is played by the shifting viewpoint of the moving observer and by the superimposition of varied impressions upon one another in an almost unpredictable way. One might almost say that it now invites his participation in an open-ended experience of space rather than his obedience to the direction of an architectural pageant-master.

In this respect architecture has moved in the same general direction

as the other arts. The well-made play with its conventional sequence of cause, effect, and climax, the painting in which a composition builds up to a visual focus, the neatly constructed, forward-moving plot of a novel, are no longer seen as inviolable institutions. At the same time we are taking a more penetrating interest in the effects of human activities on the ecology of the planet and in the relationship of buildings to their surroundings: the interaction between the immediate or controlled environment and the macro-environment—between Inside and Outside—becomes more interesting than the boundaries between them. In so far as these ideas and attitudes infiltrate the common stock and influence the behaviour of people, they influence architecture. Thus there has emerged a way of building whose spatial characteristics are marked by openness rather than enclosure, by informal plan arrangements dictated by function rather than suites dictated by convention or symmetry: a kind of architecture, new in Western history, in which one often has the feeling of being Inside and Outside at the same time, as for instance when the external wall is a single sheet of glass or when one is cantilevered out into the void.

We are living in a world increasingly accustomed to buildings of this kind, and accustomed, too, to the idea that man can not only move on the earth's surface but even float above it. The popular imagination has been caught by the idea of 'space'—however vaguely imagined—as something infinitely explorable and now being explored, and this idea is part of every Western schoolchild's frame of reference. So it is not, after all, so difficult to understand why it should seem not only fashionable but necessary to discuss architecture as much in terms of space as of solid, to regard the awareness of space as a most important means towards the enjoyment of buildings and to place a high value on the special kind of architectural quality which derives from the designer's sure grasp of what he wants to do with space.

It is very proper that this special value should have emerged quite specifically as a canon of appreciation, if only because it corresponds to the facts of life. We have already seen that the architect's aesthetic activity does not begin with the decoration of buildings or their 'styling' according to a stereotyped code of symbols, but is inseparable from his practical, space-ordering function. If his grasp of this essential task is shaky from the start, or if in following through the design process he becomes carried away by an aesthetic intention

(fired, perhaps, by the excitement of a particular structural or decorative possibility) which runs counter to the functional conception, then he is likely to finish up with a muddled design. He must be either lucky or very skilful at camouflage if something of this muddle is not to reveal itself—even years later, and to an observer who knows little or nothing of the building's original purpose—in that indefinable defect called 'lack of conviction': the thing simply has the smell of indecision, deceit, or perverseness about it. Moreover architecture's aesthetic impact does not begin and end with the outside of the building. It is an art whose works are not only exhibited but inhabited, and one's capacity for tasting its delights is proportional to one's ability to exercise the imagination on the hints given by the treatment of space—not only through actual sizes and proportions of rooms but through the way this physical space is modulated into what we have called architectural space. So it is not wholly an exaggeration to say, as Bruno Zevi does, that 'to get hold of space, to know how to *see* it, is the key to the understanding of buildings'.[1]

Getting hold of space is easier for architects themselves than for laymen simply because they are used to handling the slippery impalpable stuff professionally and it *can* become as real to them as clay is to the sculptor. It is not a mysterious or magical talent, however, but simply the development by constant exercise of a faculty which, as was noticed before, we all possess already; and anyone who is prepared to give this faculty some training can soon develop his awareness of space to a level where it makes a noticeable contribution to his experience as an observer. For a start, develop the habit of being aware of the size of the room you are in: not simply thinking of it as biggish or smallish but noticing, for instance, how much freedom of movement there is in it, how much room you have above your head, what assistance the designer may have given by way of scale and rhythm—the scale of doors, windows, stairs, mantelpieces, the rhythms of pillars or panelling or openings—to help you fix it in your mind. Then look more closely at the shape of it and ask whether it suggests anything in particular, whether it makes you want to move in a particular way or take up a position at a particular point, whether it suggests a certain stiffness and formality or relaxed informality, whether it is clear, defined, and self-contained or indefinite and rather mysterious and thought-provoking. Then begin to consider how it

[1] *Saper Vedere l' Architettura* (Turin, 1948).

connects up to the spaces next to it or outside, how solid or pierced or transparent or translucent are the divisions between: in a word, how space-permeable is this complex of volumes which you are exploring. And, moving through them, make yourself aware of changes in volume, and in height, width, and level; feel yourself expand as you pass from a confined space to an enlarged one and shrink as you go back; obey in imagination the stage-directions it may be giving you.

In the process you will begin to make personal acquaintance with some at least of the many devices which have been used throughout the ages and in all countries for modulating (and especially enlarging) physical space by playing upon the perceptions and imagination of the observer. The properties of light are important; direct daylight is a great reminder of Outside, and the uses of reflected light as a softener—or even as in the case of the mirror, a solvent—of solidity are subtle and infinitely diverse. The shaping of the bounding surfaces may be important. Concave recesses, domes, semi-domes, and vaults can all give the sensation that interior space is pressing outward against its bounding skin, while flowing curvilinear shapes can lure the eye by their legato rhythms from one compartment or volume to another so that solid and void seem to melt together, and a pronounced alternation of concave and convex—that is of void pushing into solid and solid pushing into void—can produce that curious sensation of unreality, or at least of reality suspended, which accompanies the effort to take in two opposite ideas at the same time. Decoration, too, can subvert reality, as when in Byzantine mosaic or Baroque mural painting it suggests that one is penetrating in imagination through surfaces known to be solid—with results which may be either stimulating or disturbing. The sound-reflecting properties of hard and echo-producing surfaces (especially when concave) can be used to give audible reinforcement to the visual impression of spaciousness, and, conversely, sound-absorbent surfaces can reinforce an impression of intimacy or confinement. And, finally, the interaction of Inside and Outside is capable of infinite modulation, from the peep-hole window of the medieval castle, with its strong suggestion of withdrawnness, to the modern extreme of the fully glazed wall giving on to a cantilevered balcony.

Even this brief list will perhaps be sufficient to suggest the infinite variety of possible combinations of dimension, form, and light through which architecture can communicate by playing on our

responses to spatial suggestion alone. And when the observer attempts to analyse the specific combination which has given a particular building its character, he will find himself involved also in a dialogue between space and structure, for these two are inseparable partners and often argumentative partners as well. The enclosing or dividing function of structure inevitably puts some restriction on freedom of movement. The demand for the expansion of space, for unobstructed travel by the body or the eye, presses against the restrictions imposed by structure. The basic form of any building is arrived at by reconciling these factors, and stands as a record of the way in which the argument was settled in a particular case.

The appreciation of architecture is enormously enhanced by the ability to peruse such records acutely and knowledgeably and to pass judgement on them: it is an important, indeed a fundamental, kind of judgement, too, for whatever ravages time or alteration may have inflicted on the details, colour, or ornament of a building, the record of the settlement between space and structure will still be legible in its bones.

When he passes judgement on a settlement in law, a good judge will ask himself whether it is a just and appropriate solution—as opposed to a botched-up compromise—and whether its terms are clearly and accurately, perhaps even elegantly, set down. A document which excels in these respects will please him in a quasi-aesthetic way, as a 'beautiful proof' pleases a mathematician. Similar criteria apply in architecture to the appreciation of the settlement between space and structure, but we have to acknowledge to ourselves that we are passing judgement 'on the face of it', as the lawyer would say. The factual data on space requirements and structural possibilities in any given case are concealed from us, perhaps completely lost in history, and it is not intellect and calculation which have to guide us but a sensitivity—cultivated by practised observation—to the *feeling* of appropriateness and elegance.

It is easier, of course, to detect inappropriateness and inelegance than to distinguish between the finer shades of success. Where the case for space has been pushed too far against the counter-arguments of structure, we may well be absolved from judgement altogether by the collapse of the building; at least the cracks and distortions which appear on the record are more likely to be seen as disfigurements than as happy accidents. The opposite case—where a structural sledge-hammer has been used to crack a spatial nut—presents less obvious grounds for disapproval, but common sense and a sharp eye will take the observer quite a long way. Anyone is liable to find himself spontaneously using words like 'clumsy' and 'overdone' when he notices certain kinds of ill-adjusted arrangement—as for instance when a massive hammer-beam roof capable of spanning seventy feet is used to span ten—and this is a proper aesthetic judgement: it is a recognition that the building has been in some way *visually spoiled* by an inconsistency between the spatial intention and the structural intention.

We must beware, however, of translating this perfectly valid aesthetic criticism into the intellectual argument that, since space derives from function, we have to *know* how well the spatial arrangement suited its original purpose before we can pass judgement on it. Having already said that a detectable failure of function goes against

the very nature of architecture, we would seem to have committed ourselves to this view in advance and it is very often taken as a basis for appraising the buildings of our own time. Are we expected, then, to suspend judgement on the works of the past because we have no means of knowing how well they suited their occupants? Obviously not. And in fact there is no logical inconsistency here: we cannot re-create the total aesthetic experience which a building offered to its original users any more than we can relive their lives. It is the building's impact on *us* that matters to us, and a miscalculation of space which may have made the building a good deal less than perfect in the eyes of some far-off priest or king will not necessarily mean anything to us at all. We have to judge upon the record we see, and in fact the judgement will not be entirely stupid, despite the limited evidence. We can spot an obvious muddle, such as a feature which seems to suggest a halting-place or change of direction in a spatial progression which is clearly meant to be continuous; we can sense the indecision and lack of conviction conveyed by proportions which are neither one thing nor another; and we can detect a change of scale which is felt to be inconsistent with the direction the experience is taking. We are entitled, too, to give some benefit of the doubt to a building which has survived the passing of centuries, for the mere fact that it has escaped demolition may be some kind of tribute to its suitability for human use.

To these prima facie sources of judgement a scholar will naturally add a further set of references, for he is familiar with a wide range of solutions to similar spatial problems and can say, for instance, that this looks very neat, but Palladio did it even better at Il Redentore. The absence of such scholarly equipment should not be allowed to stand in the way of enjoyment—indeed, its presence only too often breeds a kind of architectural wine-snobbery, in which the identification of style counts for more than the pleasure of the senses—but there are times when illustrations from the past are of real assistance to judgement in the present. A short excursion into history, then, may be helpful to the understanding of the argumentative partnership between space and structure which is our concern in this chapter.

For such a study we could hardly take a better subject than the Christian cathedral as it evolved between the fourth and the sixteenth centuries. Not only was it a dominant building-type during much of that period—virtually setting the pace of architectural development in the Christian countries—but its own dominant characteristics are

traceable in every case to the pressure of an inordinate and persistent demand for space. There is every reason to believe, in fact, that the West owes much of its inventive and space-probing spirit to the peculiar spatial requirements of its religion. They are peculiar in that the Christian does not offer public sacrifices to a personified god, or make private oblations to the spirits of his ancestors, or worship an all-pervading spirit present in all natural things: in this his religion differs from most of those which have left their mark on architecture. The pagan temple was essentially a guarded enclosure for the safe keeping of the god's image and treasure or for the performance of rites by the limited circle of the god's attendants: 'Thus far and no further', is the message elegantly but firmly conveyed by the Parthenon's peristyle and *cella*, a fence surrounding a strongbox. The opposite extreme is represented by the Shinto shrines of Japan. Here the conception of man and nature as interrelated and infused with the same spirit finds its clearest expression in a two-dimensional notion of space in which the physical separation of Inside from Outside plays so little part that grass ropes and changes of ground-texture can play the role assigned in the West to solid walls. The Christian place of worship, however, is not a place of sacrifice in the pagan sense nor is it a garden of contemplation. It originated as a special kind of community house for a liturgical assembly: that is, an assembled company of co-religionists in which all members have a *leitourgia* or characteristic action to perform[1]—the priest to instruct and to administer the sacraments, the laity to respond in common prayer and to receive the sacraments. Once Constantine had legitimized the faith, buildings of some considerable size were needed to accommodate such assemblies and to demonstrate the prestige of the new State religion; and they also had a symbolic function to perform which was to have lasting effects on architecture. The Christian saw the natural world merely as a staging-post on his road to a heavenly home, and the church building itself came to be seen as having its own specific *leitourgia* in the communal worship—that of directing the eyes and minds of the worshipper away from the mundane and towards the celestial.[2]

[1] H. B. Green in *Towards a Church Architecture*, ed. Hammond (1962).

[2] 'A church should', as the *doyen* of Fecamp Abbey once told Sir Ninian Comper that his church did, '"pray of itself" and indeed preach of itself... should have something to say not only to the worshipper but to the unconverted person with eyes to see.' (Green, op. cit.)

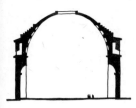

Fig. 28

To meet these requirements the early Christian Romans used certain structural techniques which had served the pagan Romans excellently in the past. This hard-headed, effective, and overbearing people had diffused all over their empire a hard-headed, effective, and overbearing style of architecture, which owed much of its imperious quality to their mastery of the semi-circular arch, the barrel-vault, and the dome. These are all methods of putting together small building-units—such as bricks—in order to span wide spaces, and they are all forms which demand some means of counteracting outward thrust as well as carrying vertical load. The Romans habitually neutralized such thrusts by simple massiveness, as the section through the 145-foot width of the Pantheon (Fig. 28) clearly shows, and this unsophisticated and heavy technique was entirely logical in their situation. A slave-owning empire had no particular motive for economizing on labour or material and the symbolic value of overpowering mass was, if anything, an asset to emperors who ruled by military might.

After Constantine it was the eastern part of the empire which became the seat of power and so naturally it was there that the Christian architects exploited most fully the technical resources which they had inherited, and especially the space-enlarging properties of the dome. Combining as it does the stillness and completeness of the circle with the explosive quality of the hemisphere, the dome is not only a dramatic shape in itself but one whose innate symbolism of the 'vault of heaven' was admirably suited to the church building's *leitourgia*. However, it presented the Byzantine architects with a double conflict between space and structure. The geometrical logic of the dome demanded a circular plan whereas the functional logic of congregational worship demanded a rectangular plan, and moreover the massive solidity of Roman construction obtruded itself on the eye in a manner which was anything but unworldly. They settled both these difficulties in one move by the adoption of the pendentive, a downward extension of the dome to fill in the corners of the square beneath it (Fig. 29), and this settlement, born of Greek ingenuity and Roman engineering competence, produced enormous aesthetic and practical benefits. Structurally, the weight of the dome was brought lower and so required less thickness in the masonry which supported it, while at the same time the leverage of its outward thrust was reduced. What remained of the thrust could be resisted quite easily by semi-domes and vaults at a lower level and could eventually be brought to earth *through the internal dividing walls of the building.*

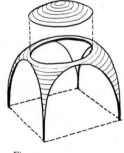

Fig. 29

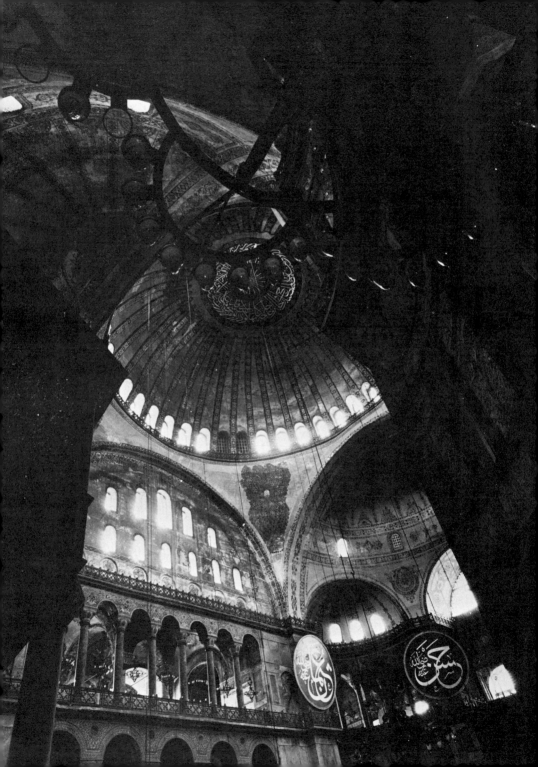

Aesthetically, the progression in scale from the lower abutments through the semi-domes to the main cupola gave the exterior a kind of inevitable majesty, while the interior achieved almost automatically a most singular spatial quality by which the emphatic masses of Roman imperial construction seem to be literally spirited away.

It is in the great cathedral of The Holy Wisdom[1] (Hagia Sophia) built by Justinian in the sixth century that one can best study this quality and appreciate the seeming inevitability with which—as in all really great architecture—it seems to grow out of the very nature of the settlement between space and structure. By the device of the pendentives the great dome of 100 foot span almost seems poised on four points dominating the whole interior, while beyond it the subsidiary spaces formed by the semi-domes not only extend the vision outwards but provide an unobstructed space 235 feet in length along the main processional axis. Through all these spaces and galleries the eye is led by the play of curved surfaces intersecting in curved lines, so that thickness—except where staccato rhythms of arcading pierce the walls—is almost dematerialized: and all these curves are not mere decoration but structural, load-bearing form. The major forces upon the structure are not felt to be acting squarely or solidly downwards, but rather to be flowing through the lines of vault and arch; and the vertical faces thus relieved of imposed load are pierced through with lightly carried arcadings which reduce solidity still further. Nor does this piercing stop at the walls. All round the periphery of the great dome daylight is allowed to shine between its ribs, and at the bottom end of the scale the very capitals of the arcade-columns are cut and drilled into a kind of lace-work.

The whole statement is so majestic in its scale and consistency as to be unchallengeable, even if it had been thinkable for any provincial church to invite comparison with the spiritual seat of the Apostolic Emperor himself. Consequently the subsequent church buildings of the Eastern communion represent, in effect, variations on the great Byzantine settlement rather than new steps in a 'broadening down

Hagia Sophia, Istanbul: the dome and semi-domes.
Photo: Kidder Smith

[1] I have made a point of translating the name of this church (commonly called Sancta Sophia in the West) because it is relevant to a full understanding of its architecture. In the view of P. A. Michelis, *L'Esthétique d'Haghia-Sophia* (Faenza, 1963), its whole spatial and structural rationale is a response to the challenge to create a building worthy of consecration not to any mediating saint but to the Wisdom of God itself—a challenge to 'embody the infinite within the finite' by making space predominate over mass.

from precedent to precedent'. The story of the Western church is very different indeed for its architects were the poor relations of Byzantium, inheriting Roman tradition without Roman power and occupying a crumbling stub-end of empire whose technical resources were dwindling with the breaking up of its economy. We find them, therefore, building on the much simpler precedent of the *basilica*,[1] which was essentially a timber-roofed, oblong hall whose width— limited above by the stringencies of timber construction—was eked out below by side aisles separately roofed and connected to the body of the church by open arcading (Fig. 30). The difficult and expensive work of vaulting was confined to a semicircular apse at the east end, and the slim columns of the arcading were commonly salvaged from the abandoned and ruinous monuments of the empire.

It is strange to think that it was out of this patched-up solution that the aesthetic and structural miracles of the medieval Western cathedrals were to emerge, but this is in fact what happened. Throughout the centuries which we call the Dark Ages the Roman church had to carry out a holding operation, Christianizing wave after wave of pagan invaders and preserving whatever it could of Roman secular learning and practice amidst the rise and fall of half-barbarian dynasties. Among the salvage was the basilican plan, still in its essentials the timber-roofed hall with its side aisles and apse (now being enlarged into a chancel) and its arcaded wall between nave and aisles. It was changing already into the familiar cross-shape, however, the transepts providing a method of enlarging usable space without either widening the roof-span or inordinately lengthening the nave. In place of classical columns thick cylindrical stone piers carried the arcading. The craft of stonemasonry had been kept alive and slowly developed, but it was still unscientific craftsmanship relying on thickness of material to provide strength. The elements of vaulting, however, had been preserved or re-learnt, and stone-vaulted aisles—the outward thrust being taken by the thick outer walls and massive internal piers—began to be used in addition to the vaulted apse.

Fig. 30

[1] *Basilica* was the Roman name for a large public hall subdivided internally by a colonnade. The term came to be applied to the halls erected by the early Christians for public worship, although, as Nikolaus Pevsner has shown in *An Outline of European Architecture* (Harmondsworth, 1962), the form of these early churches was probably derived from the Mithraic temple of the period rather than copied from the secular building.

The next step forward[1] was to vault the nave roof, but this was a much more hazardous operation since it meant supporting masses of heavy material at considerable heights and dealing with thrust by some less primitive and wasteful method than thickening out the whole wall. When they finally tackled the problem the Romanesque builders wisely fought shy of the continuous barrel-vault; instead they divided up the length of the nave roof into sections (corresponding with the bays of the arcading below) by transverse arches whose thrust was taken by concealed buttresses within the aisle roofs. In doing so they made a small but significant change in the spatial emphasis of the interior; for by thickening out the wall and the arcading pier below it to carry each transverse arch, they superimposed a strong vertical pattern upon the horizontally running basilican nave. A vertical emphasis—stressing the lofty and spiritual, the ascent of the soul, as against the earth-bound horizontal—was most apt to the building's symbolic purpose, and the emphasis was strengthened still further when the groined vault succeeded the simple barrel. A groined (or intersecting) vault is formed by crossing two equal sections of barrel-vault at right angles so that the load is concentrated at four points instead of being distributed over the side walls. Consequently the wall surface can extend upward between the points of support and, being relieved of weight, can be liberally pierced by windows.

This vault in its simplest form had already been used for crypts and relatively low aisles. To make it practicable for the kind of lofty construction to which the church builder was now committed its dead weight had to be reduced, and this was eventually achieved by treating the diagonal intersections as arches in their own right and filling in between these ribs with a slight shell of masonry. All this demanded more precise craftmanship and geometrical skill than the earlier Romanesque builders could command; but as the skills developed by trial and error, practice and example, they suggested still further possibilities. The semicircular Roman arch was still the universal form all over Christian Europe; and if the cross-section of a vault is semicircular its diagonal rib must necessarily be flatter (and thus weaker) than a semicircle, unless one adopts the safer but aesthetically untidy device of starting it at a lower level than its neighbours. Somewhere about the middle of the twelfth century the idea dawned that

[1] Forward, that is, in the direction of an ideal of absolute and symbolic permanence. To describe the change from timber to stone simply as a fire-precaution (as is sometimes done) is to over-simplify the motivation of the medieval builders.

this problem could be solved by using a pointed instead of a semi-circular arch for the diagonal and that if pointed arches were used on *all* sides, the vaulting-bay could as easily be made oblong as square.

Like the Byzantine pendentive, the pointed, ribbed vault released a great potential of aesthetic expression. Multiplied in number as techniques advanced, and carried down from roof to floor as attachments to the piers of the main arcading, the ribs convey a feeling of dramatically concentrated force; the solids between them seem (and are) less weighty; and the counterpoint of vertical and horizontal emphases is made still tenser by the gathering together of vertical lines at the apex of the roof. The physical progression from the entrance towards the altar—stepped out by the horizontal rhythm of the arcading—is matched by a symbolic upward sweep of the vision towards heaven.

Now remarkable things began to happen. The urge towards towering verticality, now that masonry techniques promised to satisfy it, became obsessive: by the beginning of the fourteenth century the nave of Amiens was to stand at 140 feet and Beauvais even higher. The oblong vault made it possible to reduce the number of supports for a given roof area, and the finer cutting and jointing of stone enabled the mass of the supporting piers themselves to be reduced without loss of strength. The solid walling between supports was becoming irrelevant from the structural point of view and almost as irrelevant from the protective point of view. Once the last Viking raiders had been Christianized the northern churches could begin to shed the fortress character which they had worn in the days of the invasions; furthermore glass, although still a costly luxury, was no longer the rarity it had been. All that was necessary for the establishment of a revolutionary aesthetic of spatial expression was a means of safely countering the thrust of an immensely high and delicately poised vault without resorting to excessive mass.

As we have seen, this challenge of thrust had confronted the medieval masons at every stage of their long progression from an architecture of great mass and little space towards an architecture of great space and little mass. At each stage they had advanced their technology to meet the challenge and now with great daring they advanced it again. In its baldest essence their problem was to organize the outward- and downward-acting forces into a triangle wide enough at the base to stabilize the effect of the height (Fig. 31). They could, of course, have done this by forming prodigiously deep buttresses in

Fig. 31

92

solid construction, but they had already progressed far beyond the stage of considering such heavy-handed methods. Instead they chose to carry up *only* the buttresses along the perimeter of the aisles, building them as great pinnacles far distant from the nave walls, transferring the thrusts to them by the aptly named 'flying buttresses' (Fig. 32) which leaped at an incline over the intervening space, avoiding top-heaviness by reducing the depth of the buttress at each upward step as the loads diminished. Here we have the most complete contrast with the self-contained construction of the Byzantines, and the discreetly concealed thrust-transferring mechanism of the Romanesque builders. The High Gothic cathedral wears its skeleton outside its clothes, like a permanent system of shoring and scaffolding carried out in stone. All the forces acting upon the structure were now channelled into relatively slim compression-members, so that the enclosing walls could become more and more a glass-filled lacework of pointed arches and slender tracery, and the effect was the more staggering since the stabilizing external framework was virtually invisible from inside.

The contrast with the Byzantine ideal is fascinating; for both are the result of the single-minded pursuit of structural logic towards essentially similar functional objectives, both achieve in a high degree the objective of spiritualizing space and etherealizing structure, and yet the results are so completely different. Where the Byzantine is an architecture of smooth planes, the Gothic presents a network of ribs; and where the Byzantine seeks to suppress the weighty associations of vertical load, the Gothic accepts and exalts verticality and so deals with it—by sweeping the eye irresistibly upwards along its ascending lines and catching it up dizzily into the network of the vault far above —that one is more conscious of the physical upward movement that takes it in than of the actual downward pressure of the loads upon their supports. This is an architecture which is highly charged in the most literal sense of the word and one which has so outgrown its simple origins that they are almost unrecognizable. The grave and statuesque masses of the Romanesque have been exchanged for the aesthetic tensions of an architecture in which a particular and transcendental kind of 'urge to space' has pushed the possibilities of masonry technique as far as they will go: and the austere and static simplicity of the basilican plan is almost submerged in the richly wrought and delicately balanced combination of spatial and sculptural complexity.

Fig. 32

93

In its last flourish the Gothic in fact kicked away completely the basilican base from which it had climbed, and the reason for the change was rooted in the functional use of space. The great cathedrals, with their extended naves and their multiplicity of side-chapels tucked away among the buttresses, were splendid symbols of the Church Triumphant's all-embracing authority, as well as of the heavenward aspiration of the soul. The long, parallel tunnels of nave and aisles are perfectly suited to great ceremonial processions and the complexity of internal volumes lends magnificence even to the simplest kind of choral music by prolonging each note and throwing back its reflection to reinforce the others so that the building almost seems to be singing with the choir. These are not, however, the characteristics of an efficient preaching-machine, and with the rise of the 'preaching orders' of friars[1] we find the Church making a last and different spatial demand upon the Gothic architects: wide, undifferentiated space to accommodate a large and attentive congregation listening, not to a sonorous Latin chant, but to the expounding of the Gospels in the vernacular tongue. And so function came to dictate the final abandonment of the basilican plan—by which one must understand a tall, dominant, and directional nave flanked by lower directional aisles—in favour of 'one spatial unity with piers (often round or polygonal) merely subdividing it'.[2] Hence we find, as this new and entirely logical fashion established itself, that the difference in height between aisle and nave disappears—in some cases the aisle disappears altogether—and the whole roof takes on the character of a single great ceiling into which the piers rise and spread their ribbing in all directions like the interlaced branches of an avenue of trees. The English fan-vault, as in King's College Chapel, Cambridge (p. 61) or Henry VII's Chapel at Westminster Abbey, represents this movement carried to its ultimate conclusion: instead of being distinct structural members separate from the thin infilling between them and differentiated in thickness according to the loading and span of each, the ribs are now cut out of the same stones as the web between, acting as closely set stiffeners to a web of interlocking masonry rather than as supports to separate segments of infilling. No more exacting call could have been made on the craftsmanship of the stonemason, or on

[1] These orders were founded in the early thirteenth century and their effect on architecture became marked, according to Pevsner, from the early fourteenth century onwards.

[2] Pevsner, *An Outline of European Architecture* (1962).

his geometrical skill and his intuitive grasp of the play of forces. In these extraordinary shells, which almost seem suspended from the sky rather than supported from the ground, ingenuity in spanning space by highly compressed masonry was stretched to its limit and could go no further.

Nor was it called on to do so. By the time the fan-vaults were being built in the north the architectural forms of ancient Rome were already being revived and developed by the architects of Renaissance Italy and were soon to sweep north, carrying all before them as the only proper expression of power and civilization. As we have seen, this was anything but an architecture of minimum weight—its whole character ran counter to the ideal of extreme structural economy—and it reconciled load, span, and support by techniques which must have seemed childishly simple to the medieval master-masons. It was the exploration of spatial possibilities *within* the limits of these techniques—that is, of carving space out of solid—that was to absorb the architects of the next three centuries, and so deeply ingrained did this habit of mind become that the long Gothic struggle to transcend the limits of structure soon seemed positively indecent. We find in fact that even when it was 'revived' in the nineteenth century Gothic architecture was esteemed for almost every quality except its essential one: for the aptness of its sculptural decoration, for the symbolism of its heavenward-reaching lines, for the 'picturesqueness' of its buttresses and pinnacles, for its historical associations with the Age of Faith.

Yet even the rough summary I have just given should be enough to show the fallacy of looking at medieval architecture in these terms. To see a Romanesque or Gothic building clearly and with complete understanding one has to look beyond the detail—magnificent though it often is—and appreciate the nature of the inner discipline which governs the whole conception. It is not an academic discipline imposed by external theories of correctness and rules of beauty, of the kind which the Romans had accepted and the Renaissance was to revive, but a discipline of structure, imposed by the nature of the materials used and thus presenting a constant challenge to the imagination and ambition of highly intelligent craftsmen. It is the craftsman's urge to show off his skill by extracting the utmost out of the materials at hand which characterizes all medieval buildings, reaching its ultimate expression in the highest flights of High and Late Gothic, where the builders were not only the craft-aristocrats

of their day but the inheritors of skills developed and perfected over almost a thousand years.

The Late Gothic, in fact, represents not only the final flowering of those skills but the last point in architectural history at which the argument between space and structure could be settled—and the appropriateness of its settlement judged—in these terms of craft skill rising to meet a transcendental vision of space. With the coming of the Renaissance the terms of reference changed completely, and there began an age of academic architecture in which the manner of the settlement was dictated to the craftsman, not evolved by him.

From the Renaissance onwards the person who dictated the nature of the settlement between space and structure was a different kind of specialist, now given the specific title of 'architect',[1] whose rules of design were not founded on the craft-lore of the builder but deduced from the study of the buildings of antiquity, and whose principal expertise lay in reconciling the demand for space with the massiveness of structure inherent in these rules. This was essentially the field of a specialist in aesthetics rather than an expert in structural economy and masonry-stresses. It was indeed the first time that these two skills had been separated, and it is significant that even the spatial drama which so often characterizes the Baroque was not obtained by exciting technical methods of reducing *structural* mass but by aesthetic devices (some of which we noted earlier) which kept the structural proprieties intact. During the centuries in which the spell of 'the antique' lay upon Europe and spread to the Atlantic seaboard of the Americas the argument between space and structure was, in general, reduced to a cool and gentlemanly debate, conducted according to well-understood rules of procedure and brought to an equitable and clearly defined conclusion. It is not merely sentimental nostalgia which finds a mellow Augustan 'stylishness' in the architecture and furniture of Georgian England and colonial America, or a sophisti-cated charm in the frivolities of French and German Rococo. They are real qualities, reflecting the relaxed touch of designers working well within the limits of possibility, just as the dynamic quality of High Gothic reflects the tension of designers who were probing the limits of structural technique.

This relaxed attitude was not to survive very far into the nineteenth century. Among the consequences of the industrial revolution was an unprecedented and rapid change in the three factors whose inter-action we have seen to be a powerful determinant of the architectural aesthetic of any society—the physical pressure for space, the psycho-

[1] The word makes its first recorded appearance in English in 1563. Its immediate ancestor *architectus* meant different things in different contexts: the Renaissance now restored its Aristotelian connotation of the man whose authority derived specifically from his possession of a body of theoretical knowledge rather than from empirical method.

logical attitude to space, and the structural options which are open—and this change could not but shake the placid assumptions on which eighteenth-century urbanity rested. Architecture might reasonably have been expected to cast off, with corresponding speed, the stylistic restrictions of the masonry tradition and give birth to a revolutionary aesthetic related to the new needs and aspirations of its time and drawing on the resources of iron and glass which the engineers were already exploiting for their own early adventures in the spanning and enclosing of great spaces.

In fact, the opposite happened. The architects certainly seized upon the advantages of the iron column and girder as a means of reducing internal obstruction, and often handled them with great skill (as the interiors of the best Victorian museums and libraries bear witness), but for the exteriors they borrowed from all the historical styles which the rising tide of book production—itself a phenomenon of the times—washed up on their drawing-boards. This was a wholly new turn of events. The classical builders had, in a sense, set back the clock by their reversion to the Roman philosophy of construction, but they had accepted the logic of that philosophy for interior and exterior alike. Now we find a situation in which the inside may consist of slim and highly stressed iron members, often carried up into latticed arches and glazed cupolas of great delicacy, while the outer walls of solid masonry reflects nothing at all of this ingenious internal economy.

It was a dichotomy which worried the more thoughtful architects of the day a great deal, as we can see both from their writings and from their attempts to give ironwork—cast ironwork especially—an 'architectural character' which might paper over the gap, and the modern observer (if he is not too puritanical about the naughtiness of putting Venetian Gothic flesh upon a cast-iron skeleton) can find a peculiar and rather grisly delight in their attempts to extricate themselves from an impossible situation. The impossibility lay in the fact that an appropriate settlement between space and structure is central to the whole activity of design, and the architect who attempts to effect it in two different languages simultaneously—the language of iron and the language of load-bearing masonry—is rather like a lawyer trying to frame a settlement in terms of two quite different legal codes and to express it in a mixture of two languages: it may work, but it is difficult to make convincing. It took the best part of a century to resolve this dilemma in the only way in which it could be

rcsolved—by a fundamental change of attitude. The inexorable pressure of the urge to space eventually forced a mode of settlement worked out from start to finish in terms consistent with a non-masonry language.

To be strictly accurate it should be noted that the pace was forced by the pressure of new *ideas* about space rather than a physical need for more unobstructed floor area. Aesthetic advance is never the automatic response to needs or techniques, but the outcome of ideas which demand expression. The ideas which eventually brought about the architectural revolution sprang from new ways of looking at the functional relationships of interior space and at the whole relationship of Inside and Outside. They are expressed architecturally in characteristics which no longer strike us as experimental or outlandish: the transparent external wall which reduces the boundary almost to invisibility; the interleaving of free air and occupied space, uninterrupted by vertical support, which is made possible by the cantilever (p. 100); an openness and informality of planning reflected externally in the apparently casual juxtaposition of masses. Nevertheless we can appreciate the essentials of modern architecture rather more readily if we have some understanding of the psychological break-though which was necessary before such architecture could be readily accepted as part of the urban scene.

For to be fair to the much-maligned Victorians, it must be remembered that when they fought shy of the new spatial experiences which their technology offered—such as the merging of Inside and Outside by the transparent wall or the suspension-in-space trick of the cantilever—it was not out of simple obtuseness or perversity. They had first of all to *learn to look for such an experience*, to be aware that the experience existed and that it—literally—made sense to explore it. It was their misfortune to have their vision obscured by the historical conception of masonry architecture as the very symbol of permanence and authority, and to live in an age when the whole apparatus of traditional authority was creaking under the strain and flux of profound changes in society, so that the power-owning classes who were architecture's natural patrons needed such symbols very badly. Solidity, substance, and historical respectability were the qualities which they expected in 'proper' architecture. Before their imaginations and their bank-balances could be opened to a radically new aesthetic of lightness and transparency the pattern of expectation had to be radically altered, and for this certain conditions had to be

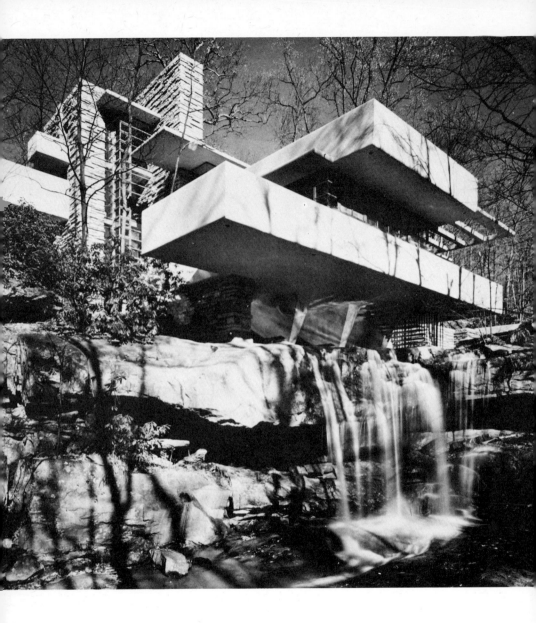

fulfilled. Unfamiliar views of space had to become familiar enough to serve as references in the cognitive process; the symbols of the old order had to lose some of their potency; and power had to pass from the old patrons whose interest was vested in the past to new patrons with a vested interest in the future.

As to the first condition, the Victorian age built up fairly rapidly, and largely through the demands made on the engineer, a stock of buildings whose function demanded skeletal or light-permeable structures with an urgency which no attachment to historical precedent could obscure. By accepting and assimilating the great glass-houses of their botanical gardens, exhibition halls like the Crystal Palace and the Paris Halle des Machines, and above all the great, glass-roofed enclosures of the railway age, architects and their patrons were gradually acquiring the taste for transparency and becoming reconciled to the naked and unashamed logic of structure. From the other arts—especially after 1858, when the art of Japan became accessible by the West—they were picking up a new outlook towards *depicted* space and towards light. By the second decade of the present century the traditional media of visual communication had been joined by the cinema, whose inherent capacity for superimposing and dissolving images and generally playing games with space and time has made incalculable additions to the ordinary man's store of visual experience. And finally man became an air-borne animal, a point in history after which no conception of space and movement could ever be quite the same again.

Concurrently the second condition was being fulfilled as the 'absolute' authorities of the past were increasingly called in question, notably by evolutionary biologists and political economists. To begin seeing the church, the court, and the bank as human institutions whose survival depends on adaptability to change is to begin doubting the relevance of architectural stereotypes which represent them as immutable and stress the sanctity of their historical roots: and so, after about the middle of the nineteenth century, the imagination of the designers can be seen slowly but inevitably freeing itself from historical idioms which had nourished it in the past and now did so no longer. The process was violently accelerated by the First World War, for this prodigious convulsion of civilization not only toppled the absolute monarchies, which had for centuries supplied even America with the symbols of power and permanence, but cracked in all directions the formal and time-sanctified fabric of social

House at Bear Run, Pa., by Frank Lloyd Wright. *Photo: USIS*

convention. After 1918 no revolution, whether in politics, morals, dress, or architecture, could ever be considered impossible, no institution inviolable, nor any symbol of authority perpetually valid.

The third condition became capable of realization as a greater share of economic and political power gradually passed from the inheritors of land to the capitalists who managed the new structure of industry. By the first decade of the twentieth century some of them at least—the patrons of Louis Sullivan[1] and Frank Lloyd Wright[1] in the USA, Charles Rennie Mackintosh[1] in Scotland, Antoni Gaudi in Catalonia, and Walter Gropius[1] in Germany, for instance—had achieved a self-confidence which could dispense with the handed-down architectural uniforms of Baroque princes or Roman emperors. But still more important—and especially after 1918—the elected representatives of the people began to emerge as major customers of the building industry. In a minor and strictly practical way they had already taken up a stake in space and light through the public health legislation by which the Victorians sought to mitigate the worst horrors of the 'insensate industrial town',[2] and now they began to play a rather different part, becoming sponsors of architecture rather than mere legislators upon it. Their sponsorship was not invariably enlightened —indeed often the reverse—but it had two especially important effects. By the simple fact of their existence these public patrons focused attention on the architect's duty to serve the community at large; and as custodians of public money they added their voice to that of the industrialist in rating the effective use of floor area higher than the prestige value of architecture as symbolic macro-sculpture. In this climate of social responsibility it was at last possible for the architect to assess the building-task as objectively as the engineer had approached his own function a century earlier, placing the efficient planning and adequate lighting of *usable* space high on his scale of priorities and exploiting aesthetically the structural techniques appropriate to the functional solution.

By 1930, then, the three conditions had been sufficiently met, in most of Europe and America at least, for a new way of building not only to be acceptable to pioneer architects and their advanced patrons but also to arouse the interest of the educated man-in-the-street. This architecture was characterized, broadly speaking, by emphasis on

[1] See Biographical Note. [2] Lewis Mumford, *The Culture of Cities* (1938).

respect for function as against monumentality, on lightness as against mass; by the 'open planning' of internal areas as against the compartmentation imposed by load-bearing masonry partitions; by wide horizontal belts of window and often, in domestic work, by a visual knitting together of Inside and Outside by means of devices such as the corner-window and the glass wall. It was—and is—characterized also by the fact that its numerous variant forms are too diverse to be classed together as a single 'style', even in the broadest meaning of that word, and this often makes it difficult for the lay observer to form, or to trust, his own judgement of them. 'Style' in the old sense of a familiar and accepted common factor uniting the artefacts of a particular culture is an undoubted help to recognition, for it carries the critic several steps forward: having made this identification in broad terms—as for instance 'Louis XV' or 'Samian ware'—he can proceed to assess the individual merits of an object as an example of a type. This kind of classification is relevant enough to the act of aesthetic appreciation when the style derives from restrictions imposed by available materials: it helps one to appreciate the part played by the craftsman's sense of appropriateness. It helps also in the appreciation of the rather different skill of the designer who works within artificial conventions imposed by religious symbolism or social demand. For example, in adopting the architectural vocabulary of ancient Rome the classicists were providing their patrons with very desirable status symbols associated with the most powerful empire the West could remember, and this is not irrelevant to our judgement of their approach to architecture.

Nevertheless, preconceived notions of 'style' in this sense are liable to be a hindrance rather than a help in coming to terms with the buildings of our own very different age, and the observer of architecture must guard against the temptation to erect a mental image of a 'modern style' to which the buildings of our time can be expected to conform. If he does, many of them will disappoint him and many real pleasures will escape him. No stylistic generalization—even in such rough-and-ready terms as 'an architecture of glass boxes' or 'an architecture of weird shapes'—could embrace both Mies's[1] Farnsworth house and Le Corbusier's chapel at Ronchamp. For an even clearer illustration consider Frank Lloyd Wright's house at Bear Run and his Johnson Wax Company building at Racine, Wisconsin.

[1] See Biographical Note.

Pilgrimage Chapel, Ronchamp, by Le Corbusier: exterior. *Photo: AFS Wright*

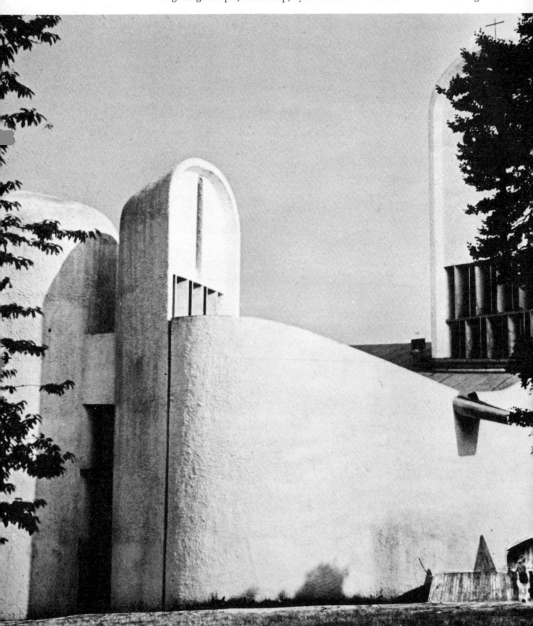

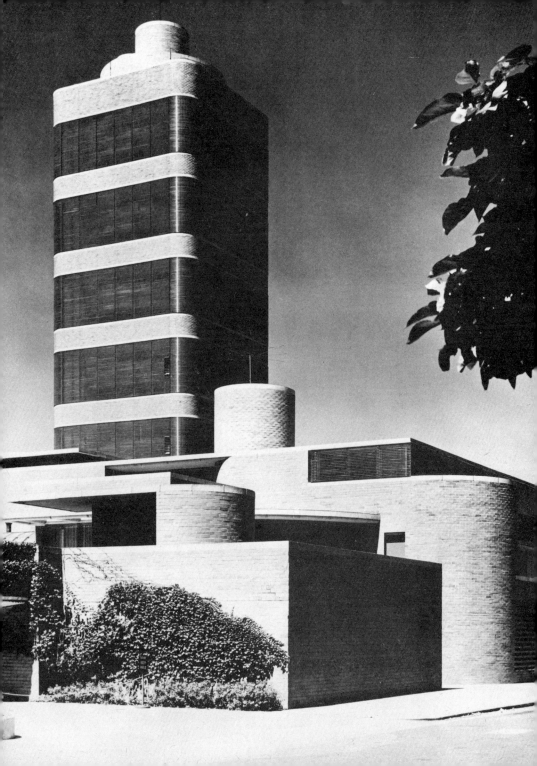

Wright was indisputably the first modern master of the art of integrating interior and exterior space, and both these buildings demonstrate his mastery of the structural means of doing so: in the first by the interleaving effect of cantilevering solids over voids in free air and in the second by cantilevering each storey out from a central supporting core and wrapping bands of glass round the non-load-bearing exterior. In spite of the consistency of his aims and methods, any attempt to find *superficial* resemblances between the two—to class them analogously, as a biologist would say—or to find a stylistic pigeon-hole into which they could happily fit with either of the previous examples is bound to be defeated. The common thread which runs through modern architecture is the thread of ideas about the relationship of space and structure and its essence is not to be summed up in terms of any single way of building. The characteristic which unites these very diverse buildings, and all others which we think of as modern, is that the occupants' freedom to move, to see and be seen, is not disciplined by aesthetic preconceptions about style or by technical limitations of natural materials but *can dictate completely the form of the structure*.[1]

Space is therefore, for the first time in history, entirely at the disposal of the building-task. This fact obliges us, if we are to appreciate the architecture of the present and the future, to modify the whole framework of expectations which has been built up through exposure to the familiar architecture of the past, whose characteristic modes of expression have been founded on the exploitation of a limited range of structural possibilities. This mental adjustment is certainly easier for us than for our grandfathers, for we are familiar—as they were not—with the aesthetic possibilities of skeletal and continuous structures and we are no longer disposed to see the time-honoured masonry styles as the be-all and end-all of 'proper architecture'. Nevertheless the adjustment is not made without a certain effort, for it calls for the cultivation of various basic faculties which Western

[1] Within the space available here it is impossible to give more than the slightest sketch of the history of twentieth-century architecture and the reader will, I hope, want to find out a great deal more. Jurgen Joedicke's *A History of Modern Architecture* (trans. Palmes, 1959) will give him a particularly well illustrated account of the subject, and Nikolaus Pevsner's *Pioneers of Modern Design* (Harmondsworth, 1960) relates the developments in architecture to the parallel movements in the allied arts. If he wishes to explore its ideological history, which is a fascinating study in itself, he should try Peter Collins's *Changing Ideals in Modern Architecture* and Reyner Banham's *Theory and Design in the First Machine Age* (1960).

education (to our great loss) has tended to suppress by its traditional emphasis on words and numbers: the awareness of space *as* space and the ability to pick up the hints or commands to movement which it can make; the ability to see and feel a shape *as* a shape, not just to classify it as 'a typical Greek Doric capital'; the ability to sense a rhythm *as* a rhythm and not simply as 'a typical Georgian window-pattern'.

This kind of awareness is especially necessary for the appreciation of modern work, which will continue to meet new needs with new techniques and thus to make statements about the relationship of space and structure which have never been made before, expressing them in a language of form which offers no short-cuts to cognition through historical associations. But it also promotes a deeper understanding and enjoyment of the architecture of the past, for all architecture is, in the last analysis, a statement of the space–structure relationship, made eloquent by the designer's ability to play with the language of his art rather than merely use it. We have already seen how he can play with space, rhythm, size, and weight—the syntax of the language, as it were—and now we must look at the subtler overtones which can be added by the play of shape, light, colour, and texture.

Buildings are shapes, and all the individual parts which make them up have shapes of their own. Before dismissing this as a statement of the obvious, ask yourself whether you have so distinct an idea of the shape of your house, or of its front-door handle, or of the chair you are now sitting in, that you could give anyone a clear and recognizable description of it. Mostly we manage with a rough mental summary of the shapes of things we see, taking them as read and cataloguing them mentally under broad generic headings like 'church with spire' or 'knob handle'. As we saw earlier, the enjoyment of architecture depends on *not* taking such things as read: hence the importance of developing a positive interest in form for its own sake.

We can start by noticing the occasions on which we do find ourselves taking such an interest. As with so many of the matters we have already explored, the consciousness of shape becomes most acute when some question of self-preservation is involved: the shape of rocks is much more immediately interesting to the climber on the cliff-face than to the picnic party on the beach below. At a rather lower level of urgency, we become aware of shape in a critical way when there is some obvious discrepancy between form and function, or between the form we see and the form which function led us to expect. To say: 'That's a damn silly shape for a corkscrew' probably reflects irritation at something which is uncomfortable to use, whereas to say: 'That's a funny shape for a church' merely reflects a certain distrust of an unfamiliar shape given to a familiar kind of building. Both kinds of criticism obviously play a considerable part in the appreciation of architecture, since apart from the all-embracing function of the building itself, most of its parts, from the roof down to the doorknobs, have a practical use. We shall return to this later: for the moment it is enough to note that making a judgement of this kind presupposes that we have noticed the *nature* of the shape itself because something in our background of everyday experience has prompted us to do so.

Below this level again, we enter a zone of interest in which shape attracts attention because one has an interest in things *of a particular kind*. Small children of the motor age are remarkably quick to detect —even at a considerable distance—the differences in shape which

distinguish one make of car from another because it is a point of pride to be able to put a name to them, and we have already noticed elsewhere the peculiarly detailed attention we pay to the shapes of our fellow-humans, especially when they are young and attractive. It is a reasonable bet that if you are already interested enough in architecture to be reading this book, your ability to take in shape is already improved simply by the existence of that particular interest, and the next step is to acquire the habit of looking out for the communications shape can make and being prepared to respond to them.

This is a matter of exercising two senses; for, unlike colour, which is purely a matter for the eye, the perception of shape involves touch as well as sight. In the process of getting a new shape fixed in the mind we make a guess at what it would feel like to the touch, and the guess is based on the comparative properties of all the things we *have* touched, or which have touched us, in the course of our lives. We know what a jagged rock will feel like before we put a hand on it and its shape, as apprehended visually, conveys associations quite different from those of a rounded boulder. We may even read similar tactile associations into the shapes of things which we do not expect to handle at all, as when we speak of the 'soft' contours of the Sussex Downs.

Obviously, the tactile associations of shape are particularly relevant to the three-dimensional arts of sculpture and architecture (whose products are, after all, capable of giving some sensual pleasure even to a blind man) and the experience is in fact incomplete if the sense of touch is *not* physically brought to bear on them. We have very little scientific understanding of the ways in which the two senses collaborate (although sculptors in particular obviously have an intuitive knowledge of them) beyond the fact that the associations evoked by a particular shape are dredged up in some very complicated way out of different sections of the memory-bank and in the process are compounded into one impression to which we may react with pleasure or otherwise. We can distinguish, however, certain *kinds* of association which seem to work together to give a form to its character.

Many of these go very deep indeed, for in responding to certain kinds of shape we are dipping down (as with the associations of gravity) into memory-layers deposited in very early childhood. We tend, for instance, to find smooth, rounded shapes more inviting—in the sense that they call upon us to touch them and make their closer acquaintance—than angular, jagged shapes which declare their nature

quite clearly at the first glance and in a way which asks us to stand clear. Sharp edges cut, sharp points jab, rough surfaces take the skin off. We are lucky if we are not carrying in middle age the scars of these early discoveries, and they leave scars on the memory as well. Consequently the opposed associations of 'soft' or rounded forms and 'hard' or angular forms are highly suggestive, a fact well known to advertising designers whose trade brings them into contact with regions of the subconscious in which architects hardly dare to tread. It hardly needs saying, for instance, that the first type-face in Fig. 33 is more likely to sell soft toys or babies' nightwear than the second.

Our early years provided another set of experimental records concerning matter—not, this time, what it can do to us but what we can do to it—from which we derive a tendency to read into a shape the way it might have been made and the kind of forces which have acted on it. The poking and prying activity by which a small child familiarizes himself with the world of matter around him is hardly to be distinguished from the activity by which he finds out what he can in the literal sense *make* of it. Clay and dough can be dented into any shape, earth crumbles, rubber springs back, pencils resist then snap, stone and metal resist altogether, bubbles burst, and so on; and the information about plasticity, brittleness, and the rest is duly registered, to be compounded with the other associations of softness and hardness and evoked along with them when a shape attracts our attention. Curving or bulging of a thin sheet suggests a pressure behind it—hence the explosive quality of the dome which we noticed earlier—while jagged and broken outlines suggest disruption, a violent overcoming of resistance. Straight lines and right angles suggest rigidity; simply by *being* straight or rectangular they show that no forces are deflecting or distorting them. We accept them as expressing the essence of the undisturbed.

The straight and the flat are also extremely positive and unambiguous, and this gives them a particular value in an art which often demands these qualities. A curved line or surface, unless it has the innate completeness of the perfect circle or the perfect sphere, provokes the unconscious query: '*How much* is it bent and *by what*?' The straight invites no such deliberation, and the same definite quality attaches to the perpendicular; they are absolutes and can admit no doubts without ceasing to be themselves. They are, too, essentially *man-made* shapes, rare in nature above the level of the crystal, and most unnatural in the organic world where every form gives evidence

Fig. 33

110

of the continual and variable interplay of forces. This has given them a certain symbolic value over and above their innate properties of calm, positiveness, and absoluteness. Surrounded as we are, especially in our houses, by straight lines and flat surfaces mostly made by machines, it is difficult to think of them as miracles or symbols of man's mastery over nature; but it will help the appreciation of form quite considerably if we do occasionally take time to look at them in that light. It would perhaps be too much to ask the reader to fell a tree and extract from it a plank about eight feet long with all its faces dead flat and all its edges dead straight; but anyone who tries it will emerge with a clearer idea of the victory over nature which the straight represents and an enhanced respect for the people who first achieved it, and he will readily acknowledge that these associative values cannot be entirely left out of the reckoning. Straight and rectangular shapes—like staccato rhythms—betray the presence of decisive and organized man, the unbending enemy of disorder, the tool-user and machine-maker, just as wayward curves and legato rhythms betray the presence of his dreaming and doodling other-self.

There remains another powerful set of associations whose existence has already been touched upon in our consideration of the aesthetics of structure—the associations of movement, which draw their power from our natural propensity for keeping an eye cocked for suggestions of life and interpreting form to ourselves in terms of the kind of energy-in-action which it may suggest. Sharp edges cleave, sharp points pierce: these associations give an aggressive forward-thrusting character to acute angles (for example, the grandstand at Galashiels, by Peter Womersley, on p. 10) and contribute to the upward-thrusting gesture made by a spire. We read a similar out-thrusting gesture into a cantilevered projection from the face of a building, and a suggestion of withdrawal into a recessed balcony. We tend to think of protuberances on a roof—especially angular ones—as 'poking up' from it rather than sitting on it, and so on. Long parallel lines are also capable of suggesting movement, especially when they run vertically (as, for instance, the mouldings of the Gothic pier) and spirals and helices even more so; the twisted 'barley-sugar' columns of the Baroque interior are the very embodiment of perpetual motion.

In this same class of association we may legitimately include those of *force under restraint*. The curves of a bent bow or a tensed spring or a bubble suggest something quite different from the flaccid curves of a bent piece of soft wire or a lump of dough. It would seem that there

are shapes which hint at the *presence* of latent or pent-up energy and not merely at the *effect* of energy—one might call them 'active' curves as opposed to 'passive' curves—and their existence adds a certain vividness to the architectural vocabulary.

Finally, it should be noted that as far as architecture is concerned shape and rhythm are practically indissociable, since a repetition or combination of shapes—even in so simple a form as the rolls of a corrugated iron roof—constitutes a rhythm, while we have already seen legato rhythms—as in the case of Baker House (p. 45)—which could equally well be described as shapes. Thus all the emotional associations of rhythm can be interwoven with the associations of shape *qua* shape in a very complex kind of aesthetic experience.

Given this rich associative background, it is evident that the general shape of the building as a whole, entering our consciousness in company with its scale, its properties of mass, and the message of its structural system, can have a good deal to say to us from the start. To this must be added, when we begin to explore it properly, the cumulative contribution of the shapes of its individual parts. Some of them impinge on us purely as things seen, their tactile associations being inferred from their appearance: few people would feel it necessary to climb up and find out whether the fretted parapet of the Doge's Palace is as spiky as it looks from below. Others (the mouldings around a Gothic doorway, for instance) make a visual impression from a distance and invite close-range confirmation of it by touch; and others again, such as stair handrails and door-knobs, *have* to be handled and so demand special consideration of their tactile qualities.

At this stage of detail we are likely to find ourselves employing the kind of aesthetic-cum-functional judgement implied in the earlier example of the 'damn silly corkscrew'. A thing made expressly to be gripped or handled should at least handle comfortably, and should preferably give the sort of sensuous pleasure which makes one almost sorry to let go of it. A shape which, for any of the reasons we have already touched on, gives out the message 'Hands off!' is something of an anomaly in such a situation—so far from contributing to delight, the surprise it provokes is entirely unpleasant, and the designer who puts it there is either possessed of an impish desire to add to the burden of human discomfort or disabled by poverty of tactile imagination. The latter is the more likely explanation: the further design removes itself from the craftsman's bench and on to the drawing-board the more likely it is to lose, somewhere along the line, the

'rightness of touch' which comes when the object has to be felt and smoothed over time and time again in the course of production by a trained and sensitive hand.

It is in the tactile sense, and the feeling for shape which accompanies the constant exercise of it, that architecture has probably suffered most from the historical process by which the craftsman has ceased to be a creative artist. A classic early example of this process can be seen in the change which overtook the details of Greek architecture in the hands of the Romans. The subtleties of profile and form which characterize the best Greek work (we have already noticed the case of the Doric capital, and Greek mouldings and cornices display the same passion for tensely curved contours) reflect the affectionate care of the marble-worker for the magnificent material under his hand. Adapting these details for the standardized public buildings and coarser building stones of their expanding empire, the Romans were obliged to reject the ideal of constant refinement of profile by sensitive individuals, prescribing instead simple quadrants which could be mass-produced to order by competent operatives but have nothing of the sensuous subtlety of their Greek prototypes. The Roman 'orders[1] of architecture' were essentially production jobs.

We are in something of the same position today, and in the face of the machine-technology upon which we all rely for our existence it is futile to lament the passing of the artist-craftsman who literally had his aesthetics at his finger-tips. The loss has to be made good in the education of the drawing-board designer who has superseded him, and a prerequisite of this (since we must now think in terms of mass-markets) is that the buyer and the user take an active and vocal interest in the feel of things. None of us need be short of practice material on which to exercise this interest: even before you leave home in the morning you have a dozen occasions—opening doors, turning on taps, using a shaver—to ask yourself 'Does this please my hand?' If everyone (and architects especially) cultivated this habit, the eventual results would extend a long way beyond an improvement in the design of hardware, since the feeling for form is a necessary part of the architect's equipment and, as we have seen, it involves the collaboration of two senses. If the tactile sense is blunted

[1] The 'order' in the classical sense refers to a specific combination of column-base, column, capital, and entablature (the latter being the combination of horizontal elements above the capital and including the cornice), proportioned and ornamented according to a prescribed formula.

or unawakened, the visual sensibility is correspondingly under-nourished and a great part of the architectural vocabulary falls into disuse or, at best, is ineptly and inexpertly deployed.

It is not a part we can readily afford to lose, unless we are prepared to reconcile ourselves to accepting a very uncommunicative architecture indeed and one which is matter-of-fact to the point of displaying a brusque contempt for human susceptibilities. To say this is not to advocate a return to the idea of architecture as macro-sculpture or to plead for more 'plastic quality' (a high-sounding expression too often used to justify the mere itch to be different), but simply to point out that form must always be considered and never taken for granted. Between the sharp, exact articulation of Mies's Farnsworth house—eminently an assembled thing made by putting together straight members and flat sheets in precise proportional relationships, a product of intellectualizing, puzzle-solving man—and the convexities and concavities of the Casa Mila—almost to be construed as a carved or moulded thing, a diversion of man the puzzle-maker—there lies an infinite variety of combinations of form produced by the counterpoint of one evocative shape against another: thrusting convex against withdrawing concave as in the mouldings of the Gothic arch (Fig. 34); sharp edge against soft contour as in the concrete shells of Sydney Opera House at one end of the scale and the flutings of the Doric column at the other; or the crisp rectangle against the cylinder as in the Johnson Wax building. The catalogue is endless, and so are the possibilities of delight offered by the play of shape to the observer who prepares himself to receive it by remembering occasionally the pleasure-giving capacity of the receptors which he carries at his finger-tips.

Fig. 34

A concern with form leads inevitably to an interest in texture, if only because the innate qualities of a shape may be emphasized or blurred by the nature of the surface, which can enhance its inherent quality or can tend to conceal it. The same concern leads also to an interest in the human urge to decorate form, the result of which may equally be to enhance it or camouflage it.

Let us first, since we have been dealing with the sense of touch, consider the contribution of texture. Like shape, texture has evocative possibilities of its own and its associations are drawn from the same store of well-learned experience. Slipperiness and treachery are synonymous; smoothness is comfortable and reassuring; roughness awakens little warnings which may be just enough to titillate interest or sufficiently strong to bring in a suggestion of menace—the 'hands off' signal—and when it is the roughness of a fractured surface (as compared with the roughness of, say, a coarse weave) it adds to this a reminder of the aggressive force which made it. A texture can therefore either reinforce or mitigate the suggestion made by the shape which carries it. A curved wall, for instance, has a 'soft' shape, especially if it is topped with a rounded coping and most strongly when it undulates vertically as well as horizontally, like the low stone dykes which wind over the hills of Scotland and northern England. The harsh, rugged texture of such walls is in direct contrast to the softness of their line and this contrast, giving a kind of aggressive strength to an otherwise gentle, yielding shape, seems in its context entirely right and proper and in no way incongruous.

Quite apart from its physical associations, moreover, texture has the power to modify the appearance of shape by assisting or defeating cognition. A very rough or shaggy texture applied to a precise shape will tend to make it amorphous, for it not only baffles the sense of touch but also denies the eye a clearly defined boundary. A smooth, matt surface, showing off the gradations of light and shade, has the opposite effect; but if it is polished to mirror-brightness, these gradations become suppressed by the play of reflections and the solid may take on an equivocal, almost supernatural quality. Textures of the simplest kind can therefore be used to modulate the qualities of shapes. Mies van der Rohe, for instance, reinforces the precision

inherent in the straight line and rectangle by having the exposed metal members finished to a high degree of smoothness, while on the other hand we find Le Corbusier, in his later work, relieving the deadness of flat concrete surfaces by deliberately leaving them rough.

Textures can not only modulate the qualities of solids but, strange though it may seem, can be used to modulate the feel of space itself and especially the transition from exterior to interior space. In this respect contemporary Western architecture may owe much to the influence of the Japanese who, as we have already noticed, have a long tradition of using ground-textures—from raked sand upwards in scale to stone slabs and wood planks—for defining spaces. But it owes even more to the deeply ingrained habit which leads us to expect the smoothest surfaces—such as plaster and polished wood—in the intimate zones of habitation, where they are closest to the touch and where their smoothness is protected from weathering, just as a satin lining to a rough tweed coat seems more natural than the reverse.[1] Equally we associate rugged textures with nature in the raw, not because nature is incapable of smoothness (glossy leaves, sea-polished pebbles, and the glassiness of still water are obvious witnesses to the contrary) but because *making smooth things*—like making straight or flat things—is a human craftsman's victory over the raw material with which nature supplies him.

Thus we find textures of floor and wall playing a part in that fusion of Inside and Outside which we have already noticed as a trend in Western architecture from the Baroque onwards. The outward extension of Baroque internal geometry into an external geometry of landscape is matched by a modulation of texture from man-made smoothness to natural roughness by way of smooth, patterned paving, fine gravel, velvety lawns, and close-clipped hedges. Conversely we find in the 'prairie houses' of Frank Lloyd Wright—pioneer steps towards the fusion of Outside and Inside in our own century—that rough field-stone and sawn timber, traditionally associated with such outer lines of defence as boundary walls and picket fences, are admitted to the living quarters. Here the textural transition has been carried out in reverse.[2]

[1] Kenneth Bayes, *The Therapeutic Effect of Environment on Emotionally Disturbed and Mentally Subnormal Children* (1967).

[2] Bayes describes how such transitions have been carried out with great skill in Aldo van Eyck's Children's Home in Amsterdam in order to give the feeling of openness without suggesting an ambiguity between Outside and Inside which—although stimulating to well-balanced people—can cause real distress to schizophrenics.

This deliberate adoption of 'natural' (or, to put it more accurately, *roughly-wrought*) textures is not entirely due to the desire to arrange a marriage between Inside and Outside: it is also a curious symptom of the upheaval in values which has accompanied the change from a craft-based to a machine-based civilization. Throughout most of human history superlative quality and 'high finish' have been synonymous while roughness—'a rough job', 'rough-and-ready'—has been a term of disparagement, and during the centuries when architecture was a matter of hand-craftsmanship this was most natural. Quite apart from the luxury value attaching to highly finished surfaces in terms of the man-hours of skilled labour necessary to produce them, a more strictly aesthetic factor enters into the valuation: where the craftsman or designer has aimed at subtlety of shape, he naturally wants this subtlety to be noticed and admired, and not lost in the distraction produced by irregularity in the material. The classical Greeks, for instance, not only worked the marble of their columns to fine limits of accuracy but finished them off with a polished coating of marble-plaster to give a uniformly textured, jointless surface, and the glossy, white-painted woodwork of the typical Georgian or Colonial interior bears witness to a similar desire to show off the delicacy of modelling and the excellence of the craftsmanship.

Twentieth-century technology has compelled a radical revision of this outlook. Now that surfaces can be machined automatically to the finest limits of precision and finished with an impeccably even skin of synthetic material, the prized rarity of 'high finish' has become a commonplace of mass-production.[1] Not unnaturally this reversal of values has contributed handsomely to the aesthetic confusion of the last sixty years, giving rise on the one hand to the doctrine of the unadorned, precise machine-finish as the true and proper symbol of the age and on the other hand to the belief that salvation depends on the 'human touch'—with its humanity emphasized by tool marks and similar imperfections—as a kind of talisman against the mystique of the machine. It is not a contradiction which worries the majority of people unduly for they have simply adopted a double standard. The same man who demands a flawless industrially produced surface on his motor-car and refrigerator, may very well collect hand-thrown pottery and the imperfect products of peasant industry to humanize his living-room.

[1] Neutra, *Survival Through Design*.

It seems to me that there is a fundamental sanity behind this apparent schizophrenia. If anything, it shows that we have an intuitive recognition of the duality of our own being and the polarity of delight which derives from it, and it is also a manifestation of something which is apparently quite fundamental to human nature—a need to have some occupation for the wandering eye. The random, the irregular, the intricately patterned, are all capable of diverting the perceptual system with continual slight surprises which appear to be necessary to our mental well-being. Smooth, clearly defined, and easily assimilated shapes which offer no distraction from the work in hand give us a highly satisfactory environment for purposeful activity but, leaving nothing to the imagination, they are not necessarily pleasing to the eye in its many off-duty moments. Consequently we find that even in cultures which attached prestige value to high finish it was not valued simply and naïvely as an aesthetic objective in its own right, but because it brought out some wonder-provoking quality in the shape which carried it—as, for instance, the subtlety of the Greek or Georgian moulding—or in the material (like the rich marbles of Byzantine wall-covering), or because it provided a ground against which carved or coloured decoration showed to best advantage.

With this last observation we move from the consideration of texture to the consideration of ornament, a much more potent kind of enrichment and correspondingly more dangerous when recklessly or ineptly applied. The words 'ornament' and 'decoration', as commonly used, generally convey the sense of a rather special kind of enrichment whose production has involved an activity of an artistic or quasi-artistic kind. Most people think of this activity as a more complex or (for want of a better word) more significant one than the creation or selection of texture, for it seems to involve a higher level of inventiveness. It may, in fact, touch a level of magic or high art—as in the religious sculpture of the Hindu temple or the Gothic cathedral and in painting such as Michelangelo's Sistine Chapel ceiling—for which the term 'ornament' or 'decoration' seems wholly inadequate: but they are the only convenient words we have, and it must be understood that I use them here in the broadest sense, as they are used in everyday speech, to include every contribution made by the allied arts (even in their lowest forms) to the enrichment of architectural form.

It is a matter of common knowledge that ornament, both interior

and exterior, has played a very considerable part in architecture until quite recent times and there are cases—for example, the wonderfully carved Hindu temples and the Churrigueresque[1] churches of Spain and Mexico—where it is difficult to say whether it is the ornament or the basic form which carries it that makes the greater contribution to the total experience. It is also very noticeable that the aesthetic impact of most modern buildings owes very little to ornament, the basic forms being allowed to speak entirely for themselves. The view (commonly held throughout the course of history) that sculpture and graphic art are indispensable adjuncts to great architecture made it natural to look upon the architect as one whose highest skill lay in the integration of these arts with his own: yet this view has come to seem quite irrelevant to the appreciation of the buildings of our own time. The appreciation of architecture *as a whole* obviously requires some understanding of the causes of this revolutionary change in values, and for this we must first go back to the primitive sources of decorative art.

One of these sources is the human tendency to use a plain surface as a playground—to doodle and scribble and generally leave one's mark on it—which has apparently existed as long as the race itself. There seems to be a need to *take possession* of the surface and in so doing provide occupation for the restless senses where no other occupation exists. Another is the tendency to see playful possibilities in stuff which one is shaping or putting together for some useful purpose. The clay of a freshly moulded pot is temptingly easy to scratch or impress in a decorative way, the complexities of bindings, weaves, and stitches invite interest in the development of pattern for its own sake, and so on. From these sources come the two main streams of architectural ornament: that which is applied by way of relief to a plain surface, and that which grows out of the nature of a manufacturing or fabricating process.

Ornament, however, serves other purposes than the giving of simple pleasure, for combinations of shapes and colours can be given explicit meanings and built into a system of communication. They can be used (as in heraldry) to establish the identity of an individual or an institution and (as in the pattern of one's national flag) to create a symbol of an institution to which loyalty is expected; and such

[1] The name commonly given to the exuberantly decorated variant of High Baroque associated with José de Churriguerra (1650–1725) and characteristic of the work of that period in Spain and Latin America.

symbols can be assembled into systems which influence human behaviour as, for instance, the international code of road signs guides the behaviour of the motorist. These possibilities are combined in military uniform (within the general concept of 'respect for the uniform' the recruit has to learn to identify the various ranks by their different embellishments and to accord them their various tokens of respect), while the uniform of a priest not only distinguishes him from the layman but associates him (in the eyes of his co-religionists at least) with authority of a supernatural kind, and thus assumes a certain magical value. Similarly, a building may be given a uniform of symbolic ornament to mark its place in a hierarchy of importance or—as in religious architecture—to help promote a particular kind of ritualized behaviour, and in the high civilizations of the past the systematic application of such ornament became an integral part of the process of architectural design.

With the concept of ornament applied for significant or magical purposes we arrive at a still more highly charged kind of decoration, which is very different from simple pattern-making. Alongside the urge to embellish, and to find special attractions and significances in particular patterns or combinations of pattern, there has existed— also from the depths of prehistory—the urge to make pictures as a means of representing the appearances of things and of actions, and thus of communicating ideas and casting spells. The power to represent pictorially gives also the power of calling up the associations of the things or actions depicted, thus making communication not only informative but persuasive: long before the days of the poster and the television advertisement people with a message to preach or an attitude to sell used the associative force of representational art as a means of putting it across, and applied that art to the colossal public bill-board provided by architecture.

The Gothic cathedrals are probably the most frequently cited examples of didactic decoration. They enveloped the medieval worshipper in a great pictorial guide to Biblical history and social duty, with stories, allegories, pious exhortations, and awful warnings all conveyed through the sculpture, painting, and coloured glass which, for a largely illiterate population, were the permanent mass-media of the time. In our own century a similar, but this time specifically secular, mission has motivated the murals of Diego Rivera and David Alfaro Siqueiros in Mexico. As for the mood-evoking function, the most obvious historical example is provided by Baroque

decoration, the symbol system of a power-worshipping and pleasure-seeking aristocracy, drawing heavily on pagan mythology for evocations of fleshly joys and godlike powers, and hardly less sensual in its religious than its secular art: a Baroque cherub often looks remarkably like a Cupid whose bow and darts have been left behind in someone's boudoir.

It must not be assumed, of course, that these functions are neatly compartmented and mutually exclusive. Gothic art, for instance, as well as making its didactic points serves to intensify, both by its symbolism and by its form and colour, the emotional associations called up by the Gothic use of space and structure. Similarly, 'mood' is a pale word for the effect which Byzantine representational decoration (formal and stiff though it often seems to Westerners) was designed to have on the worshipper instructed in its symbolism: the emphasis which Orthodox theology placed upon the saints as intermediaries between man and God gave the pictorial representation of them the special force of a direct line of communication through contemplation, and these strangely rigid, hieratic figures were intended to be much more than illustrations to a Book of Martyrs.

We can see in such cases that decoration assumes a function of engaging the spectator with the building or rather *with the myth that gives the building its purpose*. The sculptured reliefs of the Parthenon were put there not merely to relieve the plainness of masonry surfaces or even to illustrate, as a picture-book might, the mythology of the special relationship between Athene Parthenos and her city, but to engage the spectator in the myth. The prodigiously elaborate and exuberant sculpture and colour of the Hindu temple are likewise a means of weaving mythology into the worshipper's life, and there is little doubt that the same role was played by the enigmatic and often terrifying temple-sculpture of pre-Columbian Mexico and Guatemala. In cultures which look to myth as a unifying force and a key to social behaviour, its vivid presentation becomes a natural and indispensable part of religious architecture.

In this process of enriching major buildings by underlining the special nature of their functions the architect's part was not simply a passive one of providing, so to speak, the advertising space on which the sculptor and the painter were to use their magic. The idea of decoration as something bought by the yard (if funds permit) and stuck on is a relatively new one and it arose largely through a widening of the gulf between conception and execution, the inevitable price of

building for the specialized needs of a complex and impatient civilization. In a more primitive culture, where the designer is also the craftsman and works directly upon the materials, the processes of making and decorating are one. The functional wooden bracket or stone corbel or iron hinge has to be cut into a shape in any case; and if it gives the craftsman pleasure to shape it in a particularly decorative or significant way, he will do so, for the first-class craftsman is always something of an exhibitionist. It was this exhibitionism that the Gothic builders canalized with such skill into the service of a single architectural theme, assisted by a very rich and widely understood system of pictorial symbolism within whose framework the craftsmen enjoyed considerable latitude.

As we have seen, the Renaissance (and still more the classical revivals which followed it) curbed this latitude, drawing a new line between the craftsman, whose role became increasingly uninventive, and the decorative artist, a separate creative person versed in the classical modes of expression. This new man, however, remained close to the architect, for they shared not only the same basic education and aesthetic assumptions but also the belief that a work of architecture gained by the contributions of the other arts.

For one reason or another, then, all the architects of the past were operating in a situation in which ornament was a positive factor in building design and one whose possibilities were present in the designer's mind from the outset as a means of assistance in his task of giving order, clarity, and definition to a large and complicated object or, to put it more concisely, the task of *articulating form*. Since it is in the nature of ornament to seize and hold the eye by what for want of a better expression we must call a display of energy, it provides a most obvious means of focusing attention and thus of making a distinction between one part and another. It may be used, for instance, to give added emphasis to a distinction which already exists for functional reasons. Where a structure consists of timber posts and beams with a filling of panels or screens between, decoration has often been used in the past to point up the distinction between the force-conducting parts which do the work and the 'idle' infilling between them, by elaborating the one and not the other.[1] This kind of simple distinction is carried a stage further when form is enriched in a way which emphasizes its own essential nature, making vertical parts look

[1] Norberg-Schulz, *Intentions in Architecture*.

more vertical, horizontal parts more horizontal, and so on: the flutes of the classical column clearly emphasize that a column is by nature a standing thing and the treatment of the entablature above defines the lintel as a lying thing.

Equally ornament may be used to impose articulation where the structural system provides none, by breaking up wall surfaces into proportionately related areas, establishing rhythms, and thus making the form more readable, just as this book is made more readable by being divided into chapters and paragraphs. In the case of a large building this presents certain problems, for it is evident that decorative elements which have to master a great frontage must themselves be very large in scale. One solution, and probably the one with which we in the West are most familiar, is the Renaissance device of borrowing structural elements and using them quite unashamedly as non-structural applied ornament, like the pilasters, attached columns and blind arcadings, as in the design for Christ's Hospital by James Lewis. Another solution—commonly found where coloured skin-materials such as marble or tiling are traditionally used for facing walls—is to divide up the wall by bold, decorative contrasts of colour (S. Miniato al Monte). Yet another method of surface articulation is the use of the skin-enhancing and mass-dissimulating properties of flat pattern (which we have already noticed) to reduce the apparent solidity of one surface compared with its neighbours or, conversely, to use the thickness-enhancing properties of relief ornament as a means of making particular elements—windows or doors, for example—stand out. In its simplest form this picking out may amount to no more than rustication of the corners of the opening; at its most elaborate it may go as far as the sixteenth-century Portuguese window illustrated on p. 125.

This articulation of surface can be used not only to enrich *form* and make it more readable, but also as a means of articulating *space*. Taking a bird's-eye view of the whole field of architectural ornament, one can detect a hierarchy of interest which corresponds roughly to a hierarchy of value. Patterns which are complicated can hold the interest longer than patterns which are relatively simple and they have the additional value, in handcraft societies at least, of demonstrating the exercise of greater ingenuity and energy. When someone looks at an elaborately worked carving or mosaic and says: 'Think of the work that went into that' he has in fact hit upon a most significant fact about decoration: quite apart from any specific message of its

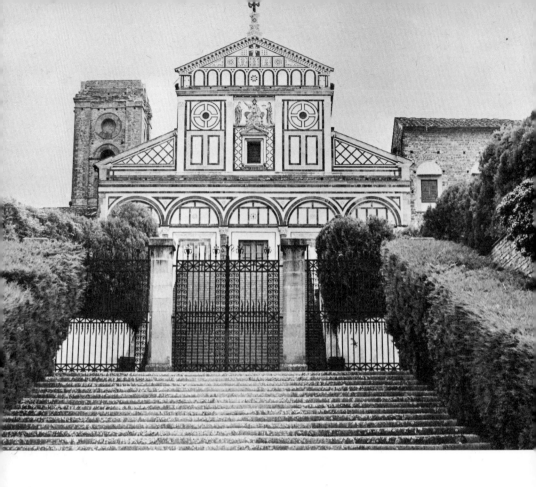

S. Miniato al Monte,
Florence. *Italian State
Tourist Office*

own it symbolizes the command of energy. At its most primitive
it speaks of energy to spare, above survival level, for purposes of
recreation; in a more complex society it demonstrates that the
owner has the energies of others at his disposal, and energies, more-
over, which are of a relatively rare and magical kind. Consequently,
elaborate ornament tends to be equated with a display of power and
thus acquires an added value which may have little to do with its
strictly aesthetic merits. Furthermore, we have already seen that the
representation of living form and action—especially human expres-
sion and gesture with all their familiar emotional connotations—is
still more eye-catching and communicative, so that (in cultures which
have been prepared to make use of it) representational decoration has
tended to occupy the highest rank of all in the hierarchy of ornament.

Portuguese window,
Manueline period

Acceptance of such a hierarchy, making it possible to interpose many shades of significance between 'penny plain' and 'twopence coloured', gives the architect a means of zoning different areas of a building according to the importance of their function,[1] and thus of reinforcing the hints or commands given by his shaping of space. Not only does a formal pattern running lengthways along a corridor emphasize the invitation to keep moving, while a centralized floor or ceiling decoration (based on the circle, the star or the regular polygon)

[1] It must be emphasized that it is the acceptance of a common code assigning different *degrees of significance* to different kinds of ornament—not the mere desire for ornament of any kind in preference to plainness—which enables it to be used to the full as a zoning medium.

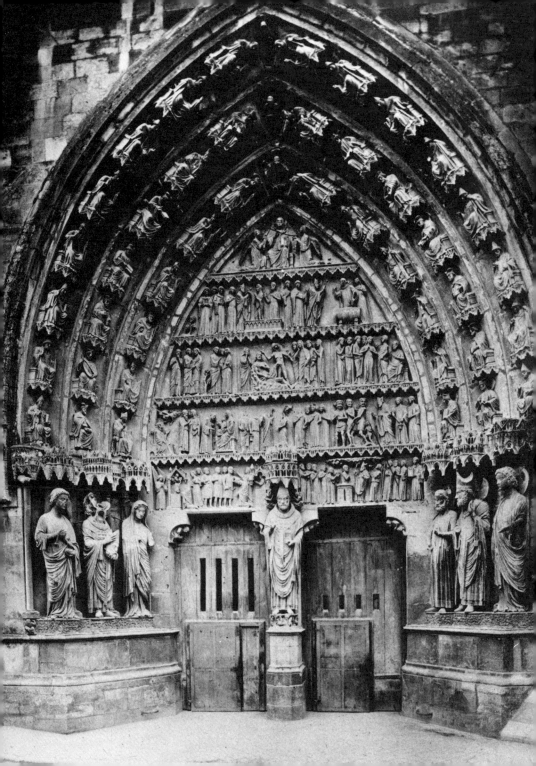

suggests a halting place, but the simplicity or complexity of the surface ornamentation may be used to give a hint whether this is a space in which we are expected to linger, allowing a complex aesthetic experience to open itself up to us by degrees, or one so easily read that we can take it in our stride as we pass through. It has already been pointed out, too, that we are liable to experience a heightened awareness of space at the point where we pass from one kind of volume to another, and we commonly find in historical architecture that some concentration of significant ornament around such points of transition—the most important usually being the major doorways which link Outside with Inside—is used both to focus attention on this experience and to prepare the observer for it. The west fronts of the Gothic cathedrals often carry the process a stage further by using serried ranks of sculptured figures to emphasize that the penetration of these immensely thick walls is a gradual affair and not an instantaneous one like stepping through a tent-flap. Finally, symbolic decoration can be used to give additional force to the symbolism of a spatial shape: the idea of the 'dome of heaven' in Byzantine church architecture is powerfully reinforced by the depiction on its surface of Christ in majesty, with the Apostles and Prophets, while earthly life is represented by the lesser anecdotal murals on the walls below and the downward gradation in importance is completed by abstract or formalized pattern on the lower parts of the walls and on the floors.

From all this it should be clear that ornament, as used in the architecture of the past, was much more than an easy, reach-me-down method of making buildings look expensive or attractive. We may not be able to feel the impact of some kinds of decoration as sharply as its creators did, or to understand completely how its presence added, for them, to the wholeness and significance of the building, for their myths are not ours. But we can distinguish clearly enough, if we will take the trouble to look, how they have used ornament to articulate form, surface, and space so that the general aesthetic statement of the building *as a whole* is given a special and forceful character; and if we will look hard enough, and inquisitively enough, we are liable to deepen our appreciation of architecture by deepening our knowledge of the people who made it.

West doors, Reims Cathedral. *Photo: Paul Popper*

For the methods which any culture has used to enrich architectural form often provide a more detailed commentary on that culture than is offered by the broad treatment of structure and space. Most

obviously, the nature of ornament is influenced by the available materials and tools, whose effect may be either restrictive or stimulating. The shallowness and 'chunkiness' of Saxon and early Norman carving, for instance, reflects the difficulty of working on locally available stone—often hard and coarse-grained—with the soft iron axe, while the sculptural richness of later English Gothic work, such as Winchester Cathedral, with its deep relief and delicate detail, would have been impossible without the much greater freedom given to the carver by the hard steel chisel working on finely grained stone of 'statuary quality', often imported from abroad. In the latter case the nature of the material is a stimulus rather than a restriction; one could instance in the same category the pleasure of using good tools on close-grained English oak which is celebrated so conspicuously in the gloriously carved roof-timbers and rood-screens of so many fifteenth-century English churches.

Moreover, a style of decoration which originated in the functional use of materials at hand may travel far from the place and circumstances of its origin and have a profound and widespread influence on architecture, and thus the ornamental conventions which are favoured in a particular country at a particular time can provide their own kind of commentary on its history and its cultural contacts. For instance, Islamic architecture, whether in Mogul India or Moorish Spain, is characterized by an inordinate fondness for two-dimensional surface decoration and intricate geometrical patterning. This was natural in a culture which shared the Mosaic disapproval of graven images; but it reflects also the natural bent of the Persians, who were itinerant artists-in-chief to the Moslem world for the best part of a thousand years, bringing to their work an apparently inexhaustible decorative inventiveness and a vigorous tradition of applied art which was already ancient when Harun al-Rashid became Caliph at Bagdad. In building this tradition manifested itself most notably through their command of polychrome decoration in glazed tiling—the Great Mosque at Isfahan is perhaps the most famous example—and it is at least arguable that it was practice, over many centuries, in extracting the maximum aesthetic effect from the modular geometry of tiling which gave the Persians their mastery of the architectural use of geometrical or formalized decoration. But this line of tradition goes back through the Persians themselves to the older Mesopotamian civilization dominated by Babylon, for the Babylonians were builders in ceramic *par excellence*, using the abundant clay of their alluvial plain

in the form of sun-dried bricks and facing this perishable material with glazed tiles to keep it intact in the rainy season.[1]

It is a far cry from Babylon to the traditional tiled decoration of Brazil, picked up by the Portuguese from their Arab contacts and passed on to their tropical colonies; but such extended chains of decorative inheritance are not uncommon in architectural history. The decorative art of Byzantium, besides contributing its own quota to the Islamic pattern-store, influenced Europe along the great land-locked waterways as far afield as the Baltic and northern Russia. Indian sculptured art profoundly affected the architecture of south-east Asia and Indonesia—as the great temples of Angkor Wat in Cambodia and Borobudur in Java bear witness—and filtered back along the trade route pioneered by Vasco da Gama to stimulate the remarkable exuberance of sixteenth-century Portuguese ornament of which the illustration on p. 125 is an example.

When a native builder picks up a decorative idea from a foreign source he commonly modifies it to suit his own purposes or the taste of his own public, so that it becomes a natural addition to the familiar vocabulary of form, and he tends to use it in ways which are consistent with the architectural dialect of his own place and time. Tudor and Jacobean builders made quite free use of decorative details adapted from Italian Renaissance originals, but the character of their houses remains identifiably English for they were not attempting to reproduce a foreign style in its entirety as an exercise in scholarship but were simply using these borrowed motifs to enliven their own vernacular.

This process of naturalization should not be confused with the very different process which made the late Victorian city a kind of museum of imported and resurrected styles, and which was largely due on the one hand to an enormous increase in the circulation of printed illustrations of exotic and historical ornament and on the other to the demand for richly decorated buildings as conspicuous symbols of newly created wealth. To meet this demand designers not only racked their own invention, but drew freely on the ready-made store of ornamental details provided by illustrated books and magazines and by the historical examples which they sketched assiduously in their spare time.

The results were not invariably disastrous, for some of these designers were men of great ability with a powerful sense of form and

[1] Neutra, *Survival Through Design*.

a highly cultivated eye for the appropriate. Their buildings are still capable of impressing us (if we can suspend our twentieth-century disbelief in the propriety of resurrecting ancient styles to serve modern purposes) by the vigour and inventiveness of their detailing and by the skill with which ornament is used to give consistency and point to the aesthetic experience. Indeed Victorian buildings (and especially Victorian interiors) provide an excellent field of study for anyone who is interested in the use of ornament as a means of articulating space and emphasizing form: he will be able to appreciate the best all the more readily because there exist alongside it so many examples of the worst, in which the embellishments play no real architectural role but merely leave the observer confused by a bombardment of miscellaneous and ill-chosen shapes, colours, and textures.

Even the best of the Victorian architects were fighting a losing battle, for the very proliferation of ornament was weakening its power to contribute to the enjoyment of the human environment. For centuries it had acted as a cohesive force: the buildings of a particular culture at a particular time had been given a certain unity (as in ancient Greece and the Moslem East) by the stylistic consistency of their ornamental treatment. The habitual eclecticism of the Victorians had exactly the opposite effect. Ornament became a disruptive force: not only do we find streets in which widely different and inconsistent ornamental styles compete furiously for attention, but interiors in which the decoration is drawn from half a dozen periods of history and perhaps as many different countries.[1]

It was small wonder that by the end of the century the tide was turning in the direction of simplicity and consistency; and this reaction was more than a simple shift of fashion, for it gained added force from those new ideas of space and structure which we have already touched upon. There seemed little point in trying to graft traditional systems of decoration—devised originally for the articulation and enhancement of massive space-trap structures, or evolved out of time-honoured craft processes—upon buildings whose spatial and structural rationale was entirely different. To do so for no better reason than ostentation seemed doubly ridiculous.

[1] In *The Architecture of Humanism* Scott pointed out that 'the welter of commonplace municipal monstrosities' was making it impossible to attune the eye to order even where order existed: 'It is as though one had to tune a violin in the middle of a railway accident.'

Nevertheless, old habits die hard. Even among the architects who rejected historicism there were those who still believed in the need for some kind of vocabulary of ornament, and they looked for a solution in the invention of new kinds of enrichment which would owe little or nothing to historical prototypes but would be genuinely characteristic of their own time. Few of them achieved more than temporary success, since such vocabularies are not readily created by individuals within one lifetime; and the results of their experiments (such as *Art Nouveau* and that curious angular 'jazz style' which one associates with the cocktail-bars and dance-halls of the twenties) are mostly historical curiosities today. The most successful were those who, like Frank Lloyd Wright, moved towards a kind of enrichment which is specifically suited to characteristically twentieth-century repetitive processes such as concrete casting (thereby maintaining an obvious relevance to the total process of modern building) and which also produces a surface so patterned that it can be described as *textured* rather than ornamented, relying for its effect on the abstract values of tactile association and the play of light and shadow.

To others, however, such as Adolf Loos[1] in Vienna and Walter Gropius in Germany, it seemed clear that the root of the ailment lay far deeper—that all ornament, historical or not, had simply *lost its relevance to the building-task*. Even its prestige value as symbol of the command of human energy had become sadly devalued as the spread of wealth and technology brought mass-produced decoration—cast, mechanically stamped, lithographed, or woven on automated power-looms—into every suburban parlour, while the same technology had completed the work begun by the Renaissance in sterilizing the crafts-man's contribution to the invention of form, and was in course of replacing him altogether by machine-processes whose aesthetic possibilities are of a totally different order and should be exploited as such. To those architects it became an article of faith that a twentieth-century building should, as Gropius put it, 'derive its architectural significance solely from the vigour and consequence of its organic proportions'.[2] For its scale, rhythms, and articulation such a building must depend wholly on the relative proportions, shapes, and spacing of its parts, and for pattern it must rely on the lines drawn upon its surfaces by such functional necessities as the glazing-bars of windows and the joints of such structural units as tiles and slabs: for

[1] See Biographical Note.
[2] Quoted in Collins, *Changing Ideals in Modern Architecture*.

its total effect it must rely on a rational statement of the relationship between space and structure so compelling that it can delight by its very conciseness and lucidity.

This is a very high expression of what I earlier called the classical quality of the thoroughbred and it makes very exacting demands. Of the designer it requires a disciplined intellect combined with a most acute sensitivity to abstract shape and to the relationship of form and space. On the observer's part it demands an equally acute sensitivity and also a willingness to debar from the act of judgement that portion of his nature which delights in mystifications and whimsies, enjoys scribbling on blank spaces and finds recreation in deciphering the scribblings of others. It must be understood, however, that it was no part of the intention of the 'functionalist' or 'internationalist' school (as it came to be called) to create a joyless architecture. Their aim was rather to evoke the purest kind of delight out of the beauty of essential form, designed so perfectly that it needs no enrichment beyond that which is provided naturally by the texture and colour of its surfaces and the play of light and shadow.

To appreciate the full flavour of modern architecture it is necessary to trace some of the consequences which flowed from this radical and very uncompromising doctrine. Before we do so, however, we have to give some attention to this matter of the play of light.

One of the most foreign things about a foreign country, and one of the most homely about one's own, is the quality of its light. The intensity and angle of the sun, its constancy or fickleness, the expected hours of sunshine in the day or year, all enter into the sense of place, and the building which is ill adapted to these conditions is liable to seem as foreign as a sun-blistered Englishman on a Spanish beach or a Jamaican in Reykjavik. Of all the facts concerning a place these are the most unalterable—as Leon Battista Alberti succinctly remarked some four hundred years ago, the architect need not let land or even water stand in his way, but he has neither skill nor power to change the sky[1]—and traditional architecture often illustrates a very complete response to them, not only in the general form of the building but in the details of its ornamental system as well.

For instance, the habitual use of a particular kind of ornament may derive directly from its appropriateness to prevailing conditions of sunshine. Thus the glare of the hot, dry Asian plains, demanding radiation-shielded ventilation-openings rather than windows in the Western sense, encouraged the delicate filigree-piercing of the Indian *jali* and Arab *mashrabiyeh*, while in a very different climate the coloured glass of the medieval cathedral converted the greyer light of northern skies into a kind of celestial blaze, turning its very diffuseness to advantage. In strong sunlight, too, even a slight break or incision in a surface has the effect of drawing a crisp line of shadow and the articulation which can be produced by such shadow-lines depends on this kind of lighting for its full effect. There are few days of the year in which a Greek Revival building of the eighteen-thirties in Edinburgh or Manchester can give more than a faint hint of the precisely etched clarity of line which characterized its prototype, while by contrast the bold, deep relief of Gothic mouldings makes them conspicuous even in the mistiest northern light.

[1] *De Re Aedificatoria* (1485), Lib. I. Alberti was a remarkable example of the Renaissance *uomo universale*, for he was not only an architectural designer and theorist but a painter, dramatist, mathematician, musician, and athlete. His classic work (also known as *The Ten Books of Architecture*) aimed at providing a systematic theoretical foundation for design, and its subject-matter ranged from micro-climatology to the grammar of ornament. It had a great influence on Renaissance and post-Renaissance architecture and some of its more fundamental observations are still quoted with respect.

Such considerations, distilled into traditions through many centuries of trial and error, become part of the intuitive stock-in-trade of the craftsman who seeks to show off his skill to best advantage, and of the architect who works with him and uses that skill to give point and richness to the communication he is trying to make. The architect, indeed, is deeply concerned with light, functionally as a form of energy which he has to control for purposes of human physical comfort and aesthetically for the contribution it can make to the total experience of the building. As far as the outside of the building is concerned his control is strictly limited, for he cannot alter the brightness of the sun or contrive openings in the clouds through which it will shine in a particularly flattering direction. But in the interior he has a great deal more scope, since he can dictate to a considerable extent how natural light is admitted and still more precisely how artificial lighting is placed: here he can modify its quality, intensity, and direction, as a theatrical producer does, to emphasize a feature or intensify a mood.

The consideration of enrichment, whether textural or ornamental, is therefore closely bound up with the consideration of light. To take a very obvious example, texture and shape gain in force and solidity when side-lit (as in the illustration of the Elephant house at London Zoo, pp. 136–7), whereas strong frontal or non-directional lighting kills the shadows and highlights which make three-dimensional form readily identifiable. Similarly, low relief and muted colour are liable to subside into insignificance in a dim light—a fact clearly recognized by the Norman builders, who compensated for the shallowness of their incised decoration by picking it out in strong heraldic colours. It is noticeable, too, that three-dimensional form such as sculpture in-the-round gains in arresting quality when lit up against a dark background and that bold outline becomes doubly bold when silhouetted against light. In the latter case the illuminated background may be a different plane, rather like the cyclorama of a theatre (as in the illustration of a Baroque chancel at Weltenburg, p. 138) or, as in the case of the glowing gold backgrounds of Byzantine mosaics, it may be in the same plane as the figure which it silhouettes.

To find miniature examples of such devices for 'supercharging' shape by the cunning use of light one need look no further than the more sophisticated window-displays in any big city. Indeed, this is not a bad way of learning to appreciate the architecture of those cultures—such as the Baroque, with its special leaning towards

theatricality—which have found a particular pleasure in extracting the maximum of drama from three-dimensional form. But light is not only a medium by which form is perceived and textural or ornamental enrichment shown to fullest advantage; it is also in its own right an element in the aesthetic experience, for it is powerfully charged with associative values reaching so far back into the history of the race and the childhood experience of the individual that they can fairly be described as universal. Most obviously light stands for clarity, for it makes things clearly observable and therefore intellectually comprehensible. Darkness symbolizes the obscure and mysterious, charged perhaps with unknown and formless terrors, but an even dimness (once the eye has adjusted itself to it) is associated with a lowering of tension which promotes rest or meditation. Moreover daylight provides an intimation of outside space which it is almost impossible to disregard: it is by our impression of the 'lightsomeness' of an interior that we make our first intuitive assessment of the quality which has been described earlier as its 'space-permeability', and the shifts and changes in daylight introduce both a rhythm and a variety into life which give the window a psychological importance far exceeding its value as a piece of lighting-engineer's equipment. And by an interesting inversion of values, when night falls it is the *illuminated* space, the pool of light made by man amid nature's darkness, which becomes symbolical of Inside and 'togetherness', associations which are powerful enough to justify Steen Eiler Rasmussen's dictum: 'If you wish to create an effect of openness, you cannot employ concentrated light.'[1] Moreover light can be used not only to suggest space or to emphasize the nature of a particular space, but to reinforce the 'drawing' or 'beckoning' power of certain spatial arrangements. In the interior a light-flooded space at the end of a dimmer vista, or the suggestion of such a space around a corner, can act as a most powerful magnet, while externally a shaded colonnade or portico will exercise a similar pull in conditions of blinding sun.

So far we have been using the word 'light' in its everyday sense, meaning the sort of light we expect from the sun or from artificial sources which approximate more or less to natural or 'pure' light. However, the operations of science from Newton's time onwards have shown that this pure light is really a cocktail of radiation-

[1] *Experiencing Architecture.*

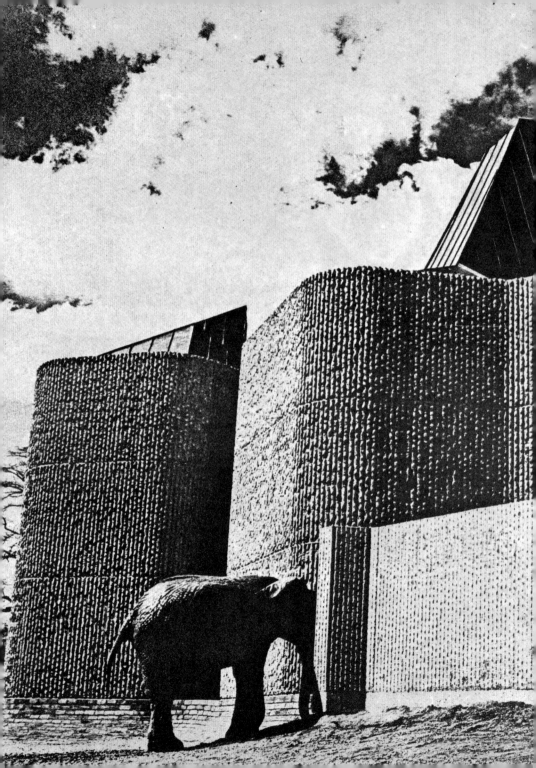

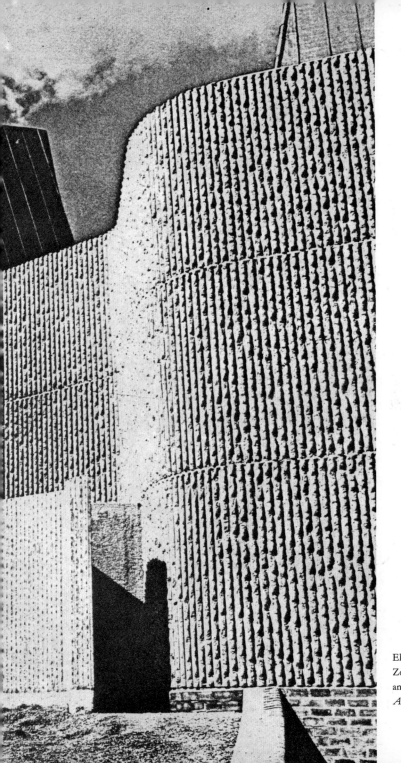

Elephant House, London
Zoo, by Casson, Conder,
and Partners. *Photo:
Architectural Review*

Baroque chancel at
Weltenburg, Bavaria, by
Cosmas and Egid Asam.

energies of different wave-lengths, that when we say we 'see a colour'
we are trying to describe a sensation caused by radiation of a particular
wave-length: in fact, that light and colour are inseparable. It is within
the architect's power to determine, within limits, the wave-length of
the light-energy reflected from the surfaces he designs and he may
even (in the interior at least) alter the natural mixture of wave-lengths
—as for instance by passing the light through tinted glass—*before* it
falls on these surfaces. And since different wave-lengths of light pro-
duce inescapable physiological and psychological effects on the human
observer—especially when bombarded with them on the scale offered
by the surfaces of a building—the use of colour puts the architect in

138

possession of a very powerful magic. The recognition of colour plays a most important part in visual perception in providing clues by which objects are identified and warning signals interpreted, and before we are very old we have equipped ourselves with a whole library of colour-associations upon which we cannot help drawing in the process of 'reading sign' on buildings as on other things. One does not have to be a psychologist, for instance, to know that colour used heraldically—as in the national flag or the colours of the home football-team—can take on a symbolical, emotionally-loaded value, and it is a commonplace of religious art that certain colour combinations, like the blue and white of the Madonna, become established as iconographically correct and consequently can play a decisive part in a decorative scheme.

It is commonly accepted, too, that we respond emotionally to *chroma*—in other words, that intense colours have more power to excite than subdued colours—and that certain bands of the spectrum have acquired associations with impressions which really belong to the other senses, such as warmth and coolness, weight, even noise and quiet. There is hardly space here to set out into the almost uncharted territory of colour-psychology; it is a debatable land into which the psychologist himself ventures with caution and only the painter, being guided by intuition and not accountable to science, can feel sure of his steps. But any serious observer of architecture must be prepared to recognize that his reaction to a building may be literally 'coloured' in the sense that the associations of colour are influencing his judgement in ways that the designer may or may not have intended.

While it is necessary to give due weight to this associative magic of colour—especially where it is provided permanently by an inherent characteristic of the facing material, as in Persian tiles and Byzantine mosaic, rather than ephemerally by a coat of paint—it is important to realize that it is not by any means the whole story. Colour is also a useful and sometimes indispensable medium for articulating form and space. Some colours, for instance, are more striking than others, and thus can give additional emphasis to a focal point in a composition. Strong colour contrasts possess a similar eye-catching quality which can be used for the express purpose of dividing up a surface (as we have already seen in the case of San Miniato al Monte), creating a rhythm or emphasizing a point of importance such as a meeting of two spaces. Colour contrast, although of a more sub-

dued kind, can also help the perception of low-relief ornament, which as we have already seen may be lost in unfavourable lighting conditions: the 'Adam style'[1] of fine low-relief plasterwork is naturally and properly associated with the so-called 'Adam colours' favoured by the later Georgians because it often needs such a background to show its crisp white elegance to the best advantage. Furthermore, there is general agreement that colours towards the red end of the spectrum are felt to 'stand forward' in a way which may be either aggressive or welcoming according to circumstances, and that colours towards the blue end are felt to 'stand back' in a way which may be interpreted as peaceful or as coolly aloof. These characteristics can be used to articulate form by affecting the apparent relationships of planes, and they can also be used to articulate space both by affecting its apparent size and by reinforcing its suggestions of advance and retreat.

From the foregoing it should be clear that the manipulation of light (including that particular manifestation of light which we call colour) offers, in its own right, considerable possibilities of touching the emotions as well as of enlivening and articulating form and space. To those architects of the early twentieth century who had rejected the traditional use of ornament for just such purposes these possibilities made a powerful appeal; and the appeal was reinforced by the fact that new experiments with light had become not only possible but necessary. Now that skeletal structures had begun to take the place of solid masonry, the admission of daylight was no longer a matter of arranging holes in the walls or roof according to well established conventions, with results which could be predicted by any experienced and competent designer. The situation was complicated, too, by the general adoption of electricity as the main source of artificial light, for this new factor did not affect only the inside of the building. The combination of brilliantly lit interior and transparent external wall placed a new importance on the appearance of architecture by night, to which still further importance was given by the invention of floodlighting and by the emergence of neon sky-signs as an inevitable corollary of commercial building. In short there

[1] Robert Adam (1728–92) and his brothers were particularly famous for a treatment of interiors which broke away from the ponderous Palladian conventions of the day in favour of a freer interpretation of classical models within a style characterized by lightness and delicacy.

had never been a way of building which so challenged the architect to play with light for twenty-four hours a day.

Much of the functionalist architecture of the nineteen-twenties and nineteen-thirties seems in retrospect to suggest that the designers of the period took this invitation rather solemnly, over-exalting the ideal of ample and evenly diffused light (much as they exalted the ideal of the severely plain, smooth surface) and overlooking or suppressing the kind of fun which can be provided by glitter, twinkle, and contrast. They were, of course, very interested indeed in light as a symbol of space, freedom, and reason—in the banishing of shadows both metaphorically and literally—and having attached a similar symbolic value to the uncluttered surface and thus banished the kind of enrichment which most obviously depends on highlight and shadow-play for its effect, they had all the less reason to be interested in light as a dramatizer of texture and relief.

Having said this, it is necessary to add that the real masters of the modern movement were not so simple as to assume (like some of their imitators) that it took no more than a widening of windows and a heightening of illumination-levels to produce a new aesthetic of space and light. Nor did they imagine that the glass-enclosed skeleton, in one form or another, would provide an automatic answer to every building task. Le Corbusier, for instance—perhaps the most widely known of all the protagonists of the international school—has produced in the chapel at Ronchamp a building which, one might say, *celebrates* the fact of light's existence in ways which could never be approached by any transparent space-frame. In this small building one is never allowed to take light for granted. Externally, it manifests itself as the revealer of form in all its clarity through the play of shade and shadow on the granular texture of white curved masses: internally, as something much more mysterious, a quality produced by the multiple reflections of sunlight from immensely deep window embrasures and by its downward penetration through shafts from invisible openings above the roof, a dimness jewelled here and there, according to one's position in the enclosed space, by a slab of coloured glass which transforms daylight into an accent of pure colour. It is futile to try to catalogue the subtleties of Ronchamp or describe the skill with which they are integrated into a single and moving aesthetic experience, but there is little doubt that its magic owes more to Le Corbusier's command of light than to any other single characteristic.

In this building, as elsewhere in his later years, Le Corbusier displayed an affection for rough surface texture which to some people, remembering the early functionalist ideal of smooth, polished precision, seemed distinctly odd. It would seem to me, on the other hand, that a concern with light for its own properties (that is, not merely as a symbol of this and that) and with pure form and the 'feel of shape' can hardly fail to lead to a concern with texture, since texture, form, and light are complementary. Large-scale rounded forms like those of Ronchamp need granular texture to bring out the full effect of the gradation of light which makes their roundness real, while in return this gradation—at close range a multiplicity of points of reflection and pits of shadow—gives light itself a new immediacy of interest. It may be significant that of all the founding-fathers of the modern movement it was the one most completely opposed to the 'machine look'—Frank Lloyd Wright—who made the most consistent use of dramatic contrasts of light as, for example, in 'Taliesin III'. Wright the nature-worshipper never abjured his passion for natural textures and Wright the individualist never turned his back on decorative enrichment, and for both of these an acute consciousness of the dramatizing quality of light is essential. Consequently it was necessary for him to take this quality into account when making his own reappraisal of the role of light in an architecture of spatial continuity and that in a way which was much less necessary for those whom he rather unkindly called the 'flat-faced' school of modernists.

I am well aware that this view contains some fairly drastic over-simplifications and I am not putting it forward as revealed truth but simply as a provocation for the kind of argument without which the appreciation of any art becomes rather a dreary schoolroom exercise. Nevertheless I believe it has a certain relevance to the situation in architecture at the present day. During the last twenty years there has been a marked revival of interest in colour and especially in strong colour contrasts applied to architecture, and with it a renewed (and often disastrous) interest in pattern. This may only be an indication of the pendulum swing of fashion, perhaps given its first impetus by the release from the enforced austerity of the Second World War and its aftermath. But there has also been an upsurge of interest in enrichment of a different kind, not bought by the can, roll, or sheet but commissioned from artists who have themselves become involved in the building operation and are stimulated by the possibility of

Pilgrimage Chapel, Ronchamp, by Le Corbusier: interior. *Photo: A F S Wright*

143

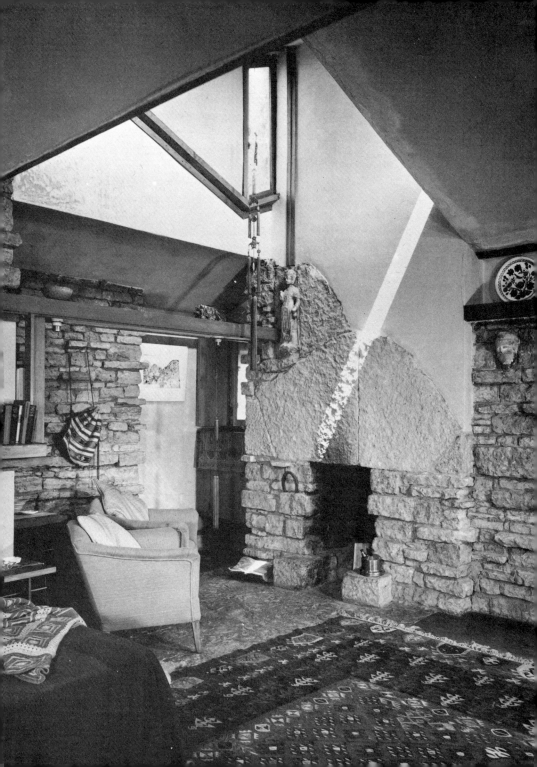

addressing themselves to a public audience from the walls of a building instead of to a private audience within the walls of a gallery.

One of the most interesting symptoms of this interest is the re-appearance of sculpture in a form much more closely related to texture than to anything which has commonly been regarded as sculpture in the past, sometimes carried out in cast concrete, sometimes in metal, sometimes in the new synthetic materials. Another is the reappearance of coloured glass, not in conventional leaded panes telling a story or adding a 'touch of class' to the bathroom window of the suburban house but as pure, abstract colour-play, generally in thick, richly coloured slabs, sometimes set directly into piercing in concrete, sometimes welded together.

Such decorations depend wholly on the play of light for their visual impact rather than on their story-line or their attachment to a traditional symbol-system and they utilize light in a way which makes us take notice of it instead of taking it for granted. From this point of view they would seem an eminently suitable accompaniment to an architecture which from its origins onwards has exalted light, and it is tempting to see this as the ultimate paradox of the modern movement: that the very reappraisal which it compelled has conduced to a development so antithetical to its original anti-ornamental philosophy.

This raises the whole question of relevance as a major issue, for it will be remembered that the core of the indictment against ornament was that, whatever its intrinsic aesthetic properties, it was simply irrelevant to the architecture of the twentieth century and that cluttering up buildings with irrelevancies is a bad thing. Now the sort of enrichment I have been citing can hardly be described as irrelevant in the light of modern industrial processes. These sculptors are not hammer-and-chisel men but users of industrial techniques which are, if anything, more advanced than those which go to make the building fabric itself, and their design—as in the case of cast concrete—often grows out of the nature of the manufacturing process itself, as we have observed primitive ornament to do. Nor can it be considered as irrelevant to the spirit of the age. These abstract and indeterminate patterns, these almost arbitrary splashes of light—not embodiments of myths but an invitation to read into them our private and personal mini-myths, as in the coals of a fire—are, if anything, more appropriate to our troubled and uncertain age than unadorned form of a classical severity with its built-in air of a complete, final, and logical statement, could ever be. The most damning charge of all—that of

'Taliesin III', Spring Green, Wis., by Frank Lloyd Wright. *Photo: Ezra Stoller (ESTO)*

145

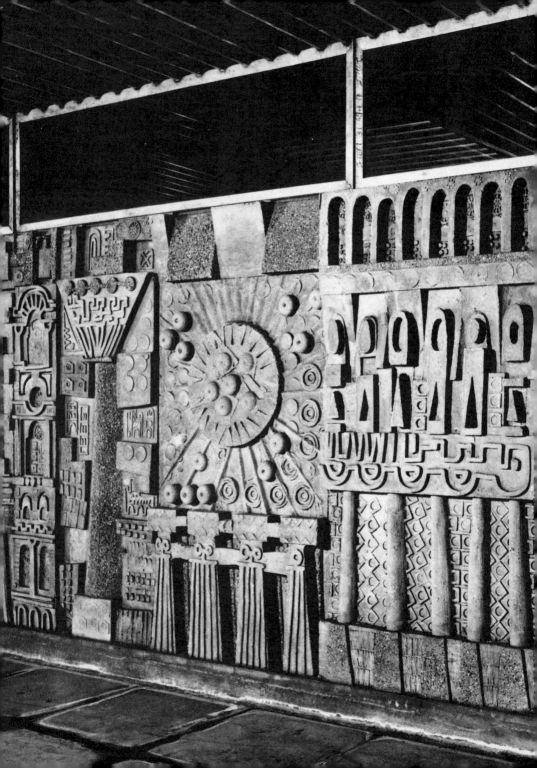

irrelevance to the building-task—will hardly hold water either, at least not as a blanket indictment. There are parts of many buildings—as for instance where one habitually finds oneself waiting for a taxi or a drink or for the Chairman of the Board to stop speaking—where some occupation for the restless eye and fretting mind is a positive functional need. In such places it would seem no more indecent for the restless eye to be offered occupation by abstract pattern conceived by an artist than by the natural abstractions of veined marble or wood veneer, and it is certainly conceivable that the mural will be more conducive to fruitful meditation than a framed portrait of the reigning monarch or the deceased founder of the company.

One cannot, then, use as a basis of appreciation any such simple dogma as 'ornament is crime' any more than one can accept Ruskin's belief that 'ornament is the principal part of architecture'.[1] The critical observer is left with the rather more exacting exercise of applying his judgement to the question whether in the particular instance under his eye it is truly an enrichment—in the sense that it gives some extra cogency and sparkle to the communication the architect is trying to make by way of space and structure—or merely a distraction. The distraction, it should be noted, may be inadvert or intentional. An architect may, if his judgement is erratic, design a building which is 'good in its bones'—that is, in the elegance of its space–structure relationship—and then give it the kind of fussy cosmetic treatment which no more enriches the aesthetic experience than the buzz of a bluebottle enhances the performance of a string quartet. Another may use the distraction of ornament quite deliberately to eke out the poverty of his imagination or disguise the weakness of his essential statement.

The temptations of this latter course are obvious enough, especially when one remembers that the unsophisticated eye is more readily caught by ornament than by 'pure' form; and so, in spite of the pendulum swing away from the prohibitionist attitude, there are still fundamentalists who fear the too ready acceptance of decoration as the first step on a perilous slope at the bottom of which the architect will find himself once more in his Victorian state as the rich man's cosmetician. In my opinion this anxiety is misdirected, for we are not in the Victorian situation. No one can unwrite the architectural history of the last sixty years or unmake the climate of ideas built up by

Concrete mural by
William Mitchell. *Cement and Concrete Association*

[1] *Lectures on Architecture and Painting* (1854).

such men as Lethaby,[1] Loos, Gropius, and Le Corbusier, nor can an over-crowded world afford the wastage on purely cosmetic tasks of people whose basic skill is the ordering of space.

It is true that one of the sources of Victorian ornamental exuberance—namely the desire of the power-owner to show off—continues to bubble away merrily and, human nature being what it is, will do so forever. It is also true that this motive often produces buildings which strike later generations as comical or irritating in the blatancy of their attempts to catch the eye. But it seems unlikely that applied enrichment will be the most favoured medium for this kind of courtship-display, for a much more forcible one, capable of catching the eye even at motor-car speeds, is available. The dramatic possibilities of form generated directly from a spatial conception (as at Ronchamp) allied to the form-inspiring resources of modern construction (as with Nervi) enable the whole building to evolve into an abstract sculpture on a superhuman scale, while the resources of modern lighting, putting that sculpture on exhibition even more conspicuously by night than by day, can dramatize the interplay of space and structure by floodlighting the solids and turning transparent walls into the glasses of an enormous lantern.

These dazzling possibilities are not without an element of danger, not to the architect's modern role as benefactor of society (his profession, in the mass, is both too idealistic and too shrewd to trade that in for the old one of monumental sculptor), but to his use of the language of his art. The new vision of structure *become* ornament is just as intoxicating as the earlier concept of structure glorified *by* ornament, and when he lets it go to his head it can affect his process of judgement and communication like any other intoxicant, investing a simple statement with wildly disproportionate aggressiveness or turning it into portentous rhetoric which he fondly mistakes for eloquence. One of the most difficult tasks of the enthusiastic architect has always been to learn to hold his aesthetic liquor and today more than ever he needs the understanding friend who can detect the symptoms and pull him up before he becomes a bore. This is the most valuable function of the critic—whether professional or amateur—and it involves some acquaintance with the process by which the architect's ideas are shaped.

[1] See Biographical Note.

It goes without saying that appreciation is deepened by cultivating the habit of intelligent criticism. By 'criticism' I do not mean the mournful activity of destroying a pleasure by analysing it out of existence or by picking it over in search of flaws. To explain why one likes something (besides being extraordinarily difficult) is rather like killing a butterfly and pinning it down on a board; but when one takes a spontaneous *dislike* to something it does seem to be in human nature to clarify the impression by finding an explanation for it. As a rule the people who enjoy X's beer simply go ahead and drink it without feeling it necessary to explain, like the man in the television commercial, about its manly, nutty flavour; it is the man who finds it weak, sour stuff who is most ready to put his opinion into words. If the opinion is an intelligent one and if enough beer-drinkers voice it, there is a chance that X and Co. will improve their brewing methods, and thus it is possible for intelligent criticism to operate as a form of quality control.

Such criticism is particularly necessary to the health of an art as public as architecture, and it demands in the first instance some knowledge of the possibilities and limitations of the medium. If someone says he dislikes X's beer because it makes a very poor filling for sandwiches, he is not going to be taken seriously; and by the same token it is not fair criticism of a Shakespearian sonnet that it does not have the epic range of a Shakespearian tragedy. Indeed if Shakespeare had ruined a sonnet by trying to squeeze the whole theme of *Hamlet* into it, he would be open to the perfectly just criticism that he had a magnificent theme but picked the wrong medium.

One is not only entitled but obliged to take this matter into consideration in criticizing a work of art. Obviously architecture is not, by nature, a representational art. An architect who sets himself to design an air terminal which looks like an aircraft or a yacht club which looks like a yacht is trying, in effect, to make a kind of visual pun in brick and concrete. At the best it will provoke a certain mild amusement which rapidly turns into boredom or irritation. Architecture is an art which must 'contain *within itself* the justification of its own primary forms'[1] and these primary forms, as we saw earlier, can

[1] Collins, *Changing Ideals in Modern Architecture.*

have only a coincidental resemblance to those produced by nature or man in wholly different circumstances.

A work of architecture has another peculiarity which affects the issue. It is not produced by the designer's own hand, and he does not therefore have that direct line of communication between the brain and the product which enables the painter or the sculptor to feel his way as he goes, taking advantage of the suggestions which the work itself will throw up as it takes shape. Long before the architect's work has begun to take on the physical form through which it will ultimately communicate something to the public he has had to translate his intention into an intermediary language (or more correctly a *notation*) of drawings and specifications, from which it has to be retranslated into reality by others. One might see here a parallel with the other 'arts of performance', such as music and the drama, but the parallel is not quite exact and its very inexactness is illuminating.

These other art forms allow the composer to continue working upon his aesthetic intention and clarifying it during rehearsal, and they also presuppose that the executants are themselves artists and, as such, capable of making some aesthetic contribution. The method of notation, in fact, allows a certain amount of latitude for individual interpretation by the performer. In architecture, on the other hand, there is no real equivalent of the full-scale rehearsal, while the contributory role of the operative has been progressively whittled away over the last four hundred years. In a money-dominated civilization the ideal contractual situation is one in which the whole work is conceived in detail and accurately priced before the first sod of earth is cut; no subsequent variation is tolerable, least of all by way of the operative's intervention as a creative individual. The more closely the architect approaches this economic ideal the more the whole aesthetic experience will come to depend on decisions taken, in detail and irrevocably, at the drawing-board stage. No fault of conception can be mitigated by the executant—as, for instance, brilliant production and acting can sometimes 'carry' a weakly written play. In fact the boot is rather on the other foot, for it cannot be counted as a virtue in the architect that he has conceived a design whose aesthetic potential depends on a standard of workmanship beyond the ability of the labour force at his disposal. A modern building must therefore stand or fall—aesthetically if not literally—on the merits of decisions made in a drawing-office at a very early stage, and some understanding of

the process by which these decisions are made is distinctly germane to the appreciation of its results.

Before the bricks can be put together the designer's ideas have to be put together, and before he can do this he has to conceive the ideas. They are not conjured out of thin air but generated out of the stock of experience at his disposal; and so, for a start, the building is going to reflect something of the richness or poverty of that experience, as well as the fertility of his inventive powers and the kind of discipline which he (or the society in which he works) imposes on those powers.

By 'experience' must be understood not only the personal stock stored away in the layers of his memory—and including perhaps such diverse items as a visit to Ronchamp, Mozart's flute and harp Concerto in C major, and the compressive strength of brickwork—but also the recorded experience of others stored in books and similar sources of information. The total pool might be compared to a mixed-up collection of jigsaw-puzzle pieces in which all the pieces of all the puzzles he has ever owned are thrown in at random with all the pieces of all the puzzles in the local shops. And if one imagines him starting to originate out of this mixed bag a *completely new* jigsaw-picture, beginning with a handful of new pieces which have just been handed to him, one will have a rough analogy to the process of design. The new pieces represent the data on the building-task—the purpose of the building, its site, the client's resources, and so on—while the completed picture which he has to produce (and whose form is at this moment entirely unpredictable) represents the building which will emerge from the process.

If this process is to have any success, it must begin with analysis; for the architect cannot just sit there stirring the heap of pieces and hoping they will mysteriously click together. He has to take a long, hard look at the new pieces, form a clear idea of their essentials, and extract from the heap only those which have some possibility of fitting. Then he can start putting together, which means looking for *possibilities of fit*[1]—and especially for those key pieces with multiple possibilities (Fig. 35) which allow whole areas of pattern to be joined together—rejecting misfits and dipping back into the heap for more pieces by which the pattern can be extended.

This is a step-by-step process of analysing possibilities and detect-

[1] This is the theme of Christopher Alexander's *Notes on the Synthesis of Form* (Cambridge, Mass., and London, 1964), a penetrating and valuable study of the nature of the design process, and one to which I have been greatly indebted.

ing relationships through which a new order can be produced out of chaos by making decisions between alternatives. At this level designing does have much the same absorbing interest as solving a jigsaw-puzzle holds for a child, and it offers the same excitement when a relationship is found which makes the whole thing begin to come out. Ideas are not inert bits of wood, however, for they have a suggestive life of their own. It is rather as if a piece of the puzzle were able to speak up and say: 'Try me with those two over there'. This power of ideas gives the design process, once under way, a kind of accelerative quality which makes it different from simple puzzle-solving, and it is to this force that the designer has become accustomed to look for the generation of his 'intention'. It opens his eyes, perhaps quite suddenly, to 'the way the thing wants to go'. Or to put it in another way, it makes him acutely conscious of a string of relationships which seems so likely to produce a far-reaching order that he feels compelled to follow it through to a conclusion.

The building will inevitably reflect the force or weakness, the validity or misguidedness, of the intention thus conceived which, as we now know, is really three intentions—functional, structural, and aesthetic—inextricably interlocked. For instance the string of relationships may extend excitingly but in a direction which stultifies the development of a broader order. Thus we find buildings in which the designer has committed himself to an intention generated by an exciting chain of structural insights or a compelling set of proportional relationships, and has developed it at the expense of the other two aspects, leaving behind a building which is eloquent of his cleverness in one facet of his art while betraying his ineptitude in the others. Again the intention may gather around itself a pattern of

Fig. 35

relationships which seems beautifully complete and self-sufficient but turns out on close inspection to have only the slightest link with the original 'pieces' which initiated the operation—that is, with the building-task. One's attitude to this kind of building inevitably depends on how far one brings moral judgements to bear on aesthetics (and on whether one is footing the bill), but it may be remarked that such buildings are rare birds indeed in a utilitarian civilization. Much more common are those which exhibit a pattern of relationships most conscientiously constructed from the basic data but not extending very far. The usual word for them is 'uninspired', and the fact that we apply it at all to architecture shows how deeply this idea of producing buildings by a private and individualistic process of design has entered into our attitudes of appreciation.

We know that there is a certain kind of excitement in the activity of invention, in detecting among a multitude of possibilities those relationships which are capable of being extended into an order which did not exist before, and we have seen that there can be a moment in the process when the way towards such an order is glimpsed so clearly that the excitement adds a dynamic force to the whole design process, sweeping the inventor along the path it is taking. Where, as in architecture, there is an aesthetic objective as well as a practical one such an excitement is communicable to others through the common language of emotionally charged form, since the 'useful' pieces of the architect's jigsaw—the properties of materials, the ways of handling space, and so on—have emotional associations hooked on to them which have to be built into the pattern and thus establish lines of emotional communication between designer and observer. In such a case the impact made on the observer does depend on the direction taken by the design activity at a particular point and the people who christened this point the 'moment of inspiration', in the belief that such peculiar hyperactivity could only have been breathed into the artist by a god, were simply explaining an observable phenomenon in the only terms which made sense to them.

It is in the nature of the phenomenon, however, that it can take place only in the context of the kind of activity we have been examining, in which the possibilities are multiple, the problem complex and immediate, the ultimate objective not visualized at the start, and the designer a single individual. Logically (assuming this individual follows through to its utmost the intention which infused the operation at the point of break-through) the building which emerges from

this inspired process can be expected to be a complete, self-contained, self-declaratory, and unalterable creation.

This is in fact the classical ideal of the perfect building; but we know very well that there are great and moving works of architecture which do not conform to it at all, which are the work of many minds over several centuries and from which quite important parts of the original conception—such as the spires which should have capped the towers of Reims and other French cathedrals[1]—have been left out altogether and apparently have never been missed. We know also that there are innumerable vernacular buildings in which we can clearly see an aesthetic intention—Scottish castles, for instance, are full of endearing irrationalities which were obviously the result of someone's fancy and are nevertheless completely integrated within the design-concept—although we can be quite sure that this intention did not grow out of any concentrated activity over the drawing-board.

It seems, therefore, that we must beware of concluding that the kind of building which represents the ideal product of the design process as we have come to know it will necessarily provide us with a critical yardstick for applying to buildings born of a different process. If we make that assumption and apply that yardstick, we shall only be blinkering ourselves to whole worlds of wonder and delight, as did the classicists who dismissed the Gothic as 'rude and barbarous'. To take a broader view of the process, we have to go back to the analogy of the puzzle-pieces.

We have seen that under modern conditions the designer has to search out all the relationships between the pieces and fix them in his mind and on paper before the work starts. For the eighteenth-century architect this had already begun to be a necessity because he was working within a framework of classical rules of 'harmonious composition' which governed the relationships of parts to the whole and left little room for the happy accident. The modern architect is also bound by disciplines which, although different, are still more exacting.[2] The medieval builder, however, was in a different situation

[1] Pevsner, *An Outline of European Architecture.*

[2] Because they derive from formulas which are essentially abstract and negative (the cost per unit area must not exceed x shillings or dollars, the distance between fire exits must not exceed y feet, and so on) and which, being unrelated to aesthetic values, provided a challenge to ingenuity rather than a direct aesthetic stimulus. The Classical disciplines on the other hand, being devised by designers specifically to assist the forma-

and the primitive vernacular builder in a different situation again, and we can understand their architecture much better if we look at their very different approaches to their own jigsaw-puzzles.

The great medieval buildings were not put up in a hurry. They were interrupted by disasters, plagues, and shortage of money, a 'stop–go' process extending sometimes over centuries: and even on those which went smoothly we may find that the mason-in-charge ('job architect' we should call him today) had grown from apprenticeship to middle-age on the same site. Against such a time-scale, and with executants who were capable of translating a broad conception into detail out of their own gradually matured craft-lore, there was no sense in trying to build the whole pattern in advance. It was only necessary to fit together the pieces which established the main chains of relationships, in the sure knowledge that sufficient pieces would be forthcoming, out of the communal store of experience on the job, to fill in and carry forward the pattern without any very noticeable discord as the years rolled on. The executants were not handed a cut-and-dried intention, worked out explicitly to the last detail; they *lived with* an intention, contributing to it and making it grow under their hands, modifying it as might be necessary when it seemed to be pulling in an impossible or wrong direction.

They were assisted in this by the fact that the number of pieces in the store was limited not only by the simplicity of their technology but, more important, because so many possible misfits had been discarded already. The 'rightness' which we often claim to detect in such buildings is not imaginary; it is the product of a long process of testing forms, keeping those with the maximum possibilities of fit with regard to the kind of problem expected and rejecting the others. The process which today's designer has to carry out afresh with each new problem (and for which he may need a computer) had already been run in slow motion as far as the medieval builder was concerned, and the unknown variables which can so easily lead to an unfruitful or disastrous decision and a muddled intention were relatively small in number provided he knew his job as a craftsman.

The medieval mason was, as we saw earlier, deeply engaged in the progress of the long dialogue between space and structure and

tion of the *aesthetic* intention, did present a true aesthetic challenge. The distinction is rather important because the thoughtful observer, having recognized that in Georgian architecture discipline is often the very foundation of delight, tends to wonder why our own highly regimented age produces so few parallels.

although each step forward was based almost entirely on craft-lore, they were forward steps nevertheless. The process of evolution by misfit-rejection, although slow, never stopped and tended always towards the favouring of forms which were adaptable to the next move. Hence the appearance of organic consistency (quite different from the very determinate consistency of Classical work) which these buildings so often have even when they embrace work by different hands and of different periods. The situation is still simpler, however, in the case of the primitive or vernacular builder living in a society which has no such urge towards continual adaptation and whose demands upon space are not complex. Here the pieces of the puzzle are few and there is no long process of analysing possibilities before the individual builder starts his operations. The available alternatives were sorted out long before by generations of his predecessors who set the needs of survival and comfort against the facts of climate, materials, and resources and evolved an optimum formula, dictating for instance 'the proper shape for a house', the pitch of its roof, the placing of its openings, its orientation. Aesthetic inventiveness in such a situation is curbed by the fact that in such a society a good-looking house is by definition a house built according to the formula for a good house in the practical sense, and this formula may over the centuries become charged with a quasi-religious significance which makes change unthinkable and limits the inventive role of the builder to personalizing his own house by distinctive ornament. In the extreme case the primitive builder may be as closely bound by precedent as the modern builder by the architect's plans, with the important difference that the forms dictated to him have not been generated out of any single high-pressure operation in the mind of an individual but have evolved by a slow process of exploring the fruitful options and dismissing those which, on past evidence, lead to failure. Consequently these forms are valid for the whole of that culture in that place. They belong together and they belong to that place, and convey the same self-assured rightness of intention which the drawing-board designer is trying to achieve by a selfconscious[1]

[1] I owe this terminology to Alexander's *Notes on the Synthesis of Form*. He distinguishes between the 'unselfconscious' culture (in which functional requirements are simple and static and design decisions are made according to established custom) and the more advanced 'selfconscious' culture. In the latter new functional problems are perpetually arising and call for a design approach 'based on explicit general principles of function rather than unmentioned and specific principles of shape'.

process. It is not an accidental rightness, though it often looks casual; it is the result of a design process guided by an intention which is no less real for being formed by a community over centuries instead of by an individual in a flash of inspiration. The delight which such vernacular buildings can give is not the gift to humanity of a single mind but on the contrary a vindication of W. R. Lethaby's dictum that 'architecture is more than one man deep'.

Much more than this could be said about the design process, and the influence which the organization of that process has upon the architecture of any given place and time. Even this brief sketch, however, should have been enough to establish a groundwork of under-standing and such a groundwork is even more necessary to the critical appreciation of the architecture of the present and the future than that of the past. We have seen that the process as now organized necessi-tates the production and explicit setting down, in advance and in one self-contained operation, of a most comprehensive intention by which the building must stand or fall. We have seen also that in a different situation the intention is not so worked out, in every detail and in its minutest implications, but grows as the building grows, the initial designing being rather in the nature of providing a stable trellis-work for this growth and the contribution of the individual being merged in a continuous operation of the many. And we have noticed a dif-ferent situation, again, in which the master-theme of the design is prescribed by long-established custom and the individual can only contribute personal variations within accepted bounds of propriety. Finally it has, I hope, been clear that all these modes of organiza-tion, tending though they do to very different approaches to the use of the architectural language, are capable of arousing wonder and delight in anyone who looks at buildings with open eyes and mind.

As observers we have today far more open minds than, say, the connoisseurs of the early eighteenth century. We are prepared to see more than 'rude grandeur' in the medieval cathedrals and to find higher qualities than 'picturesqueness' in vernacular and primitive architecture. As creators of buildings, however, we are inevitably handcuffed to the selfconscious design process which has evolved out of the complexity of our civilization and the correspondingly complex structure of its building industry; and this process tends to-wards the ideal of a building which—however deeply rooted in social purpose and however removed in function from monumentalism—is,

nevertheless, a complete, precise, unalterable, and eloquent statement born of a single-minded and comprehensive intention.

Every architect hankers after eloquence and it is necessary to society that he should do so. His building is not a private communication between individuals but a public performance for which he is both author and stage-director, and our lives are not made more tolerable, far less enriched, if this performance leaves us bored, irritated, and confused. This present examination of the design process was initiated, certainly, by the suspicion that the new possibilities of his art can easily tempt the architect into ridiculous rhetorical overstatement—a temptation to which he is still more exposed, as we have just seen, by his elevation to the position of aesthetic dictator-in-detail—but it is not real eloquence that the critic, as his understanding friend, must be prepared to censure. Like the theatre critic, the observer of architecture has to equip himself to distinguish between this genuine and emotive quality and the rhodomontade of ham acting and over-assertive language which are more likely to produce boredom than dispel it, and for this it is necessary to pursue the question of communication a stage further.

Because it is an admirable quality in the evangelist, the advocate, and the lecturer, eloquence is often assumed to be the same thing as oratory, rhetoric, or the power of exposition, whereas it is really a factor which enters into the judgement of *all* attempts at communication between man and man. It is not a term which we need reserve for the criticism of complicated or consequential communications such as the advocate's address to the jury or the politician's effort to sway a mass-meeting, for we know very well (and the cinema keeps reminding us) that a gesture as small as the twitch of a facial muscle can justly be described as eloquent. Nor is eloquence to be confused with wordiness or elaboration on a simple theme, for it is just as often a matter of making the maximum impact with the greatest economy of means. Mies van der Rohe's axiom 'less is more' not only describes his own highly refined idea of eloquence in architecture but is itself an example of eloquent terseness. Nor, again, does it necessarily depend on the possession of a great range either of ideas or of vocabulary, for many simple people have the power, both in speech and in gesture, to illuminate an idea or an emotion in a way which permanently impresses itself on the memory, and in this simplicity also we find eloquence.

It is, in fact, by this capacity for impressing an idea or a theme upon the memory that we should most properly recognize the eloquent communication, and it lodges its theme in the mind because the elements of the language have been put together in a particularly penetrating way: in the common phrase, it 'strikes home'. This is as true for architecture as for any other kind of human communication. We have already seen that the essential and irreducible theme of a work of architecture is concerned with the relationship of space and structure and we have imagined it as a statement that the dialogue between the two has been settled in a particular way. We know, too, that other themes can be intertwined around this main theme, like the sub-plots within a play, and that they may—as with the sculpture-themes of the Greek temple or Gothic cathedral, or the rhythm-themes of the Renaissance palace—play a most important part in supporting or amplifying it. We have also seen that these themes penetrate into the consciousness of the observer by way of an experience of movement

through space which may be quite prolonged in time and in which several of the senses are involved, so that it is *sustained* eloquence rather than the epigrammatic flash of wit which the designer must achieve if the experience is to be memorable in its totality. He has not only to engage his audience but keep it engaged over a period, neither boring it by monotony, nor irritating it by incoherence, nor shocking it into unreceptive stupefaction by a reckless or badly planned attack on its security-system. Sustained eloquence, therefore, is not to be confused with verbosity—whose architectural equivalent is the over-burdening of the primary forms by irrelevant enrichment—or with the kind of emotional tirade which defeats its own object by inducing embarrassment or sheer fright and, if sufficiently prolonged, induces tedium as well.

It has been said earlier that the enjoyment of architecture is in some respects more akin to attending a performance than contemplating an object, and architecture certainly shares with the arts of the stage this necessity for sustaining a level of eloquence which engages the audience throughout the whole experience. The creator of any dramatic entertainment, whether it is a pageant, a circus, a ballet, or a play, has the problem of holding his audience and the techniques for doing so are a part of his craft without which neither nobility of theme nor lavishness of production will necessarily assure him a hearing. Some of the devices which contribute to the indefinable quality of 'good theatre' can be translated into architectural terms and will be seen to contribute to that equally intangible quality which, in Paul Valéry's words, makes some buildings speak and some others —the rarest—sing, while others remain dumb.[1]

There is for instance variation of *pace*, and its architectural parallel is the modulation or counterpointing of rhythms; as we have seen in the case of the Quirinal and the Doge's Palace, the presence of such modulations can mitigate the monotonous or overpowering quality of a sustained simple beat, and their absence can make a long, depressing street-frontage seem doubly long and doubly tedious. Closely related is variation of *emphasis*, that is, the pointing up of a significant incident or phrase, with which we may compare the architect's use of the properties of shape, texture, light, and colour as a means of articulation. These two devices can by themselves go a long way to dispel boredom. The observant eye can find a certain refreshment in

[1] *Eupalinos; or, The Architect* (trans. W. McCausland Stewart, 1932).

a London terrace of the late eighteenth or early nineteenth century, undemonstrative though its architecture is, whereas the mid-Victorian 'by-law street'[1]—although built to a very similar basic formula of plain, narrow-fronted, brick-built units repeated along the whole frontage—suggests nothing but a mean and stultifying monotony. The extra quality of the earlier example does not lie in the basic space–structure theme (which is of the same simple kind in both cases), nor in the material used, but in the thoughtful treatment of correspondences (for example, the varied but related window-heights) and contrasts (painted stucco window-margins against dark brickwork, giving sharpness and definition to the rectangle) and in the restrained emphasis given to the street-door and the windows of the principal rooms.

In the theatre these devices of variation are used not merely to dispel monotony but as means towards a more ambitious objective, the variation of *tension*. Tension is the very stuff of drama and it is the existence of a play of tensions which gives a work of architecture, too, the quality which is often described as 'dramatic' or 'exciting'. Such a quality may originate in the confrontation of space and structure. In the High Gothic cathedrals of France, for example, or in such modern works as the sports-halls by Nervi and by Tange already mentioned, the tension is inherent in the challenge thrown at structural imagination by spatial demand. In Renaissance and Baroque work, as we have seen, it arises from a different sort of conflict, this time between spatial demand and structural *convention*, finding its expression less in constructional virtuosity than in the dramatic manipulation of the scale and shape of both solid and space within that convention. It is one of the peculiarities of our own time, on the other hand, that the dramatic roles of space and structure have been reversed. It takes a very ambitious spatial requirement indeed—as in the two examples just quoted—to extend modern structural possibilities to their limit, and below this level of demand structural possibility is not the challenged but the challenger. It says to space— that is, in effect, to human functional need—'Here I am. Come on, use me.'

This is a subversive invitation, for it tempts the architect to twist the spatial side of the argument—that is, the side concerned with human needs—beyond all logic in order to make melodramatic capital

[1] A street built strictly to the letter of the by-laws which gave effect to the minimal requirements of the Victorian Public Health Acts.

out of an inherently simple and commonplace situation. The 'over-designed' building so produced is architecture's equivalent to the play with a contrived plot, in which a simple situation is twisted into an agonizingly artificial shape in the attempt to give it some epic quality. Like it (and unlike the work whose dramatic quality is really inherent in the basic theme) the over-designed building risks falling from esteem once its exciting quality has been traced to structural perversion. It is usually the sensitive and discerning critic who first finds it tiresome: it sets his teeth on edge for various reasons, of which the most valid, perhaps, is its essential lack of the virtue of economy of means. Instead of applying his skill to playing upon tensions which do exist, the designer has gone out of his way to erect an apparatus of dramatic tension on no real and substantial foundation. We have seen that there are two ways to delight, one of them leading along a clearly defined and predictable course from one satisfactory sensation to the next while the other unfolds through a series of speculations, doubts, and reassurances, and we know that the normal man likes to have a foot on each. The tension inherent in this dual orientation is always accessible to the architect and he can play upon it, if he knows his language well enough, even within the limits set by a logical and in itself not particularly heroic settlement of the space–structure argument. One may extend the theatrical parallel to point out that it is not the sweep of heroic events which moves the audience of a Chekhov play, but the exploration of the human predicament through the subtleties of character; and we need the Chekhovs of architecture no less than its Shakespeares and Racines.

Still more we need designers who are capable of eloquence at a much lower level of tension, for humanity does not seek to be 'purged by pity and terror' at every street-corner. Most buildings are called upon to be incidents in the panorama of the city rather than to provide great climactic experiences. Our encounters with them are casual meetings rather than pilgrimages, and it is the aggregate of such contacts which makes urban life on the whole stimulating or soul-destroying, pleasurable or sordid. When one recollects a certain street or house as a pleasant place to have visited, one is acknow-ledging that it has made itself memorable not as the great public spectacle is memorable but by handing out some small enrichment of life.

To design a building of this kind really well is not necessarily as simple as might be supposed from the modesty of the result, for it

calls for the same 'unsleeping sense of the appropriate'[1] which characterizes the great work and indeed its very understatement requires a delicate skill in handling the finer shades of the architectural language. The appreciation of its qualities, too, may depend on the detection of modulations of rhythm, shape, texture, and colour which may be very subtle; and to receive all these subtleties one needs the kind of familiarity with the language which comes only through the habit of 'reading sign' on architecture by noting and comparing the different ways of putting the elements of the language together, as a moment ago I compared the London terrace with the by-law street.

It must be repeated that there is no easy substitute for the habit of direct and acute observation; and certainly if one aims to enjoy architecture as a whole, and not simply the work of a particular period in a particular country, one need not look for much help from formal rules of composition. The principles of correctness which in the view of Classical revivalists were indispensable to the creation of 'good form' are not the same as the principles—largely based on an explicit code of religious symbolism—which Byzantine architects supported as strongly, and neither of them can provide a ready-made critical apparatus to assist the appreciation of a Japanese temple or a Persian mosque.

It always helps, however, to understand the aim of one's mental processes, and in this case the aim (whether one is conscious of it or not) is essentially the *assessment of fit*. One instinctively applies the criterion of fit to a building which has come under observation, even when one is not primarily concerned with aesthetic values—a well-built house, in anyone's language, has its parts well fitted together in a craftsmanlike way and is not simply botched up. In forming an opinion of its aesthetics one is equally looking for evidence of misfit (that is, for the element which seems to connect badly with the rest) and at the same time hoping to see that evidence of eminently *good* fit which is the mark of a heightened sense of the appropriate; and one's total assessment of the building's eloquence is a summation of these impressions of aptness or ineptness of fit.

This statement needs some qualification, however. Mere absence of misfit is not a very high quality in itself. It produces a building which is inoffensive and, while that is certainly something to be thankful for, it is not much of a positive contribution to the enrichment of life.

[1] H. S. Goodhart-Rendel, *Vitruvian Nights* (1932).

What one is hoping to find, rather, is the more positive quality described by Alberti (who called it *concinnitas*, literally 'perfection of fit') as 'the veritable nourishment of all grace and splendour':[1] that is, the kind of correspondence between part and part, and between each part and the whole, which enhances the inherent virtues of each by harmony or contrast with the qualities of the others. The search for such correspondences has its own dangers, since it tends to lead towards an idealization of the explicit and definable, and even towards the belief that 'grace and splendour' can only be achieved through adherence to explicit and definable formulas.

At first sight, therefore, it might seem that no theory of appreciation based on the concept of fit could concede the existence of the kind of delight which we find in the indeterminate, paradoxical, and even incongruous. To draw such a conclusion, however, would be to confuse 'good fit' with 'tight fit' and this is not a mistake which should be made in aesthetic judgements of architecture any more than in the judgement of its practical aspects. A door is evidently a bad fit if daylight shows all round it, but it is not a virtue to have it fit its posts so tightly that no one can open it: on the other hand we will not call the *parts* of the door well-fitted unless they are tightly put together so that it keeps its shape. In other words we make our judgement in the light of the total purpose of the thing, and of the degree of tolerance which that purpose allows.

The same applies to the judgement of architecture in its broader sense. If the whole emotional tenor of the experience, built up by the disposition of its spaces, its rhythms, its play of shape and light, is reaching towards the mysterious or fanciful pole of delight, an element or pattern of elements which intentionally breaks the spell will be a misfit in this broadest sense however perfect *in itself* this intruder may be. There are even occasions when the lucid and candid classical statement benefits by a well-placed injection of the incongruous, just as a passage of speech may be illuminated by a paradox or a passage of music or painting by a discord. It should be noted, for instance, that not all eloquence, even in architecture, is necessarily serious: there are architectural equivalents to the eloquence of the after-dinner speech and the light comedy and, unless one is an unnaturally solemn character, one will tolerate a higher level of incongruity and ambiguity in the architecture of pleasure—in the pub, the coffee-bar, and

[1] *De Re Aedificatoria*, Lib. X.

the discothèque, for example—than in the architecture of business and ceremony.

Every stable culture has a tendency to arrive at its own communal conclusions about what is acceptable as good form both in this wider sense of the kind of architecture which fits various modes of social behaviour and in that narrower field of detailed aesthetic judgement which prescribes, for instance, that the 'correct' ratio between the diameter and height of a Roman Doric column is 1 : 7. Such decisions, collectively, form the basis of a *style*, that is, a particular dialect of the architectural language which, in the eyes of that culture, provides a satisfactory way of ordering the various parts in the light of their several functions. We have already seen how in a primitive culture such an order has evolved through the rejection, generation by generation, of the obvious misfits—the tool which fits the hand badly, the roof which fails to shed rain, the pattern or colour-combination which nobody likes—and can result in special values, which become aesthetic values, attaching to those which have been promoted by this slow process.

Such forms then assume the property of signs in an aesthetic code, capable of conveying a message to the public when used according to the conventions of that code—capable, for instance, of giving the building its place in a hierarchy of social importance. One very commonly finds, in such societies, that certain forms, patterns, and colours are reserved exclusively for the chief's house or the shrine. A tradition so established may sometimes be passed on and perpetuated long after the original basis of selection has been forgotten, and even after the society itself has become extinct. The portico of the Georgian mansion and Colonial courthouse stands in line of descent, through the public buildings of the Roman Empire, from the *pronaos* of the classical Greek temple and this in turn was an idealization of the veranda of the *megaron* or chief's house of Homeric times.

The requirements of the stylized code may be close and comprehensive, determining the whole form of the building. The builders of the beehive-shaped *trulli* of Apulia, for instance, were 'allowed latitude for individual expression only in the lump of plaster which crowns the cone of the roof '.[1] But in a more highly developed culture it is less often the total form which is prescribed, the sign-system being—as in Roman and Renaissance work—an open one which

[1] Alexander, *Notes on the Synthesis of Form.*

allows its parts to be put together in a variety of combinations pro-
vided certain more or less standardized conventions are observed.

The existence of a common style of this kind is a great help both to
the designer and to the critic. From the designer's point of view it
reduces the number of dubious pieces in his mental jig-saw puzzle and
enables him, without exercising more than average competence, to
produce a building of quite high 'fitness-appeal' or, if he is more
ambitious, to concentrate his whole energy on exploring, with a high
chance of success, the possible combinations of the 'good' pieces that
remain. It will also provide him with ready-made and tested solutions
to one of the key problems of architectural detailing, namely the
problem of 'collisions'; for it is at the meetings of one plane or shape
or material with another that the question of fit, both in the practical
and in the aesthetic sense, becomes acute and it is here that all sorts of
ill-considered design decisions come home to roost. When a modern
architect calls a building 'meticulously detailed' it is the able handling
of these collisions that he has in mind, for in present-day architecture
—where, as we have already noted, the opportunities for ornamental
camouflage are strictly limited—this quality assumes a particularly
high importance. The kind of building whose spatial effects are
obtained by butting planes of plate-glass at right angles against a solid
flanking wall and against, say, a marble floor at the bottom and an
acoustic-tiled ceiling at the top can in fact provide the keen observer
with a happy hunting ground of difficult collisions, in which he can
train his eye in the detection of fit and exercise it for the appreciation
of the more delicate shades of appropriateness to be found, for in-
stance, in Georgian and Colonial architecture.

The run-of-the mill domestic buildings of the late eighteenth and
early nineteenth centuries are in fact outstanding examples of the
benefits of such stylization. Coming as they did at the end of a long
and gradual process of style-refinement—indeed, just at the point
when the possibilities of that style had been quarried almost to ex-
haustion—their builders (often working from pattern-books and
not to architect's instructions) were equipped with a very refined
repertory of devices for contriving the junctions and terminations of
elaborately moulded timber finishings and plasterwork. When we
call the houses of this period 'beautifully built' we are responding
to an evidence of fit which Alberti would certainly have recognized
as *concinnitas*.

The communal acceptance of a style also makes it relatively easy for

the critical observer to rationalize his subjective judgements once his memory-store has been stocked with a selection of ideal patterns against which he can test the forms presented to him: if they fit the ideal, no more searching appraisal is necessary, since the ideal itself has been constructed by a process of misfit-rejection. Consequently the connoisseur who is judging[1] within a single style has a relatively narrow field of vision. The style is the embodiment of its own general principles, whether they have been formed by the unselfconscious primitive process of imitating the good and rejecting the failure or by the academic rule-making of the selfconscious culture. He can safely base his opinion of the work upon its conformity to those principles and, beyond that, by the felicity or otherwise of the variations which the individual designer has introduced within the limits of tolerance permitted by the code.

It will be generally agreed that there is no such convenient short cut for the observer of modern architecture. At the most he may be able to distinguish the 'style'—in the more restricted sense of personal idiom—of this architect or that, or the house-style by which a busy firm may seek to reduce the increasing burden of decision-making by individuals; but he will look in vain for any universal stylistic guide to the twentieth century's idea of good form. In a complex culture whose building-tasks are highly diversified and which is endlessly productive of new techniques for meeting them, there is no inevitable and immutably 'right' way of doing everything, little opportunity for potential misfits to be weeded out by the slow, assimilative processes of craft-lore and no generally accepted symbol-system reflecting the importance which society attaches to certain kinds of building, which may provide a key to the kind of eloquence considered fitting in each particular instance. It is the more necessary, therefore, to probe to fundamentals and to recognize, without the help of any architectural phrase-book or toast-master's guide, the eloquence which arises from the sensitive modulation of the emotional associations of form, space, and light, and from the perfect consonance of the functional, structural, and aesthetic intentions.

It is necessary, too, to recognize the kind of eloquence which is produced by the apt placing of a building in the landscape or town-

[1] I hope the reader will remember that I have in mind the kind of judgement which enables a man to form his own tastes and question his own prejudices. Such judgement is necessary to the appreciation of architecture: the magisterial kind, which merely awards a 'pass' or 'fail' according to some prescribed formula, is not.

scape which forms its context. For a work of architecture is not only to be interpreted as a single communication contained within the boundary of its outer walls as an easel-picture is contained within its frame: it is also part of a place, and the interaction of building and place, the fit or misfit of one to the other, affects the aesthetic experience no less than the fit or misfit of its parts to one another.

It will have become clear to the reader by this time that the interaction of force and restraint is a recurrent theme in the study of architecture and that the appreciation of any building is widened by some insight into the workings of that interaction. This is as true for the relationship of the building to its site as it is true for the relationship of its parts to one another. But the building stands not only in a context of place but in a context of time and society. The forces which brought it into being were the needs and aspirations of human beings in that place at that time, and the restraints were those imposed by their technical, material, and economic resources as well as by the code of social behaviour (whether embodied in unwritten convention or in statutory instruments) which that particular culture saw fit to impose on its designers.

The relationship of building to site will not only say something about the resources available to the builder—the rich man may flatten a hill, the poor man has to make the best of it—but tell how he, as an individual within a culture, felt about the whole matter of the context of place. This is most obviously true where the building is one of a group—it may look like good company for them, or like an august guest or a brutal intruder—but it is no less true of the isolated individual building. A great Palladian mansion like Stowe, for instance, expresses very clearly the concept of the self-contained single composition, but its character as a building cannot be wholly dissociated from the treatment given to its setting. The natural landscape around it is not natural at all but contrived as part of a total aesthetic experience of which the building is the climax and in spite of the two hundred years that have passed this connection between building and landscape is still something which speaks to the observer. It is the embodiment of a way of life not yet too remote to be interesting, and the experience of the building in its *whole* context of place, history, and social assumptions would not be the same if the parkland were ploughed up to the door.

Our present-day habit of thinking of a building as a 'work', like a painting or a piece of sculpture, tends to blind us to this importance of context. Quite often, for instance, a community will decide, very properly, that a particular building is worth preserving in its own

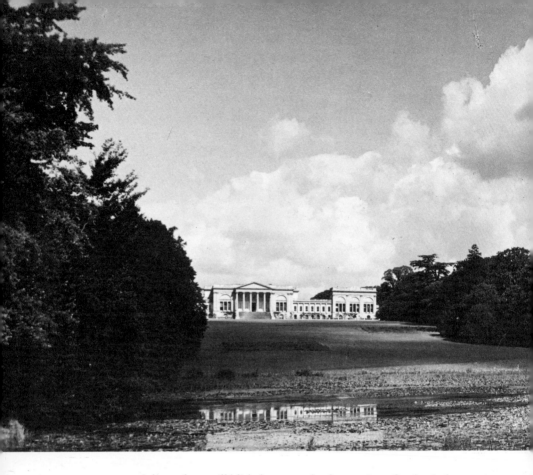

right, and yet will blithely accept the destruction of a physical context of adjacent buildings which, acting as a foil, gave it the greatest part of its aesthetic significance. The demolition seems no more unreasonable than throwing away one's old clothes; but in fact it has done something to make that community's own human context a little more meaninglesss and confused than it need have been. For buildings have not only the capacity to act as pointers (like the spire of the parish church) by which we can take our bearings in space: they are also embodiments of history, reflections of past cultures, and by setting our own achievements against them we can take our bearings in time, deriving from their mere existence some necessary reassurance of continuity.

Our callousness in this matter is a sign that we are losing our *sense of place*, an expression which means something different from the

Stowe, Buckinghamshire,
by William Kent. *Country
Life*

ability to make accurate topographical surveys. It is a sense which is usually strongly developed in 'unspoiled' primitive people, partly because their survival depends on knowing the right fishing-place and the good pasture and partly because their world is peopled with inexplicable forces which make one place lucky and another unlucky and which have to be propitiated. Innumerable wayside shrines all over Europe, the special places of ancient cultures wisely adopted and baptised by Christian missionaries, remind us of this, as do the isolated temples on Greek hill and headland; for the ancient Greeks, like the Japanese, had elevated the primitive idea of the 'specialness' of place into a metaphysical system in which the placing of a building in a particular setting could play an integral part in establishing a relationship between man and the unseen forces of the cosmos.

In such societies the practical and superstitious feelings about place

go hand in hand, for the working life, the home life, the religious life, and the place are not split apart as they are for the suburban commuter: hence the 'atmosphere'—a vague but convenient word for describing a particular kind of aesthetic and social consistency—which makes their villages places of refuge for the city-dweller. Hence, too, the shattering effect which his intrusions commonly have on the close-knit pattern of such settlements, for the architectural elements in that pattern are in the main products of the unself-conscious design process. A common idea of the rich man's house, the poor man's house, the church, once established, has produced continuity over a long time-span and the accepted vernacular type-detail of door, window, or chimney-head tends to run through the whole settlement as a recurrent motif. The synthesis is most complete when the place itself supplies the materials of building: the farmhouse may be built of the same stones whose removal made the fields cultivable; the trees felled to make a clearing form the wall of the log cabin.

These circumstances are very different from those prevailing in an environment created by the modern design process, and this makes it extraordinarily difficult to integrate the products of the one with the products of the other. Mechanical precision of line, surface, and dimension are luxuries to the peasant craftsman—we have already noted that the difficulty of achieving this quality made it the perquisite of the rich, if obtainable at all—and so wherever his stylistic convention allowed latitude for improvisation he improvised to suit the materials as they came to his hand. Since this is the very antithesis of the modern design process, just as the roughly hewn material is not the natural outcome of the modern manufacturing process, it is not surprising that attempts to reproduce vernacular building so often carry the stamp of artificial folksiness rather than true congruity with their neighbours.

To achieve congruity between building and landscape, or between old building and new, the architect has to rely on a profounder faculty than the ability to reproduce traditional detailing. The concept of place, of the unity of human and habitat, played an almost mystical part in Frank Lloyd Wright's philosophy, but he did not design his 'prairie houses' as imitation log cabins nor model his own home in the desert on the *hogan* of the Navajo Indian. He seems rather to have passed the significant elements of the landscape through the crucible of his own deep feeling for place and his own powerful imagination and to have produced from them some virtue which gives the building

its sense of belonging. The same capacity characterizes the work of Alvar Aalto, which seems to belong to the landscape and the people of his country much as does the music of Sibelius, but which no one could reasonably describe as 'Finnish vernacular'.

It is not to be concluded, therefore, that the selfconscious design process is by its own nature inimical to the ideal of a special harmony between building and place, but it will only succeed in establishing this liaison when the designer is capable of bringing the feel of the place into focus with the context of time and society against which his own attitudes have been hammered out instead of trying to reincarnate ideas and attitudes which are irrelevant both to the building-task and to the design process itself. There is one factor, however, which must enter into the reckoning. It makes abundant sense for the vernacular builder with his limited resources to adapt his building to the contours of the site; but for the modern architect with the resources of modern plant it may make much more sense to adapt the place rather than the building. The decision between these alternatives is not necessarily made for him, as in the primitive case; he has to make it as a conscious and calculated design-decision which will have a profound effect on the whole aesthetic impact of the building.

He may be confronted, therefore, not with the problem of creating a building well adapted to its place or one which celebrates (like the Greek temples) the 'specialness' of a particular place but with a problem of a different kind, which is nothing less than the *creation of place* in the sense that he has to set about endowing some considerable part of the human environment with a new and special quality: not merely creating a new physical context, which is a matter of public-works engineering, but imposing a new and pleasurable aesthetic order.

To leave one's mark on the earth's crust in this way has always been reckoned a notable achievement, and until our own time it has generally been the prerogative of the powerful and absolute ruler. So it is not surprising that the large-scale civic architecture of the West and Western ideas of 'urbanity' have been deeply influenced by the pretensions of Baroque rulers.[1] We have already noticed how

[1] The emergence of Baroque social attitudes and their influence on city design has been most ably treated in Lewis Mumford's *The City in History* (1961), a major work which is necessary reading for anyone who seeks an understanding of architecture as a component of the total human environment.

they imposed their concept of aesthetic order on the immediate land-scape around the palace or the mansion, and these same concepts of order also characterized the Baroque attitude to the design of cities. Hence we find the long vista closed by a building of importance such as a palace or a church; the formal sequence of the opening and closing of space, the boulevard, the crescent, the square, the circus, each indicating in its own way whether one is expected to keep moving or invited to loiter; the magnetic features—for instance the obelisk, the statue, the fountain—which mark the focal points in a pattern of directed movement.

In all this the Baroque city and its derivatives are marked by the Baroque sense of occasion. The sense of occasion is another kind of sensitivity to context and, like the sense of place, it offers a contribu-tion to the reality of life which our contemporary society has sadly watered down. The office Christmas party is a very feeble echo of the rituals with which primitive man—to whom they are of vital concern —marks the turn of the seasons, and recurrent rituals of this kind may have such religious force, even in urbanized societies, as to exercise an effect on the placing of buildings: It has been pointed out, for instance, that the route of the Panathenaic procession had such an influence on the shape of the *agora* and the placing of its public buildings that 'the position and size of the Parthenon are compre-hensible only when it is viewed in relation to the entire Panathenaic sequence'.[1] Similarly the cathedral, a focus of great religious festivals as well as the ordinary rituals of daily life, was generally a determinant in the medieval town-plan, having its effect both on the street-pattern and on the placing of other buildings such as the guildhall; for it also had a processional approach, unfolding (as in Greece) by stages and turns and sidelong twists and surprises.

In both these examples we can see man, even in his urbanized state, adapting himself to place in the unselfconscious designer's way. The Baroque plan, by contrast, was far from unselfconscious, for it was formed according to studied academic principles whose objective was not the adaptation of buildings to natural or time-sanctified lines of movement but rather the *enforcement* of new lines of movement, and the placing and scale of its buildings were, ideally, dictated by this motive. The eloquence of the important building was not to be considered as a casually placed outburst but as the climax of a planned experience of movement through space to which the whole

[1] Edmund N. Bacon, *Design of Cities* (1967).

urban setting would form a carefully modulated introduction. The unity of the medieval town was the natural result of the unselfconscious design process working upon a limited range of materials and building-tasks. The unity of the Renaissance town lay in the family resemblance of buildings which, however haphazardly placed, had a certain stylistic consistency. But the Baroque conception of unity was something much more ambitious, for it involved planning the city as a producer might plan some great theatrical spectacle, in which the minor buildings are not individuals who happen to be around 'on stage' but are most deliberately grouped according to a hierarchy of importance in which the great public building is the star performer, lesser public buildings have supporting parts, and the housing which forms the lowest rank is arranged as a disciplined chorus-line.

To impose such a pattern on open landscape—as, for instance, Peter the Great sought to do at St Petersburg—is no small ambition in itself; but to impose it on the living organism of an existing city requires power, ruthlessness, and patience of a wholly extraordinary kind. Wren's plans for rebuilding London after the Great Fire of 1666, for example, foundered on the conflicting and powerful interests of the ground landlords, in the face of which his royal patron was virtually powerless. Consequently we generally find that even the most powerful Baroque rulers had to confine their activities to relatively limited areas of their cities, and even then seldom lived long enough to see their dreams materialize.

Nevertheless the ideas generated by the Baroque sense of place and occasion had an influence out of all proportion to the extent of the work actually completed by the princely patrons of the seventeenth and eighteenth centuries. The great contribution of Baroque thinking was to clarify the idea of the building as part of a deliberately and self-consciously designed context, in which both diversity and coherence are present by deliberate intent and in which the interaction of each building with its neighbours becomes a matter of careful consideration. The spaces enclosed by buildings are treated as, in effect, outdoor rooms and the street frontages form the walls of those rooms. There is a calculated modulation from the 'low-tension' domestic building —essentially a front, not a magnet inviting the spectator to pursue the aesthetic exploration beyond the area railings but rather something for him to pass by with a nod of approval—to the 'high-tension' public building which offers a more complex experience.

The individuality of the single dwelling is completely subordinated to the collective effect of the street or square. Such ideas, taken up and humanized by the entrepreneurs of a more democratic society, produced in the squares and crescents of London, Edinburgh, Bath, and Dublin a sense of place which one has to be insensitive indeed not to recognize. In part, the quality of the unspoiled parts of these cities derives from a peculiarly Anglo-Saxon genius for reconciling buildings with nature: the better part, perhaps, of that English love of the country which has also fringed the peripheries of the same cities with the dreariest kind of suburbia.[1] But it results also from a very highly cultivated awareness of the interaction of buildings with each other, and this kind of awareness is most necessary to the appreciation of architecture.

The observer, in fact, must ask himself not only 'What is this building communicating to me?' but also 'What is it doing to the *place*?' It may be doing various things which contribute to making the immediate environment tolerable or intolerable. It may block the sun or the view from an open place and in so doing alter the whole relationship of the other buildings to their setting; or it may frame a view as in a theatre proscenium and so give it a new and surprising intensity. It may make a point or destroy one already made—Broadcasting House in London effectually destroyed the point John Nash made a hundred years earlier in designing All Soul's, Langham Place to suit the sharp turn of Regent Street. It may give point to a whole space, as does the portico of St Paul's, Covent Garden, whose function as a shelter-point plays such an essential part in Shaw's *Pygmalion*. It may be exactly what a long street needs to break its tedium or it may be an unwelcome addition to an already indigestible experience of competing visual stimuli.

In the course of such studies the observer will realize that there is room in the townscape for all sorts of eloquence—the well-timed understatement, the purple passage, the burst of high spirits, even the broad jollity of the red-nosed comic—and he will have occasion to notice how a piece of misplaced eloquence can not only defeat its own object by seeming ridiculous but can even destroy the sense of place altogether. This is not simply a matter of architectural good manners —for it is not particularly a virtue to make a boring party still more

All Souls', Langham Place, London, by John Nash. *National Monuments Record*

[1] There are of course suburbs and suburbs. I am referring specifically to those in which (to quote Norberg-Schulz) one finds 'neither a natural nor an artificial order but a chaotic repetition of separate elements'.

Houses and windmills on Mykonos. *Photo: Hester Henderson*

boring by being afraid to speak out of turn—but really a matter of coherence. The offence of the ill-placed building is not against etiquette or good taste, but against man's need to make sense out of his environment: it is an addition, which may become intolerable, to the confusions and irritations of life.

By coherence we are not to understand the monotony of the repeated simple pattern. This is only too easy to achieve; but pattern becomes interesting—attractive, in the proper sense that it attracts and engages the spectator—only when it is at the same time both complex and sufficiently orderly to be readable. The visual pattern made by a group of buildings as we *see* them—as distinct from the physical movement-pattern dictated by the street-plan—is the result of the interplay between primary forms (the masses and silhouettes of the buildings) and secondary forms (that is, accents such as windows, doors, balconies) and colours. The maximum unity of primary forms combined with maximum standardization of secondary forms, when carried through the whole of a prolonged spatial experience such as that provided by a street or a neighbourhood, produces the coherence

'Habitat 67' Montreal, by Safdie, David, Barott, and Boulva. *Photo: Architectural Review*

of the barracks and the mind closes itself through sheer boredom. Maximum diversity of both primary and secondary forms, similarly prolonged, produces a bombardment of confused visual impressions against which the mind also closes itself in sheer self-protection. The kind of coherence which *engages* it is provided, broadly speaking, by the presence of unifying secondary elements within a complexity of primary form or by the enlivening of a very self-contained primary form by diversity in the design or placing of the secondary forms. The first approach can be seen in examples as diverse as the Aegean village illustrated here and the 1967 'Habitat' housing in Montreal; the effect of the second has already been observed in the Doge's Palace.

In either case the unifying influence may be either the common use of a particular form, whether primary—as, for instance, the roof-pitch—or secondary, such as a window or door detail. It may have its origin in vernacular tradition like the high-pitched roofs of medieval Germany or the 'crow-stepped' gables of Scotland, or it may be adopted as a matter of deliberate design policy dictated perhaps by

the prevailing style (as in the Georgian terrace) or adopted, as in the case of the Montreal housing, by a particular designer for a particular job.

There are two other notable aids to coherence: one is smallness of size and the other is a hierarchy of parts. The first hardly needs explanation. The experience which is limited in space and duration presents relatively few opportunities of either boredom or confusion, and it can be rapidly taken in. Hence the value of a street arrangement which breaks up large areas into smaller and more intimate ones and allows each to give its own feeling of place within the larger context. To walk among the Inns of Court in London is an experience very noticeably different from walking along Oxford Street. As for the hierarchy of parts, its importance in making sense of the environmental pattern is obvious enough to anyone who has used a conspicuous building on the skyline to orientate himself in an unfamiliar town: a dominant element in any pattern acts as a key by which we are helped to relate the minor parts to each other and to the whole.

The importance of such a hierarchy in the urban pattern, however, goes a good deal deeper, as we can see by looking at the typical medieval town. Here the most conspicuous buildings, such as the church, the guildhall, and the castle, were not only the largest but were also the most permanent evidence of the place's history as well as symbols of the determinant institutions in the lives of its people. Such buildings served to give them their bearings not only in space but in time and—since the hierarchy of architectural form corresponded recognizably to the social hierarchy—in society as well. The medieval burgher lived in a state of close engagement with his place and his time and with the social and religious fabric of that place and time and his architectural surroundings gave reality to that engagement to an extent almost beyond the comprehension of the modern city-dweller.[1]

Equally the aesthetic incoherence of the twentieth-century city

[1] Since the great physical size of the cathedral or the palace was matched by the respect accorded by the general population to the institution with which it was identified, such buildings played a meaningful part in creating what Norberg-Schulz calls the 'symbol-milieu', and this was a major component in the building-task. The modern office-block, existing quite independently of the affections and loyalties of the people outside its walls, has no comparable function of transmitting treasured cultural values from generation to generation. Thus its size is not readily correlated with its significance and (like a dumb giant playing a minor part in a play) the odds are that it will introduce incongruity rather than coherence into the total experience.

reflects only too accurately the whole predicament of twentieth-century man: his uncertainties and evasions, his loss of touch with place as a concrete influence on human life, all the improvisations by which he tries to adapt to his own needs an urban pattern (if pattern it can be called) produced by the improvisations of his predecessors. For, to be fair, this incoherence is not the creation of one or two generations: the modern city (unless it is very exceptional) is super-imposed on the earlier chaos of the nineteenth-century city, and this in turn may well contain traces of the eighteenth-century attempt at urban order and even, surviving miraculously, some relics of the medieval town upon whose body 'inorganically and indeed can-cerously, by a continuous breaking-down of old tissues and an over-growth of formless new tissue'[1] it has grown.

Faced with the fact that present population trends, if continued over the next forty years, will demand as much urban building as man has achieved in the whole of the previous six thousand, it is not surprising that the more far-sighted architects of today see their profession's main task in far broader terms than did their predecessors —as nothing less, in fact, than the attempt to restore human dignity and a humane order to this muddled environment, in which these qualities are already dangerously close to extinction. Few of them would quarrel with Professor Peter Collins's view that 'among all the conflicting ideals of modern architecture, none has proved today of such importance that it can take precedence over the task of creating a humane environment',[2] with its corollary that the architect does the community no service if he sees no further than the boundaries of the single individual building and ignores the vital relationship of building and context. Fewer still would underrate the difficulties of the task in a society which often seems suicidally indifferent to the aesthetics of its environment, which treats its buildings as com-modities to be appraised only in terms of economic potential and which values sites as abstract capital assets rather than concrete places which people may love or hate, in which they may find delight or boredom, and which will influence their lives for better or worse.

[1] Mumford, *The City in History.* [2] Collins, *Changing Ideals in Modern Architecture.*

Epigraph

To live in an environment which has to be endured or ignored rather than enjoyed is to be diminished as a human being. The society which ignores this fact is at risk, for it is presuming too far upon human adaptability: drabness, confusion, and mediocrity make an imponderable but real contribution to the frustration and depression which produce stultified, sick, or apathetic citizens.

Society is insured against this risk only to the extent that the intelligent people in the community care about the whole matter of the built environment: not simply about the efficiency with which traffic flows through the streets and water and drainage through the pipes, about the abstract statistics of housing, but about the effect of place, as man has made it, on the feelings of people. To that extent the will to understand and enjoy architecture is not only a source of personal pleasure but a force upon which the health of civilization may depend more than is commonly realized.[1] The practitioner of any art needs the stimulus of criticism (whether favourable or unfavourable) conducted at a level of understanding which he can respect, and the practitioner of an art so public as architecture needs especially to encounter this level of criticism among the general public, and not only among his fellow-practitioners, if he is not to become a dangerously isolated and self-centred character.

In primitive cultures this is no great problem. The options open to the designer (if we may call him that) are few, and they have been so thoroughly explored by previous generations that he and his public share a wide common ground of opinion about the qualities of a 'good' building. At a more sophisticated level a similar though more flexible framework of criticism is provided by the existence of a style in which acceptable norms are embodied in a kind of aesthetic code familiar to designer and public alike. As we have seen, the concept of style in this sense breaks down when there is a rapid increase both in

[1] In *Between Dystopia and Eutopia* (Hartford, Conn., 1966), Constantinos Doxiadis has demonstrated that the urban population of the world is likely to quadruple by the end of this century, and that it is most unlikely that man will adapt himself successfully to this degree of urbanization unless he pays infinitely more attention to the scale and quality of his built environment than he does today.

the diversity of a society's building-tasks and in the diversity of techniques and materials available to meet them.

Deprived of such a common basis of criticism, both the architect and his public find it extremely difficult to rationalize their preferences: so difficult in fact that some people have held that these preferences are entirely personal and subjective (thus effectively denying the critic any constructive role), while others have sought to replace the outmoded stylistic canons by quasi-moral norms, maintaining, for example, that a building ought to be judged by the truthfulness with which it exhibits its function, its structure, or its materials. Whatever its virtue in helping the designer to discipline his own idea-forming process, dogma of this kind is not particularly helpful to the observer. Failure to produce some decent and stimulating aesthetic order may well, as we have seen, be traceable to an unsound functional intention—that is, failure to translate the requirements of the building-task into well-ordered spatial terms—or to an ill-considered structural intention. But any attempt to make a simple equation between utility and beauty is beset with pitfalls in a period in which user-requirements can change so rapidly as to make a building functionally obsolescent almost before the paint is dry; and as far as structure is concerned we have already noticed that unless it produces form of an inherently dramatic kind or displays aberrations gross enough to jar on his intuitive sensibilities, the observer takes it very much on trust. Until recently one could have taken a more justifiable stand on the principle that the 'right use of materials'—that is, the use of every material in a way which exploits its inherent qualities —is an immutable condition of excellence, and certainly the perverse use of a material in a way to which it is fundamentally unsuited is fair ground for objection. But even this principle, illustrated as it is in innumerable buildings of the past and present, may be a broken reed for the critic of the twenty-first century, in which—so far from accepting the nature of the materials at hand—the designer will increasingly call upon the industrial chemist to synthesize new molecules for his purpose.

The absence of ready-made stylistic or quasi-moral criteria may at first seem to present formidable difficulties to the observer who seeks to cultivate the habit of judgement. But in fact it can prove a positive gain, for it obliges him to develop his own resources and his own curiosity. The appreciation of architecture in a period of rapid change, such as ours, is not a matter of saying: 'I ought to like or dislike this

building because . . .', but of becoming aware that one does react in a particular way to some buildings at least, and of being interested enough to look harder and, learning from the experience itself, to become more acutely aware of more buildings. The valuable critic is not someone who merely likes what is familiar to him, and still less is he someone who pretends to like what he has been told to admire. He is someone who is prepared to expose himself fully to the new experience and ask himself what it is doing to him and how it is doing it.

Such an observer will not fall into the trap of dismissing a building as an irrational freak simply because it does not fit a stereotype which already exists in his own mind; nor will he fall into the equally dangerous trap of assuming that a building has nothing to say to him because its delights are subtly rather than flagrantly displayed. He will take the trouble to decipher the whole communication it is trying to make, and will arrive at his own conclusions whether that communication is worth his attention or not.

The bases of that assessment will, I hope, be clear to the reader by this time. The critic will be looking for that quality which was described in the last chapter as 'eloquence' and whose essence lies in a consonance of means and ends. He will be looking for evidence that the designer knew what he was doing not simply with bricks, cement, and steel but with the deep-seated and irremovable emotional associations of scale, mass, rhythm, space, shape, and light. He will ask himself whether the cumulative emotional effect of the aesthetic communication, its 'level of tension', is gauged to its purpose; whether the architect failed to rise to an occasion (something more than low-tension charm is expected of a cathedral) or whether on the other hand he was merely making a great ado about very little (something much less than awesomeness is expected of a cottage): and he will ask himself, too, what contribution it makes to the sense of place.

The observer who accustoms himself to this kind of judgement will find that the mere exercise of it adds a dimension to his life because he is in fact training himself to see things that he never saw before. By deepening his understanding of what he sees, he is both deepening his understanding of himself and sharpening his perceptions of the world around him. This is the fundamental contribution of any art to the enrichment of life: and of all the arts it is most important that architecture, the most public and accessible, should be drawn upon for that contribution. The city is man's greatest

invention, and he has been accustomed for centuries to look to its buildings as symbols of his aspirations and to lavish on them his care, his resources, and his affection. His ambitions now reach beyond this planet and it is not, as in medieval times, the cathedral but the space-craft which calls forth the highest technical expertise of the most advanced societies and an immense deployment of their economic resources. But it remains all the more necessary that he should retain and develop the faculty of 'reading sign' on his immediate terrestrial environment if he is not only to continue adapting it successfully to his physical needs but also to enrich it for his greater emotional satisfaction. Aristotle said that 'men come together in the city to live: they remain there in order to live the good life'. And while we may not today regard the erection of a great building as the peak of human ambition, we dare not pretend that the good life is an auto-matic outcome of the technical ability to fire cathedrals at the moon.

Biographical Notes

ALVAR AALTO *b. 1898* whose work is mainly in his native Finland is one of the outstanding architects of this century and is admired particularly for his close attention to the relationship of building and landscape, his sympathetic treatment of materials, and his evident respect for humanity, both in the individual and in the mass. Rasmussen, who lays great emphasis on the distinction between ceremonial and informal rhythms, cites Baker House as a particularly fine example of a building whose rhythmic qualities abolish the 'ant-hill atmosphere of old-fashioned dormitories'.

FILIPPO BRUNELLESCHI *1377–1446* a goldsmith by training, was the pioneer architect of the Renaissance.

ANTONI GAUDÍ *1852–1926* was a Spanish architect whose work is notable for a prodigious vitality of plastic and decorative invention. His best-known work is the unfinished church of the Sagrada Familia in Barcelona.

WALTER GROPIUS *1883–1969* practised in Germany from 1910 to 1934, and (with Maxwell Fry) in England from 1934 to 1937, when he went to Harvard University as Professor of Architecture. His Fagus factory at Alfeld (1911) and his model factory for the Cologne Werkbund Exhibition of 1914 were landmarks in the development of the 'international style'. From the start he foresaw the provision of efficient, low-cost housing as a major architectural task of the twentieth century, and laid great emphasis on the satisfaction of functional needs as an inspiring motive. As Director of the *Bauhaus* (formerly the School of Arts and Crafts) at Weimar and subsequently at Dessau, he aimed at the integration of architectural education with training in industrial design, a concept which was to have far-reaching effects on twentieth-century architecture.

LE CORBUSIER (CHARLES-ÉDOUARD JEANNERET) *1887–1965* was the best known and probably the most influential of all modern architects, both through his work and through the vivid and forceful presentation of his theories of architecture and town planning in such books as *Vers une architecture* (1923) and *Urbanisme* (1924). In the former he states as an article of faith that 'all the great problems of modern construction must have a geometrical solution' and the search for such a solution

eventually led him to evolve the *Modulor* method of proportional design, which employs an infinitely extensible set of dimensions all proportionately related to one another and to the scale of the human body. His application of the system is best exemplified in the Unité d'Habitation at Marseilles.

W. R. LETHABY
1857–1931
who became principal of the Central School of Arts and Crafts in London in 1894, played an important part in bringing the social ideals of William Morris to bear on architecture, and was one of the earliest advocates of a 'functional modern vernacular'.

ADOLF LOOS
1870–1933
worked mainly in Vienna, where between 1900 and 1910 he evolved a severely rectangular style of domestic architecture, totally devoid of ornament and relying on proportion, space, and high-quality materials for its effect. His manifesto *Ornament and Crime* (1908) did much to prepare opinion for the post-war movement towards cubic forms with unrelieved surfaces.

CHARLES RENNIE
MACKINTOSH *1868–1928*
practised in Glasgow and the West of Scotland between 1896 and 1913, his most famous work being the Glasgow School of Art, the competition for which he won in 1896. His remarkable gift for combining sensuous, flowing lines with broad simplicity of mass earned him a European reputation and particularly influenced the Viennese modernists.

LUDWIG MIES
VAN DER ROHE
1886–1969
succeeded Gropius as Director of the *Bauhaus*, then moved to the United States where he became Professor of Architecture at Illinois Institute of Technology in 1938. His work is characterized by openness and lucidity of planning, severity of form, great precision of detailing, and immaculate finish. His Lake Shore Apartments, Chicago (1951) and Seagram Building, New York (1956–9) are good examples.

PIER LUIGI NERVI
b. 1891
an Italian engineer notable for his success in designing wide-span concrete structures whose elegance derives from the search for maximum efficiency of structural form in terms of 'most work for least weight'. The best known works with which he has been associated are the City Stadium, Florence, the Turin Exhibition Hall, and the Sports Palaces and Stadio Flaminio in Rome.

LOUIS SULLIVAN
1856–1924
practised in Chicago from 1879 onwards, his best-known buildings being the Carson Pirie and Scott store (1899), the Wainwright Building in St. Louis (1890), and the Guaranty Building in Buffalo (1894). All of them embody a philosophy of

design radically opposed to the European classicism which was then fashionable in the eastern states: he coined the phrase 'form follows function'.

KENZO TANGE established his reputation with the Memorial Hall at Hiroshima
b. 1913 in 1950, consolidated it with a series of civic buildings in Tokyo and elsewhere during the next decade, and became internationally famous with the building of the Olympic Sports Halls.

FRANK LLOYD WRIGHT worked as a young man with Sullivan, for whom he had a deep
1869–1959 admiration. Beginning with domestic work in Illinois, Wisconsin, and Ohio, his practising career extended over sixty years and included such diverse works as the Imperial Hotel, Tokyo, and the Guggenheim Museum, New York, as well as those illustrated here. A passionate individualist—he has been called 'the Walt Whitman of American architecture'—he was the first modern architect to exploit to the full the continuity of interior and exterior space. His work is intensely personal and original, combining an innate romanticism with great structural inventiveness.

Index

Dark Ages, 90
decoration, 80; didactic, 120
deformation, 18, 55, 63
delight, 25 ff., 36, 73, 162
Denmark, 51
design, process of, 149, 172; selfconscious, 156, 157; unselfconscious, 156, 175
discontinuity, structural, 59
diversity, 179
Doge's Palace, Venice, 40, 42, 45, 50, 56, 112, 160, 179
dome, 87, 110
Doric order, 26
Doxiadis, C., 182 n.
duality, 16
dug-out, 71

eclecticism, 130
economy: of effort, 38; of means, 162; of structure, 64, 95, 97, 187
Edwardians, 44, 49
Egypt, 52, 57
elasticity, 58, 59
Elephant House, London Zoo (Casson, Conder, and Partners), ii–iii, 136–7
eloquence, 13, 52, 158, 159 ff.
emphasis, 160
energy, 8 n., 20 ff., 28, 29, 42, 43, 112, 122, 124
engineering, structural, 44
enrichment, 115 ff., 160
Eskimo, 9, 71
Exhibition Hall, Turin (Nervi), 63, 187
expectation, 26, 28, 33, 73
exuberance, 44
Eyck, A. van, 116 n. 2

Fagus Factory, Alfeld (Gropius), 186
Farnsworth House, Plano, Ill. (Mies van der Rohe), 64, 71, 103, 114
ferrocimento, 63
Finland, 173, 186
fit, 19, 151 ff.
floodlighting, 140
Florence, 48
folksiness, 172
Fontana, D., 40, 160
forms: primary, 178; secondary, 178
Fry, E. M., 186
Functionalist school, 132, 141
Furness, F., 21, 23, 24

Gama, V. da, 129
Gaudí, A., 21, 43, 102, 114, 186
Georgian, 33, 97, 117, 118, 140, 154 n. 2, 165, 166, 180
gesture, 9, 11, 12, 124
Glasgow School of Art (Mackintosh), 187
glass, 67, 78, 133, 138, 145
Gombrich, E. F., 1 n.
Gothic, 36, 39, 46, 55, 79, 93, 94, 95, 96, 98, 111, 112, 114, 118, 120, 121, 122, 127, 133, 154, 159, 161
Gothic Revival, 95
Grandstand, Galashiels (Womersley), 10, 11
gravity, 8, 9, 11, 21, 51, 56, 57, 109
Great Mosque, Isfahan, 128
Greek, classical, 7, 26, 46, 57, 113, 117, 118, 130, 159, 165, 171, 173
Greek Revival, 133
Green, H. B., 86 n.
groined vault, 91
Gropius, W., 102, 131, 148, 186
Guaranty Building, Buffalo (Sullivan), 187
Guatemala, 55, 121
Guggenheim Museum, New York (Wright), 188
Guyana, *see* Caribs, *benab*

Habitat 67, Montreal (Safdie, David, Barott, and Boulva), 179
Hagia Sophia, Istanbul, 88, 89
Halle des Machines, Paris, 101
Harun al-Rashid, 128
heraldry, 119, 139
Hindu sculpture, *see* sculpture
house-style, 167
hybrid, 19

iconostasis, 77
idiom, 12, 167
igloo, *see* Eskimo
illusion, 17 n. 2, 79
imbalance, 20, 28, 47
Imperial Hotel, Tokyo (Wright), 188
incongruity, 164, 180 n.
inconsistency, 84
indecision, 81, 85
India, 128
industrial revolution, 67, 97
Inns of Court, London, 180
'insincere' architecture, 17
inspiration, 153, 157